ADAM PURPLE &
*THE GARDEN
OF EDEN*

Copyright © 2012 by Harvey Wang and Amy Brost

All rights reserved. Except as permitted under U.S. copyright law, no part of this publication may be reproduced, distributed, or transmitted in any form or by any means, or stored in a database or retrieval system, without the prior written permission of the publisher.

Traveling Light Books
c/o Harvey Wang
309 East 4th Street, #3C
New York, NY 10009

First Edition: September 2012

ISBN 978-0-615-54722-0

Art Director and Interior & Cover Designer: Samuel M. Leeds

All photographs © Harvey Wang except those on pages 6, 7, and 27-29, which are © Adam Purple and used by permission.

Illustration on page 11 courtesy of the Storefront for Art & Architecture, New York, NY, from the 1984 exhibition "Adam's House in Paradise." Architect: Ludmilla Pavlova; Artist: Tony Saunders.

Paintings by Patricia Melvin on page 89 appear courtesy of the artist.

ABOUT THE AUTHORS v

THE ARTWORK AND EARTHWORK OF ADAM PURPLE 1

THE GARDEN OF EDEN FROM ABOVE 25

ADAM AT HOME 37

ZENTENCES 51

ADAM WORKING 57

IN *THE GARDEN OF EDEN* 71

DESTRUCTION 91

ABOUT THE PHOTOGRAPHS 107

ABOUT HARVEY WANG

In the 1970's and '80's, Harvey Wang was a resident of Chinatown and the Lower East Side, an admirer of Adam Purple, and one of the few photographers to visit Adam throughout the creation and expansion of *The Garden of Eden*. These collected photographs, published for the first time, may be the most complete visual record of *The Garden of Eden*. Wang also printed a series of photographs of the Garden in its earliest stages. These were printed at Adam's request, from his own negatives. Those negatives, along with much of Adam's own documentation of the Garden, were subsequently lost. That loss makes this collection of photographs essential to securing a place for *The Garden of Eden* in the cultural memory of the city of New York.

Harvey Wang has published five books of photography, all critically acclaimed portraits of Americans from many walks of life. His books include *Flophouse: Life on the Bowery* (Random House) and *Holding On: Dreamers, Visionaries, Eccentrics and Other American Heroes* (W.W. Norton & Co.) both collaborations with oral historian and radio luminary David Isay. *Harvey Wang's New York* (W.W. Norton & Co.) is a book of portraits of older New Yorkers whose occupations and way of life are being threatened by change. It was called "a humane modern classic" by the *Washington Post*.

Wang has exhibited widely at museums, including the National Museum of American History at the Smithsonian Institution in Washington, DC, the New-York Historical Society, and the Museum of the City of New York. In addition to his portrait photography, Wang has exhibited photographs from his travels in Africa and across the United States, and from his life in New York City, particularly in the 1970s and 1980s.

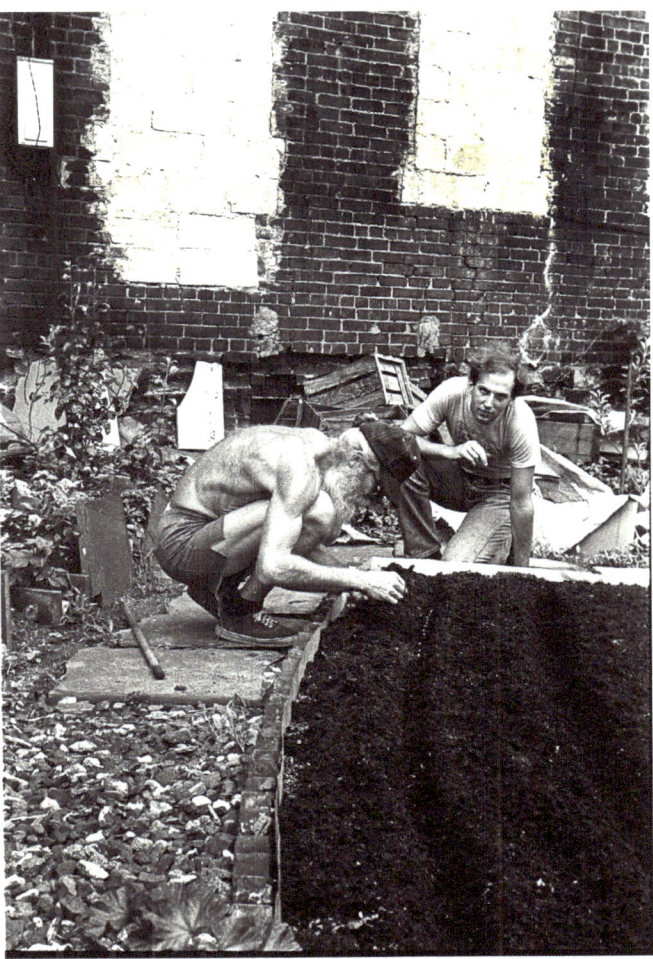

ABOUT AMY BROST

Amy Brost first came across Harvey Wang's photographs of *The Garden of Eden* in 2004, and reached out to Adam to learn more about his work. She continued to work closely with him on and off over the following seven years, determined to find a way to bring Adam's work to a wider audience. In 2006, she interviewed him as part of the StoryCorps oral history project. In 2010, she circulated Harvey's pictures and information about Adam to several major museums, and as a result, the New Museum included Adam in their *Bowery Artist Tribute* series, Volume 2. Harvey and Amy then mounted the exhibition "Adam Purple and *The Garden of Eden*: Photographs by Harvey Wang" at the FusionArts Museum at 57 Stanton Street on the Lower East Side in Manhattan. The exhibition ran from February 2-20, 2011. Amy started a short film "Adam Purple and *The Garden of Eden*" to promote the exhibition and help raise funds on Kickstarter.com.

Soon, with help from Harvey and editor Krystal Lim, it developed into a full-fledged documentary short film. The film had its debut at the 2011 LES Film Festival, which took place just blocks away from where *The Garden of Eden* once flourished. Subsequently, the film was screened at Brooklyn Shorts, the American Conservation Film Festival, and the 34th Starz Denver Film Festival.

The New Museum also included *The Garden of Eden* in its 2012-2013 exhibition *Come Closer: Art Around the Bowery, 1969-1989*.

Amy Brost is currently an Andrew W. Mellon Fellow pursuing graduate degrees in art conservation and art history at the Conservation Center, Institute of Fine Arts, New York University.

The Artwork and Earthwork of Adam Purple

Amy Brost
With fact-checking and editorial assistance by Adam Purple

January 8, 2011, marked the 25th anniversary of the destruction of *The Garden of Eden*, an earthwork that once spanned five city lots on Manhattan's Lower East Side. The fact that it is no longer extant could account for its absence from land and environmental art scholarship, along with the fact that the artist, Adam Purple (David Wilkie), lived within the city but in many ways totally apart from it. His desire to use his earthwork as a way to confront both the surrounding urban environment and the attitudes of its inhabitants eclipsed any desire he had for recognition by the art-world establishment. A search of the literature yields no substantial discussion of Adam Purple's role as an artist, nor is he mentioned in discussions of contemporary "environmental" artists working with related themes and approaches. What one does find is a significant number of articles in the news media in the 1980s covering the controversy surrounding the destruction of *The Garden*. While this part of *The Garden*'s existence is well documented, there has been no survey of Adam's work, including his anti-establishment leaflets and hand-made books, that recognizes Adam as an important artist in his own right.

Adam had no formal art training, though he did apply for and twice receive Artist Certification from the New York City Department of Cultural Affairs. He considered himself an "environmental sculptor" [1] and called *The Garden* his "Earthwork." [2] Still, he never devoted time to developing a "career" as an artist and had no art-world protégés. As such, he was not an influential part of a movement *per se*, but he was nonetheless an important American environmental-ecological artist. Particularly noteworthy is that, over the course of more than 10 years, Adam Purple executed a fairly large-scale earthwork in the heart of one of America's largest cities, without financial patronage, and with little more than his own two hands and a bicycle.

1. Adam Purple, "*The Garden of Eden*: An Environmental 'Radical Transformation'" (proposal submitted to the 16th annual meeting of the Environmental Design Research Association, City University of New York Graduate Center, New York, New York, 10-13 June 1985). Reprinted in *LIFE with les(s) ego*, 108.
2. Adam Purple, "*The Garden of Eden*: An Environmental 'Radical Transformation'" (paper presented at the 16th annual meeting of the Environmental Design Research Association, City University of New York Graduate Center, New York, New York, 10-13 June 1985), 2. Reprinted in *LIFE with les(s) ego*, 118.

Before coming to New York City in 1968, he (as "les ego") had created two rare books in Australia, where he was engaged in protests against French nuclear testing at Mururoa Atoll.[3] The first was a tabloid-sized scrapbook called *Psychenautics*, which he donated to the Mitchell Library in Sydney, N.S.W. It was a compilation of newspaper and magazine clippings about the psychedelic revolution in the mid-1960s. The second was called *Zentences*. Its Dutch-door structure allowed the reader to pair separate noun (top pages) and verb (bottom pages) phrases in interesting combinations. Readers could pair words or phrases like "FREEDOM," "MY MIND," "ORGANIC FOOD" or "NUDITY" with endings like "can be discovered at any age!" or "sometimes frolics!" or "awaits me in a magic mushroom!"[4] The non-linear, exponential Dutch-door structure of *Zentences*, in its original 48-page form, would create 2,304 combinations, not including blank top and bottom pages.[5] Recipients chose only 40 nouns and 40 verbs from 100 available, and "les" would then add first names and seven extra noun pages and eight extra verb pages to create a unique, personalized book.[6] The Author's Note to the 1971 version states that "about 500 copies of handmade editions...were distributed under the title *Meditation Manual for Mini-Minds and Mystics* between October 1967, in New South Wales, Australia, and 1971 in New York City."[7] Measuring 1.375 x 1.75 inches, the miniature *Zentences* displayed his bookbinding skill. John Rathe, a librarian at the New York Public Library, said, "This is not an art object pretending to be a book. It is, in fact, a book made in classic fashion."[8] Although it is estimated that fewer than 100 copies of *Zentences* survive, one can be studied in the "miniature collection" of the New York Public Library's rare books division.

Zentences also exists in a do-it-yourself format, with hand-lettered pages designed to be photocopied, then cut to fit a 6-hole loose-leaf binder 4.375 inches tall and 2.75 inches wide (Figure 1). When those binders became scarce, Adam suggested binding the pages with string or binding rings.[9] While the typewritten and bound volume has its own magical quality, his loose-leaf version, with the verb pages written in careful script and the noun pages embellished to the point of near-illegibility, has a distinctly different character. It invites even more participation on the part of readers, who can add and reorganize pages at will.

The "rare-book" author came to New York in part to find a publisher for *Zentences*. Even though he thought Random House would be the obviously appropriate publisher for his random book, a contract and distribution agreement could not be reached, and he felt he was not offered a fair deal.[10] When the late Bennett Cerf was shown a copy of *Zentences* at Random House's Madison Avenue office, he said, "Not enough dirty words."[11] Soon thereafter, "les" began to construct the ecological earthwork sculpture that would define his creative efforts for more than ten years.

Perhaps his most critical decision, the single

3. Adam Purple Interviewed at StoryCorps. Interview by author. November 22, 2006.
4. Adam Purple, *LIFE with les(s) ego* (New York: les ego, 1983), 10.
5. Purple, *LIFE with les(s) ego*, 10.
6. Adam Purple, e-mail message to author, January 24, 2011.
7. Author's Note to 1971 edition of *Zentences!*
8. Jesse McKinley, "A Rare, Classic Volume, All One Square Inch of It," *New York Times*, February 22, 1998.
9. les(s) ego, *Zentences! Meditation Manual for Mini-minds & Mystics!* (New York, 1971). Reprinted in *LIFE with les(s) ego*, 12.
10. StoryCorps interview.
11. Adam Purple, e-mail message to author, January 24, 2011.

decision that ultimately relegated him to artistic obscurity, was his site selection for his earthwork. He began *The Garden of Eden* behind his tenement building at 184 Forsyth Street. Soon thereafter, he developed his artist persona and began using the pseudonym Adam Purple. The site was located in Block 421 of Eldridge Street between Stanton and Rivington Streets, in the heart of Manhattan's Lower East Side, occupying lots 63, 64, 65, 67, and 68.[12] In a 2006 interview for the StoryCorps Oral History Project, Adam was asked why he chose this site for his endeavor, and he replied:

> "So, when I looked out my window...before the buildings on Eldridge Street were taken down, I was watching mothers sitting in the back window of a tenement building looking at their children playing in the garbage in the basement pit behind the building, a basement-level pit. And I thought, wow, that's a hell of a way to raise children, with no place to, you know, put your feet on the dirt."

When Adam began working on the site in 1975, much of Manhattan's Lower East Side had become a dangerous, violent, drug-ridden wasteland. In the midst of this, Adam began the process of clearing 5,000 cubic feet of debris from the two lots behind his tenement building. Adam was determined to create *The Garden* by hand, without the use of engine-powered tools of any kind,[13, 14] not even vehicles.[15] He argued that the automobile, along with what he called the "infernal combustion engine,"[16] were "counterrevolutionary,"[17] whereas *The Garden* would represent environmentally sound reclamation of abused land.[18]

The bulldozed, un-sifted compacted rubble was 12 to 18 inches deep, and covered each lot. Adam estimated that a 6-story, 24-apartment building would have approximately 300,000 whole bricks,[19] many of which would be broken or pulverized during demolition. Adam dug into the debris with a pick and manually sorted out the materials in the rubble. He kept whole bricks to use for pathways in *The Garden*, but the broken bricks ("bats") he considered unusable, except for use in "brick-bat calligraphy."[20, 21, 22] On the whole, he found that two-thirds of the rubble was unusable, and broken glass, plastic, etc., were discarded. However, some of the unusable

12. Sheyla Baykal, Speech, Board of Estimate, New York, New York, January 13, 1983. Reprinted in *LIFE with les(s) ego*, 75.
13. Adam Purple and Eve Purple, "The Garden of Eden," *Yipster Times*, March 1978. Reprinted in *LIFE with les(s) ego*, 30.
14. Norman Green, "The Purple People," *New York* Magazine, August 27, 1979.
15. Georgiana Pine, "Tiny Eden Blooms amid the Rubble," *New York Post*, May 15, 1978. Reprinted in *LIFE with les(s) ego*, 32.
16. McKinley, "An Unreconstructed Hippie Takes on the City's 'Pinheads.' When Is He Going to Get Some Respect?" *New York Times*, February 22, 1998.
17. Stewart Taggart, "Gardening with Zen and Urban Anarchism," *The Washington Post*, October 31, 1981. Reprinted in *LIFE with les(s) ego*, 52.
18. John Peter Zenger II, "Rubble Reclamation," *Garden* Magazine, July/August, 1979. Reprinted in *LIFE with les(s) ego*, 37.
19. Zenger, "Rubble Reclamation."
20. Photographs of *The Garden* published in *LIFE with les(s) ego*, 22-25, 28.
21. Harvey Wang, photograph of *The Garden of Eden*, March 21, 1979, in Purple, "*The Garden of Eden*: An Environmental 'Radical Transformation,'" (paper), 8. Reprinted in *LIFE with les(s) ego*, 124.
22. Harvey Wang, photograph of *The Garden of Eden*, December 30, 1978, in "A Garden Grows in Manhattan," *Crain's New York Business*, August 12, 1978. Reprinted in *LIFE with les(s) ego*, 133.

material was still recyclable; the surplus whole bricks could be sold for about 25 cents each, and pieces of iron, copper, and lead could also be recycled. Wood could be burned and the resulting ash used in soil production. He twice sifted the finer debris, first with a half-inch screen, and then again with a quarter-inch screen, to separate the small gravel that could be used for walkways from the sand that could be used in soil production.

In addition to brick sand and potash from unpainted burned wood, Adam needed one more essential ingredient in his recipe for virgin topsoil – manure. To haul this material, Adam lashed a milk crate to the rear rack of his purple bicycle with polyester rope. Almost daily, he made the seven-mile round trip to Central Park to bring carriage-horse manure back to *The Garden*. He was able to carry about 60 pounds on each trip.[23] Wearing purple tie-dye and collecting horse manure tended to draw a fair amount of attention, and Adam called this activity an act of "conspicuous conservation." [24]

Adam termed his combination of potash, brick sand, and horse manure the "maxi-method" of topsoil creation, and claimed that it would generate 2,167 square feet of topsoil per person per year.[25] His corresponding "mini-method" of soil creation added 36 square feet per person per year of topsoil, and involved composting his own vegetarian human feces, kitchen vegetable peelings, and dead leaves from nearby Sara Roosevelt Park, along with other weed prunings. <u>Figure 2</u> shows Adam at work on March 21, 1975, and the accompanying diagram illustrates his working method. This photograph was the first in a series designed by Adam to document his progress on *The Garden*.

Once the requisite amount of topsoil had been produced, Adam began work on the beds and plantings. He arranged the plantings in concentric broken-circle beds, with a double yin-yang symbol in the center. Adam's circular design had mathematical and metaphysical meaning: *The Garden of Eden* grew exponentially with the addition of each new ring of beds. Adam earned a Bachelor of Science degree in Education from Emporia, Kansas State Teachers College in 1952, and a Master of Arts in Journalism degree from the University of Missouri in 1956.[26, 27] While he majored in English at KSTC, he also completed a minor in mathematics. Having enjoyed mathematical games, he said of *The Garden*'s design:

"Well when you throw a rock in the water, circles go out. And, the circle is historically a universal symbol, and you break the circle because you make like a labyrinth, you could walk in a spiral, you could walk out of *The Garden* in a spiral and if you noticed from the pictures of it, the central yin yang was four pieces – that's a yin yang split into two. Two squared is 4, that's an exponential function. The next circle was five sections, and the next one was six sections, seven, eight, nine and so on. So, each time you laid another circle, the number of sections in the circle increased by one. So, that's an arithmetic progression: one, two, three, four, five,

23. Zenger, "Rubble Reclamation."
24. John Lewis, "'Riddle Man' Sees Life As Garden of Delights," *Daily News*, June 6, 1976. Reprinted in *LIFE with les(s) ego*, 26.
25. Zenger, "Rubble Reclamation."
26. les(s) ego, *LIFE with les(s) ego*, 225.
27. McKinley, "An Unreconstructed Hippie Takes on the City's 'Pinheads.' When Is He Going to Get Some Respect?"

six and so on. So, it's a mathematical game and it was easy to work because the width was about the length of a rake handle..."[28]

After starting *The Garden*, he saw and admired the circular garden designs in *Garden Cities of To-Morrow* by Ebenezer Howard, a 19th-century utopian city planner. In Howard's diagrams, each garden city unit was comprised of concentric circles radiating out from a civic center. These circles contained ample parkland, residences, and shops, with small factories on the outermost edge. The area between garden cities was all country and farmland. One of Howard's plans included the prominent caption, "Illustrating correct principle of a city's growth – open country ever near at hand...."[29]

The central symbol, the "double" yin-yang, was also a symbol of the sexual revolution/liberation in the 1960s. In a 1984 article in *The Villager*, Adam explained, "A traditional Yin/Yang represents one man and one woman. But this stands for two men and two women together and that's a revolutionary concept in itself."[30] Adam, as the "Reverend Les Ego"[31] and before he began work on *The Garden*, had founded the catholic union mission (or c.u.m.), a group that combined communal sex and taking LSD to attempt to bring about the "non-violent underminding of all government." According to Rev. Les Ego, "The only basic requirement for entry in c.u.m. is that a person be one-half of a sex-positive heterosexual couple, the basic yin-yang unit. The mathematical implications of foursomes, sixsomes, eightsomes, etc., should boggle any thoughtful head."[32]

Each of the circular plant beds took Adam an average of five weeks to make. He made the borders out of salvaged bricks reinforced on the inside edge by salvaged sheets of galvanized sheet metal.[33] The pathways were made from the bricks Adam chose for their superior beauty, and he fitted them together into the labyrinthine walkways and filled the gaps with sand. By June, 1976, Adam had arranged for another photo to be taken (<u>Figure 3</u>) to document "ONE YEAR's hard labor to reclaim about half of TWO tenement lots: One person, One lot, One year!"[34, 35]

In following years, more tenements were torn down, and Adam expanded *The Garden* to occupy five lots by 1982 (<u>Figures 4-5</u>). It grew to 15,000 square feet of flowers, herbs, trees, fruits, and vegetables, as well as 100 rose bushes and 45 fruit and nut trees. Adam's crops included sweet corn that grew taller than he was, all manner of fruits (strawberries, apples, pears, apricots, nectarines), vegetables (asparagus, cucumbers, leaf lettuce, string beans, green peas), and the city's largest public black raspberry patch, grown on salvaged mattress springs on a Connecticut drystone wall. Garden snakes, brown thrushes, toads, walking sticks, butterflies, bees, and praying mantis

28. Purple, StoryCorps interview.
29. Ebenezer Howard and Frederic J. Osborn, *Garden Cities of To-morrow*. (Cambridge, MA: M.I.T. Press, 1965). Reprinted in L*IFE with les(s) ego*, 2, 4.
30. Brian O'Donoghue, "Destruction Seems to Be Future for 'The Garden of Eden'" *The Villager* (New York City), July 26, 1984. Reprinted in *LIFE with les(s) ego*, 91.
31. Howard Smith, "Scenes," *The Village Voice* (New York City), April 8, 1971. Reprinted in *LIFE with les(s) ego*, 8.
32. incidentally el and rev les ego, "C.U.M. to World Orgy I," *Inner City Light* (New York), July/August 1979, Vol. 1. No. 2 ed. Reprinted in *LIFE with les(s) ego*, 38.
33. Zenger, "Rubble Reclamation."
34. Adam Purple, e-mail message to author, January 16, 2006.
35. Adam Purple and Eve Purple, "The Garden of Eden," *Yipster Times*, March 1978. Reprinted in *LIFE with les(s) ego*, 30.

Fig 1. *Zentences,* 1973. Hand-lettered version. Instructions, cover page, title page, and author's note.

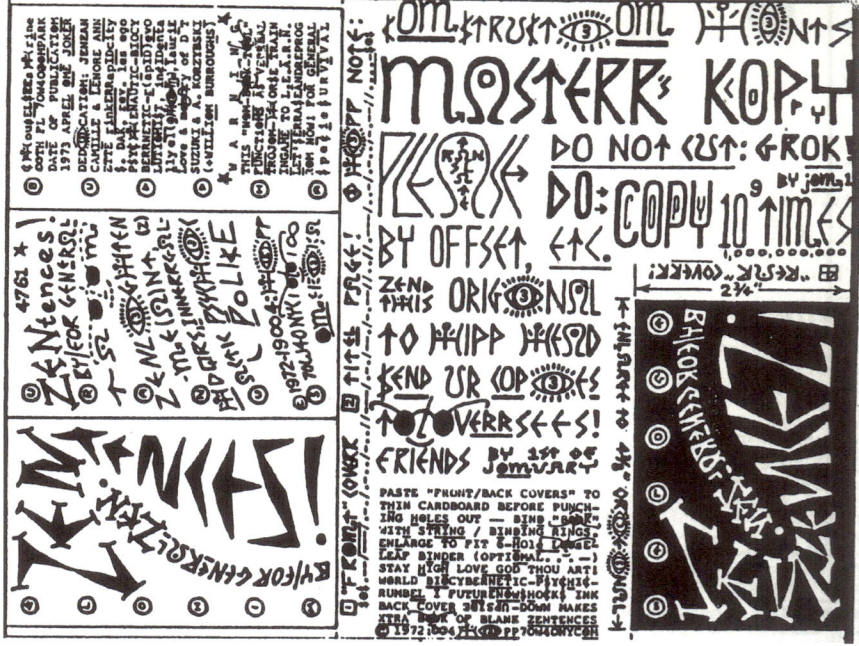

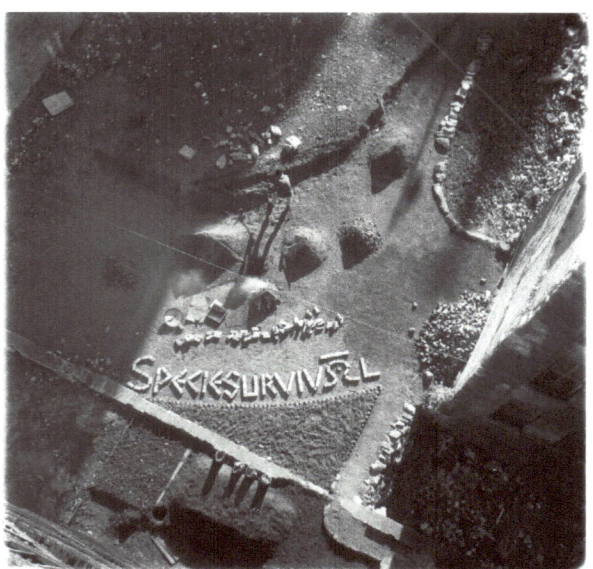

Fig 2. *The Garden of Eden*, 1975
Photo by Eve Purple

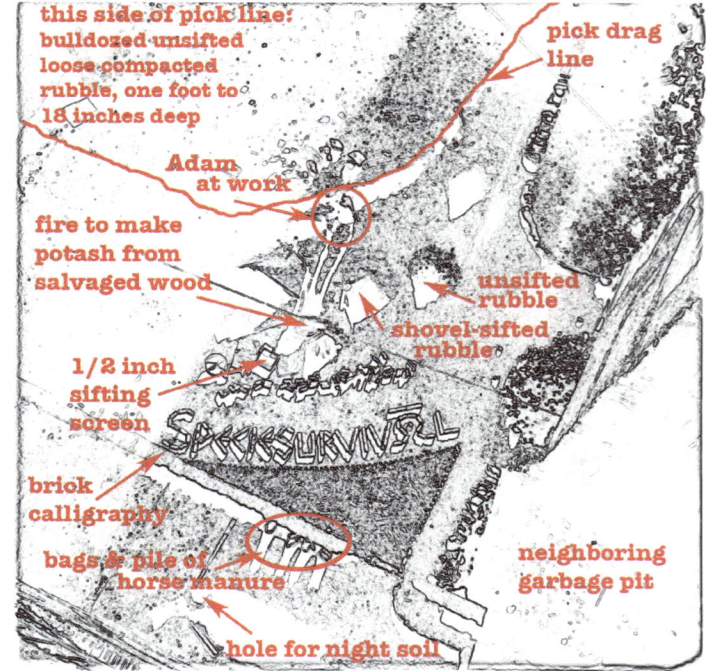

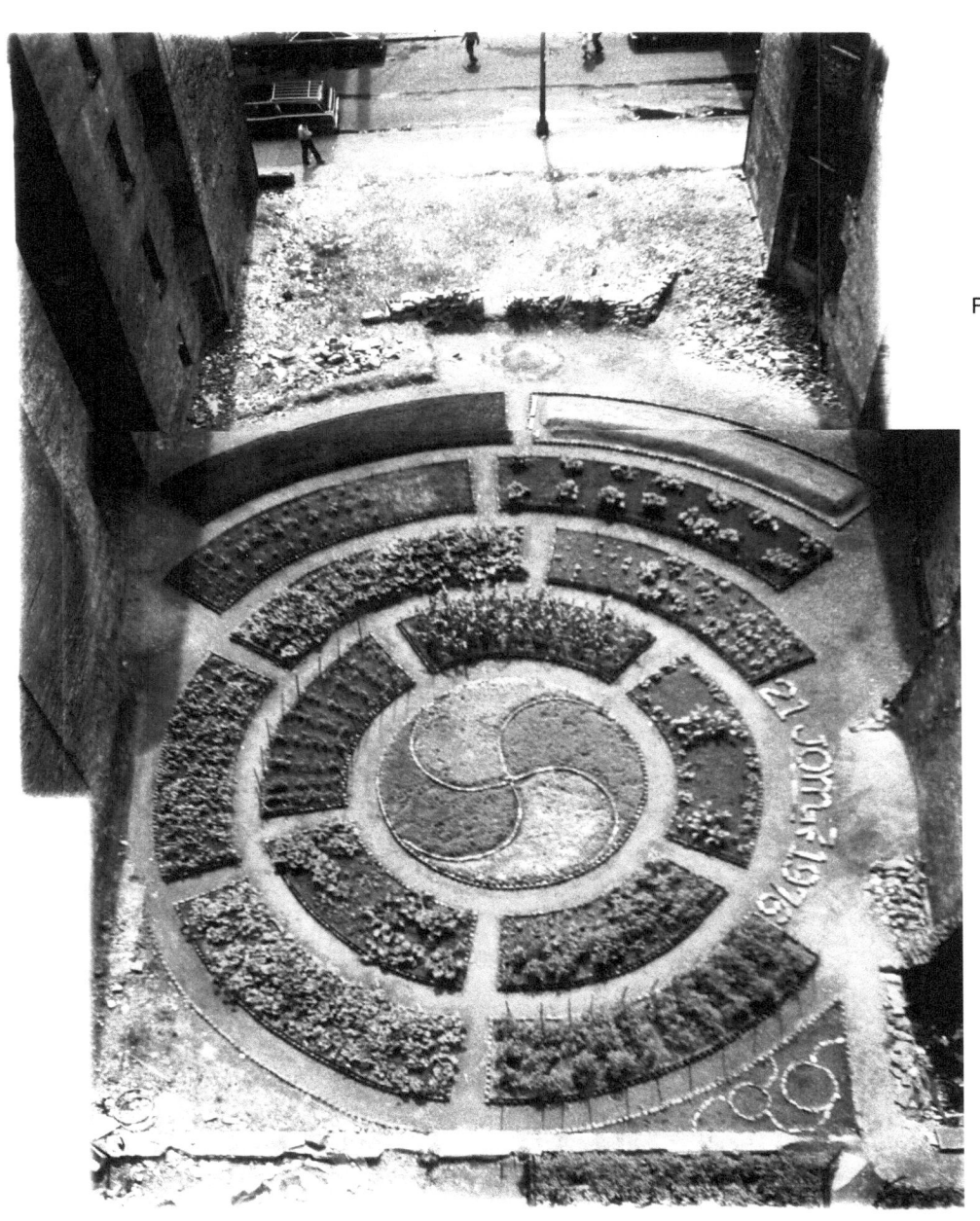

Fig 3. *The Garden of Eden*, 1976
Photos by Adam Purple
(composite)

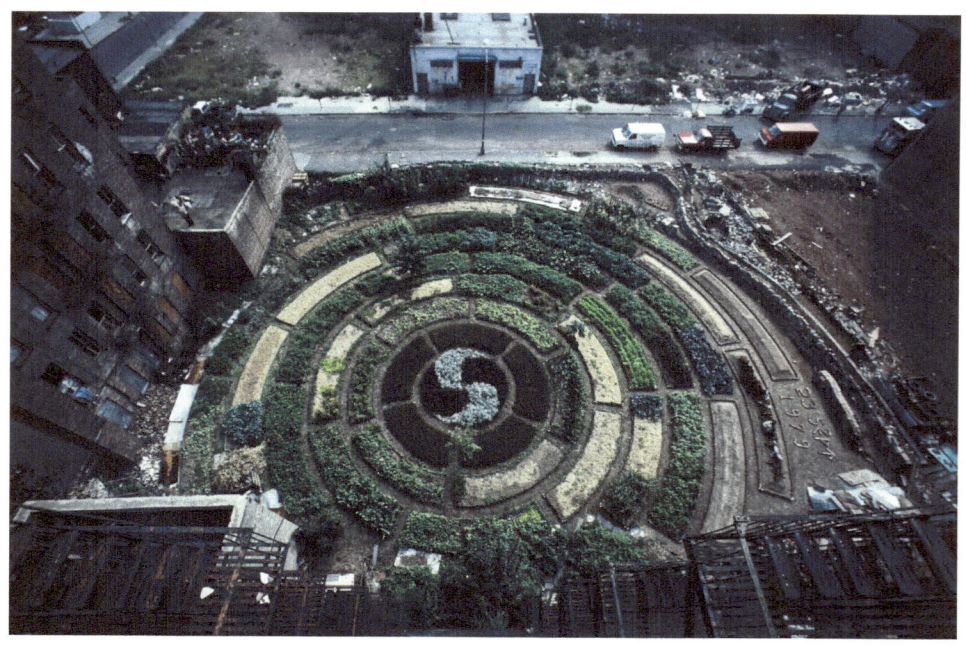

Fig 4. *The Garden of Eden*, 1979
Photo by Harvey Wang

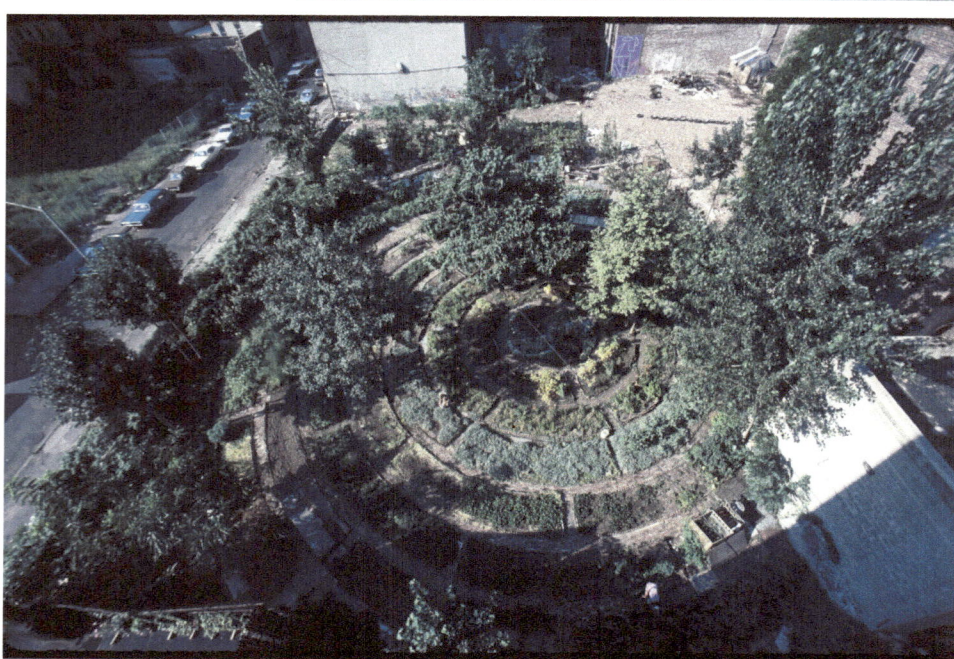

Fig 5. *The Garden of Eden*, 1985
Photo by Harvey Wang

Fig 6. Busimessy Reply Mail, 1988. From *LIFE with les(s) ego*, 196.
Fig 7. Busimessy Reply Mail, 1988. From *LIFE with les(s) ego*, 199.

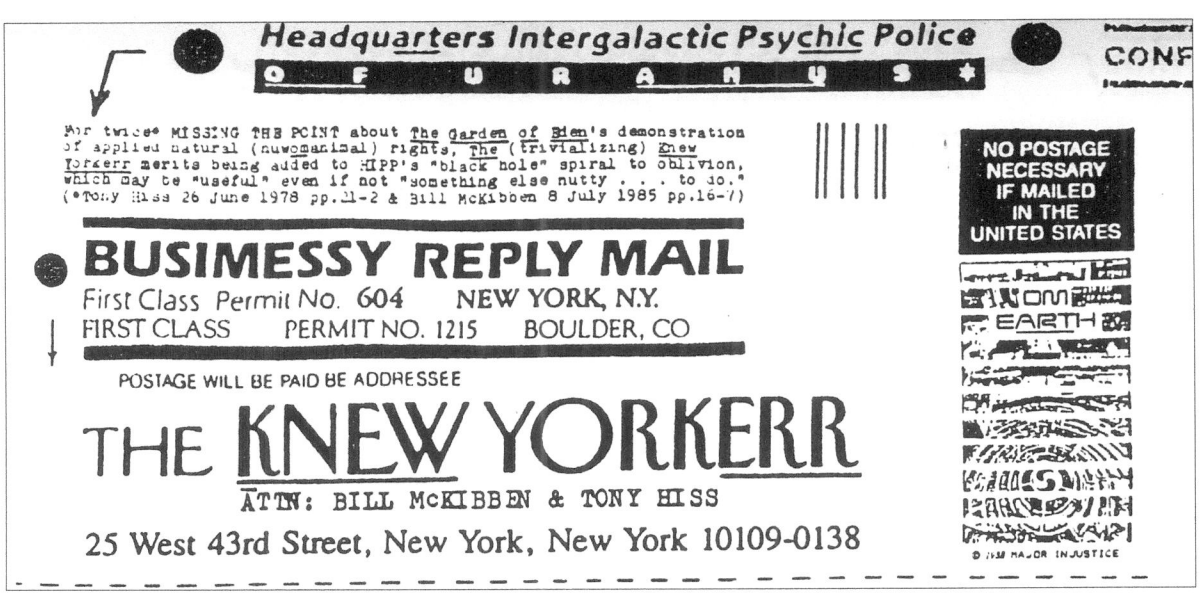

all made their way to *The Garden*. Plantings included eight black walnut trees, a myriad of flowers, sweet (white) alyssum and ornamental (purple) basil to create the double yin-yang symbol, and one Chinese Empress (Paulownia) tree near its center.[36]

Adam submitted a detailed description in his "Rubble Reclamation" article published in the Horticultural Society of New York's *Garden* magazine, July-August 1979. The Editor wrote of Adam and his then-partner Eve: "With little or no help from the outside world, they have transformed a large vacant lot in one of the most foreboding areas of the lower East Side into one of the most imaginative and productive ornamental gardens in the City. [...] What they lack in money they make up for by ingenuity, hard work and devotion."

The Garden of Eden had one steady Adam, but it also had two Eves. The first Eve, Diane Angela Dibona [37] (who also called herself Alice Pagan[38]), was originally from Brooklyn[39] and worked with Adam from the earliest days of soil preparation and was still working with him as of August 1979, when she was interviewed for an article in *New York* Magazine. Norman Green wrote in "The Purple People" that Eve not only had worked with Adam in *The Garden* for the previous five years, but also had cleaned out the two apartments above theirs to use as rental units,[40] a feat she accomplished while pregnant. On November 1, 1978, Diane gave birth to a daughter, Nova Dawn, but by February of 1980, Diane and Nova Dawn were no longer living with Adam, and he had no knowledge of their whereabouts.[41] In a news story a year later, there is a mention of a new Eve, and another child. The February 1981 article in the *Daily News* describes the family as Adam, "his wife, Eve, and son, Adam."[42] Adam Purple's self-published scrapbook, *LIFE with les(s) ego*, is "dedicated to Adam David Reiss-Wilkie, born 13 July 1980 at Bellevue Hospital, NYC." [43]

Much of the later media coverage focuses on Adam Purple and his fight to save *The Garden* from destruction, which by sheer volume outweighs coverage of his collaboration with the Eves. Because the first five years of manual labor were shared by Adam and Diane, her contribution to the realization of the project should not be understated. She took the photograph in Figure 2 of Adam working in *The Garden* [44] and also accompanied Adam leafleting [45] as well as biking to Central Park [46, 47] to collect manure, which Adam hauled to *The Garden* by bicycle.[48] The two also coauthored articles about *The Garden* for the *Yipster Times*.[49] Norman Green wrote of Eve in his August 27, 1979, article:

"Eve is 23, soft-spoken, direct, and warm. She was sixteen when she first met

36. Adam Purple, e-mail message to author, August 20, 2006.
37. Empedocles II, "1980 People's Telephone Ko.," *Inner City Light* (New York), February/March 1980, Vol 1, No. 5 ed. Reprinted in *LIFE with les(s) ego*, 42.
38. Eleanor Swertlow, "Good-Will Harvest Saves Garden from Destruction," *Daily News* (New York), October 27, 1976. Reprinted in *LIFE with les(s) ego*, 27.
39. Green, "The Purple People."
40. Green, "The Purple People."
41. Empedocles II, "1980 People's Telephone Ko." Reprinted in *LIFE with les(s) ego*, 42.
42. Steven Hager, "How One Man's Garden Grows," *Daily News* (New York), February 25, 1981. Reprinted in *LIFE with les(s) ego*, 48.
43. les(s) ego, *LIFE with les(s) ego*, cover.
44. Adam Purple, e-mail message to author, February 4, 2006.
45. Green, "The Purple People."
46. Pine, "Tiny Eden blooms amid the rubble."
47. Tony Hiss, "The Talk of The Town: Green Notes and Comment," *The New Yorker*, June 26, 1978. Reprinted in *LIFE with les(s) ego*, 34.
48. Lewis, "'Riddle Man' Sees Life As Garden of Delights,"
49. Purple, "The Garden of Eden."

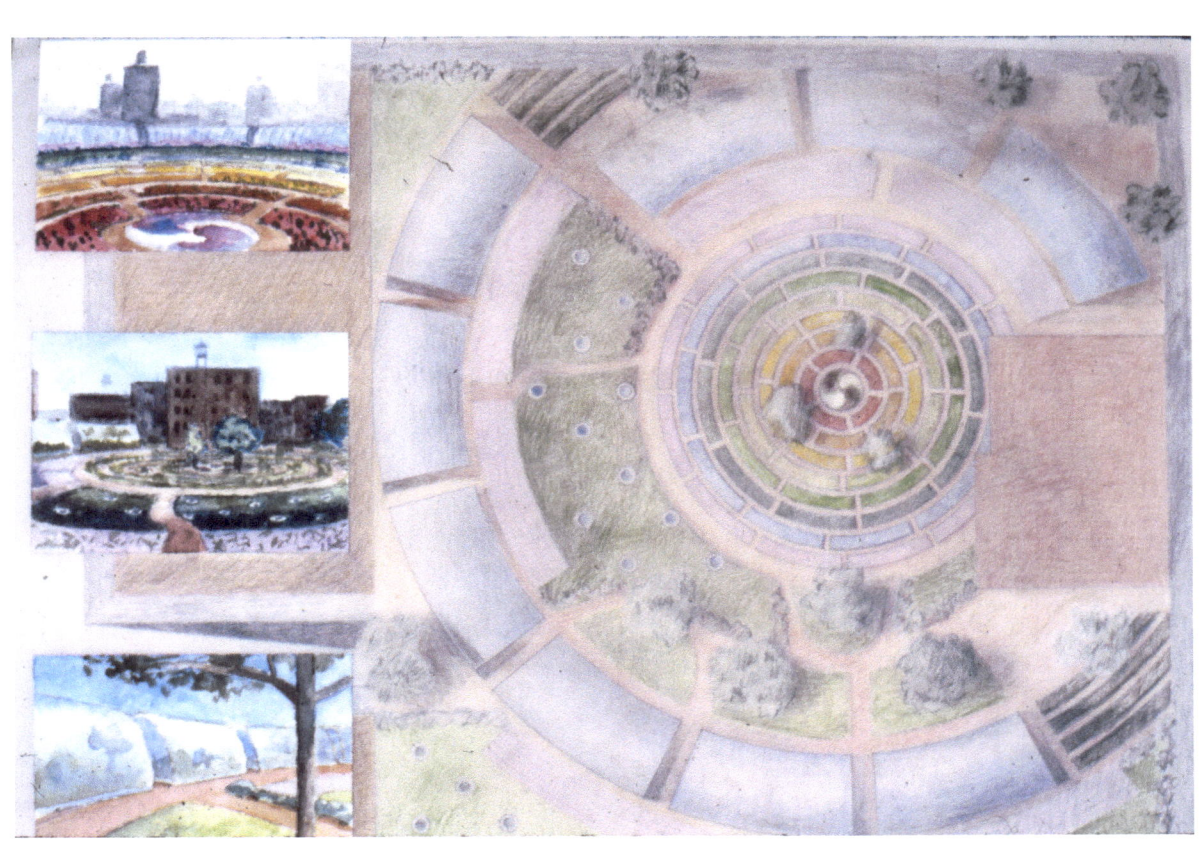

Fig 8. *The Garden of Eden*, Architect Ludmilla Pavlova, Artist Tony Saunders, 1984
"Adam's House in Paradise" Exhibition, Courtesy of the Storefront for Art & Architecture
(Previous page)

Adam in Central Park. Not long thereafter, she moved in with the mysterious Purple Man, then also known as the reverend *les ego*. [...] When their landlord turned his back on their building, the couple stayed on and made improvements. Eve sewed up new electric-grape-colored clothes. She became a Purple Person." [50]

From the beginning, *The Garden* attracted some local media attention centered on Adam's apparently inscrutable activities. In one of the earliest articles about *The Garden*, an interview in the New York *Sunday News*, the author refers to Adam's neighborhood nickname at that time, the "riddle man."[51] From the article, it's apparent that Adam was unconcerned with his media image, and he failed to provide the reporter with any explanation of what he was doing. The reporter seemed bewildered. A reading of the news clippings makes it clear that the general news media did not always have the time, patience, or attention span for a social activist/anarchist/gardener/revolutionary who was using a garden as the medium of his political and artistic expression. For the most part, the media characterized *The Garden* as a squatter's garden. Before long, and before the media had a chance to fully grasp the artist's intentions for this earthwork and consider it in an art historical context, a new story seized the headlines: *The Garden of Eden*, threatened with destruction. From then on, that would be the primary "angle," and the fact that the case dealt with an artwork would be nothing more than a side note.

Adam applied for and received Artist Certification from the New York City Department of Cultural Affairs in 1982 [52] and it was renewed in 1985.[53] In his February 20, 1982, application for certification, Adam was required to answer the question, "Describe your particular art form and tell us why a large space is imperative for its creation." According to Adam, he began his answer as follows. (This passage is formatted as Adam wrote it, with partial underlines and baseline shifts designed to efficiently add additional layers of meaning to the text.)

"The Garden of Eden (a dynamic organic sculpture on Eldridge Street in Manhattan's Block 421, Lower East Side) may be described partly as a non-linear, minimum-technology, urban agricultural art-project designed to demonstrate how abandoned-bulldozed lots (in even the most "depressed" ghetto) can be converted into abundantly fruitful and beautiful open-space without necessitating any government or private funding. Started officially on 21 OMarch 1975 (with some 18 months' previous preparatory landscaping), The Garden is conceived as ultimately expanding through contiguous area to a "Great Circle" hemispheric sculpture (obviously visible to an orbiting satellite or to advanced intragalactic observation). Consequently, its aesthetic orientation continues to be as a non-verbal "teaching-machine" alternative to the unwise, uncritical,

50. Green, "The Purple People."
51. Lewis, "'Riddle Man' Sees Life As Garden of Delights,"
52. New York City Department of Cultural Affairs, March 1, 1982, Artist Certification. Reprinted in *LIFE with les(s) ego*, 61.
53. New York City Department of Cultural Affairs, March 1, 1985, Artist Certification. Reprinted in *LIFE with les(s) ego*, 113.

unhealthy, and unchecked exploitation of the E̲arth's su̲rface, etc., in/by the planet's ᵒₐccidental half even though such continued exponential exploitation risks species extinction." [54]

"Adam Purple" was the name David Wilkie used when acting as the artist-in-residence and creator of *The Garden of Eden*.[55] It was one of several names he used consistently. Of his pseudonyms, he told a reporter, "I use names like tools, you dig? Instead of socket wrenches I use names." [56] General Zen (a "what," not a "who" [57]) with a last name short for "zenlightenment" [58], was the entity whose representative, Agent Zenger, lived at 184 "Foresight" Street, the "Royal Embassy of Uranus." [59] "Agent" John Peter Zenger II was named after the journalist who prevailed in a landmark 18th-century libel case, a major victory for freedom of the press. General Zen oversaw the mission of bringing "zenlightenment" to our species, and John Peter Zenger II engaged in media relations to that end. At the "Embassy," a number of other personae were on hand to further that mission as well. The pseudonym r(apid)evolutionary les(s) ego (or rev. les ego for short) was David's nom de plume, an expression of the idea that "we all need less ego than we have"[60] so that we can correct our shared assumption that we as humans live separately from "the total ecological zenvironment." Other names included i.c. tinus II, Ms. Lysis Trata, and E. M. Pedocles, derived from the ancient Greek architect Ictinus, the dramatic heroine Lysistrata, and the philosopher Empedocles, all of whom illuminate different facets of David's values in very precise fashion. The planet of origin for General Zen and its emissaries was Uranus, so chosen because of the importance of your anus, and mine. As journalist Norman Green wrote in *New York* Magazine in a 1979 interview with Adam:

> "The problem, from Adam's point of view, is our civilization's gross incontinence. We're fouling ourselves. He calls the leaders of government 'ignoranuses.' Ignorance of the anus is a grand metaphor for the cavalier poisoning of the air, earth, and water with smoke and aerosols, radioactive refuse, deadly chemicals and sewage." [61]

Almost always esoteric, John Peter Zenger II's writings to politicians and the news media easily alienated all but the most patient and literary of his readers. Most people would have needed a few days and the help of a reference librarian to decode his letters and extract all the embedded meanings. Clear communication was not his goal. As architect James Stewart Polshek remarked, "What makes him interesting is that he's not a nut. He likes to pretend he is, but he's one smart cookie." [62]

54. les(s) ego, *LIFE with les(s) ego*, 60.
55. Adam Purple, "Statement to the New York City Board of Estimate" (speech, December 16, 1982). Reprinted in *LIFE with les(s) ego*, 72.
56. Rob Derocker, "*The Garden of Eden* Is Threatened," *The Villager* (New York), March 11, 1982. Reprinted in *LIFE with les(s) ego*, 63.
57. les(s) ego, *LIFE with les(s) ego*, 65.
58. *Inner City Light* (New York), "General Zen Strikes Again," May/June 1981, Vol. 2, No. 4 ed. Reprinted in *LIFE with les(s) ego*, 49.
59. General Zen to Richard Ropiak, September 21, 1982. Reprinted in *LIFE with les(s) ego*, 68.

60. les(s) ego, *LIFE with les(s) ego*, inside cover.
61. Green, "The Purple People."
62. McKinley, "An Unreconstructed Hippie Takes on the City's 'Pinheads.' When Is He Going to Get Some Respect?"

In addition to using pseudonyms, Adam, who had learned the skill of composing texts with hand-set lead type in the late 1930s,[63, 64] frequently embellished his correspondence with hand-written symbols and variations in capitalization, typeface, and punctuation to add layers of meaning. One example of the efficiency of this approach can be seen in the expression "EartHwork" [65] and other variations Adam created to typographically emphasize "art" and "work" within that word.[66, 67, 68] He also strategically underlined certain words found within other words, as in the case of "physiological," "artistically,"[69] "orientation"[70] "obviously"[71] and "Westerrn 'Civilization'"[72] among many others. His selective underlining of certain letter pairs was intended to create specific associations. "El" underlined was a reference to "elohim," Hebrew for "the gods." "Ur" underlined referred to the Mesopotamian city of Ur, known as Tell al-Muqayyar. Adam also underlined "an," as in Pan, [wo]man, plant, animal, ant, land, angel, etc.. In Sumerian and later Assyrian and Babylonian mythology, An (and later, Anu) was the sky god, the god of heaven. Other markings included Adam's)—(symbol, an enhanced "H" based on the astrological symbol for Uranus, which in turn was based on the last name Herschel, the planet's discoverer. He also used a stylized "A" symbol derived from the Greek letter Omega, into which he placed a dot to make it mean simultaneously both the "beginning" and "end." [73]

Several of his embellishments were intended to layer his texts with philosophical meanings. Adam wrote that the E underlined meant Euclidean, because the E overlined meant "NON-Euclidean [Euclid was PRE-The Calculus]." [74] The overline meant a minus sign. A capital "A" overlined meant NON-Aristotelian. Just as quantum physics was developed to accommodate phenomena that the older model, Newtonian physics, could not, new systems of logical calculation are being developed that expand upon classical ideas in order to solve trickier philosophical problems. Non-Euclidean and non-Aristotelian thinking require one to question and discard old assumptions in order to arrive at more accurate answers for our time, which explains Adam's often-used call to action, "L.E.A.R.N. – Let's Errase And Reprogram Now for speciesurvival!" [75, 76]

With this orientation in mind, it is interesting to see some of his writings from that era (such as the "1980 People's Telephome Ko," [77] and others), as well as his manipulated business reply mail cards from the 1980s, which he called "busimessy reply mail" (Figure 6-7). He would modify them and then mail them back, postage-paid by the corporate addressees.[78]

Adam "zenvisioned" *The Garden* expanding into

63. Purple, StoryCorps interview.
64. Adam Purple, e-mail message to author, January 24, 2011.
65. Adam Purple, e-mail message to author. January 24, 2011.
66. Purple, "*The Garden of Eden*: An Environmental 'Radical Transformation'" (paper), 3. Reprinted in *LIFE with les(s) ego*, 119.
67. Harvey Wang, photograph of *The Garden of Eden*, March 21, 1979, in Purple, "*The Garden of Eden*: An Environmental 'Radical Transformation'" (paper), 8. Reprinted in *LIFE with les(s) ego*, 124.
68. General Zen to Letters Editor, (unpublished) *The New York Times*, September 11, 1985. Reprinted in *LIFE with les(s) ego*, 143.
69. Lysis T. Rata II to Lewis Lapham, December 10, 1980. Reprinted in *LIFE with les(s) ego*, 45.
70. les(s) ego, *LIFE with le(s) ego*, 60.
71. Lysis T. Rata II to Katharine Gates, January 1, 1984. Reprinted in *LIFE with les(s) ego*, 82.
72. General Zen to Victor Navasky, January 2, 1984. Reprinted in *LIFE with les(s) ego*, 83.

73. les(s) ego, *LIFE with le(s) ego*, 22.
74. Adam Purple, e-mail message to author, February 18, 2007.
75. Adam Purple, e-mail message to author, January 14, 2006.
76. les(s) ego, *LIFE with les(s) ego*, cover.
77. Empedocles II, "1980 People's Telephome Ko." Reprinted in *LIFE with les(s) ego*, 42.
78. les(s) ego, *LIFE with le(s) ego*, 196-201.

a "Great Circle Hemisphere Sculpture." To him, the center of *The Garden* would signify the point at which a "r(apid)evolution" had begun, like a literal impact crater, a "ground zero."[79] Its impact would be to replace the skyscrapers of New York, and remake cities in such a way that the concerns of the "huwoman" species would be balanced with the needs of the natural world. Adam described the effect:

> "Well, I had started *The Garden* in '75 and the landlord left in '76 … as I remember, but I had already started *The Garden*, and I wasn't going to abandon that because I could see other buildings were going to come down … it was circular and it would expand and the circles would bump into buildings and knock the buildings down, metaphorically, which of course they did." [80]

In New York City in the 1970s and early 80s, it was perhaps not so far-fetched to believe that the city would continue its descent into ruin, and that such ideals would have a chance to succeed on some significant scale. In a 1984 photo, the hand-painted sign at *The Garden* reads, "*The Garden of Eden* – Inner-urban community earthwork. Begun in 1973, *The Garden* was originally conceived as an ever-expanding soil restoration project ultimately taking form as a Great Circle Hemispheric Sculpture. WELCOME."

The Garden garnered significant attention in the local, national, and international media. Adam kept a careful record of media coverage,[81, 82, 83] which included national TV coverage in Italy, West Germany, Japan, and the United States, magazine coverage in *National Geographic*, as well as European magazines *Stern*, *Panorama*, *GEO Special*, and *Swisshôtel*.[84, 85, 86] It was featured many times on New York City's local news programs, NBC's "Real People" and ABC's "Ripley's Believe It or Not." [87] People came from all over the city to visit *The Garden*, which was an open, public space. Adam's records of visitors show that students of all ages, elementary to university, visited *The Garden*, as did gardeners, architects, scholars, and journalists.[88]

Up until 1981, Adam's biggest problem was the fact that the city regarded him as a squatter,[89] rather than the landlord's "super" [90] because he continued to live at 184 Forsyth Street after the landlord abandoned the building in 1976.[91] Soon thereafter, the city began its attempts to collect rent from Adam. In 1980, he received a bill for $2,400 for back rent,[92] a bill that had ballooned to $55,200 by 1982[93] and to $352,706 by 1998, including $6 for only one smoke detector,

79. Green, "The Purple People."
80. Purple, StoryCorps interview.
81. *Inner City Light* (New York), "Land Use Versus Land Abuse At *The Garden of Eden*," September/October 1980. Reprinted in *LIFE with les(s) ego*, 44.
82. les(s) ego, *LIFE with le(s) ego*, 76.
83. les(s) ego, *LIFE with le(s) ego*, 179.
84. les(s) ego, *LIFE with le(s) ego*, 77.
85. les(s) ego, *LIFE with le(s) ego*, 121.
86. *Geo Special* (Germany), August 13, 1986. Reprinted in *LIFE with les(s) ego*, 180.
87. les(s) ego, *LIFE with le(s) ego*, 77.
88. les(s) ego, *LIFE with le(s) ego*, 66.
89. Hager, "How One Man's Garden Grows." Reprinted in *LIFE with les(s) ego*, 48.
90. les(s) ego, *LIFE with le(s) ego*, 221.
91. McKinley, "An Unreconstructed Hippie Takes on the City's 'Pinheads.' When Is He Going to Get Some Respect?"
92. *Inner City Light*, "Land Use Versus Land Abuse At *The Garden of Eden*."
93. les(s) ego, *LIFE with le(s) ego*, 57.

which the city never delivered.[94, 95] From Adam's perspective, he was the legal superintendent of the building, although he was never compensated for it, and the city, as owner, neglected its responsibilities by failing to provide any services.[96, 97]

On October 27, 1981, the first story about a greater threat to *The Garden* appeared in *The Village Voice*. In what is perhaps the best summary statement of what would lead to the destruction of *The Garden*, the authors wrote, "Now, because of a complex set of ridiculous circumstances, a chunk of low-income housing is going to be built right on top of Adam's garden."[98] Detangling the intricate dealings that culminated in destruction of *The Garden* on January 8, 1986, warrants its own academic investigation, as a case-study of how abuse of individual rights can only result in a travesty, not a greater good. The "complex set of ridiculous circumstances" included an inadequate environmental impact statement that made no mention of the existence of *The Garden*[99, 100] the questionable and possibly illegal use of condemnation by the city to acquire the land for the federal housing project,[101, 102] and the overall failure of city officials to fully explore alternative sites or alternative designs for the housing project that would have incorporated *The Garden*. The city even proceeded with the destruction of *The Garden* while Adam's pro se (without an attorney) case was pending before the U.S. Court of Appeals for the Second Circuit of New York, a move that prompted a stern rebuke in the Order to Show Cause filed on March 13, 1986, and signed by The Honorable James L. Oakes and The Honorable John R. Bartels, with The Honorable Amalya L. Kearse dissenting.[103, 104] Disappointingly, a short time later, on May 15, 1986, Adam was curtly denied sanctions by that same court, and the matter was closed.[105] In short, *The Garden* had not one friend with the real political power required to change its fate.

There was a tremendous outpouring of support for *The Garden*, and the supporters' statements emphasized its value to the city and community. Friends of *The Garden* included prominent scholar and art historian Lucy Lippard, who wrote that it was "...particularly valuable because it is a work of art that functions on three levels: environmental, esthetic, and social." She also called it "...an urban "earthwork," in the tradition of the great Japanese and European gardens, and all the more important because it was done by an artist, independently, without patronage,

94. les(s) ego, *LIFE with le(s) ego*, 222.
95. McKinley, "An Unreconstructed Hippie Takes on the City's 'Pinheads.' When Is He Going to Get Some Respect?"
96. *Inner City Light*, "Land Use Versus Land Abuse At *The Garden of Eden*."
97. les(s) ego, *LIFE with le(s) ego*, 222.
98. Howard Smith and Lin Harris, "Paradise Paved," *The Village Voice* (New York), October 21-27, 1981. Reprinted in *LIFE with les(s) ego*, 232.
99. O'Donoghue, "Destruction Seems to Be Future for 'The Garden of Eden.'"
100. les(s) ego, *LIFE with les(s) ego*, 225.
101. Baykal, Speech, Board of Estimate, New York, New York, January 13, 1983.
102. O'Donoghue, "Destruction Seems to Be Future for 'The Garden of Eden.'"

103. Friends of *The Garden of Eden* and David Wilkie a/k/a Adam Purple v Anthony Gliedman, HPD (US Court of Appeals for the Second Circuit March 13, 1986). Reprinted in *LIFE with les(s) ego*, 170.
104. Brian O'Donoghue, "Court Asks the City to Explain Destruction of Garden," *The Villager* (New York), March 20, 1986. Reprinted in *LIFE with les(s) ego*, 173.
105. Friends of the Garden of Eden and David Wilkie a/k/a Adam Purple v Anthony Gliedman, HPD, Order, Docket No. 85-6278 (US Court of Appeals for the Second Circuit May 15, 1986). Reprinted in *LIFE with les(s) ego*, 176.

from love of place."[106] Other supporters included journalist Norman Green, plant pathologist John McPartland,[107] Jean Rioux,[108] architects Barry Benepe[109] and James Stewart Polshek,[110] poet Allen Ginsberg,[111] the students and faculty of the Southern California Institute of Architecture,[112] WNBC-TV reporter Lloyd Kramer,[113] New York City artists Morag Benepe and Allen Hirsch,[114,][115] anthropologist Barbara Kirshenblatt-Gimblett,[116] Dr. Judith P. Harik of the American University of Beirut,[117] and Richard E. "Rambo" Sloane, an inmate at the Auburn Correctional Facility. Rambo had come across *The Garden* "while engaged in a shoot out with some Puerto Rican strong-arm boys (1981)" and was deeply moved by the experience. In a letter he sent to Adam from prison in 1984, he wrote "I thought I got hit died and went to heaven."[118] *The Garden* was celebrated for being an oasis, an open-air classroom, a work of art, and even a "living laboratory" of "small scale urban polyculture" generating data that Mr. McPartland felt was "both unique and sorely needed."[119] Ms. Kirschenblatt-Gimblett argued that "Discounting grass roots creativity makes the statement that local people cannot help themselves. Housing plans that discount local initiatives like *The Garden of Eden* make the statement that only "official" solutions count. This is the quickest way to foster apathy and dependency, to perpetuate the cycle of poverty."[120] Mr. Polshek wrote of *The Garden*, "The idea of replacing it with housing is, to me, as serious an urban crime as the Saint Bartholomew's tower."[121]

Adam knew of the work of the Underground Space Center at the University of Minnesota[122] and had developed a plan to expand *The Garden of Eden* across Eldridge Street into a ninth circle, which would be comprised of a series of greenhouses and underground living spaces.[123] Once *The Garden* was threatened by destruction, some turned their attention to how the entire housing project could be redesigned and re-imagined to provide the new housing units while preserving *The Garden*. From September 13 to October 4, 1984, the Storefront for Art and Architecture at Kenmare and Lafayette Streets in SoHo held an exhibition called "Adam's House in Paradise." Gallery owners Glenn Weiss and Kyong Park had invited 100 architects from all over the world to submit alternative

106. Lucy R. Lippard to 'To Whom It May Concern,' Statement to the NYC Planning Commission, October 13, 1982. Reprinted in *LIFE with les(s) ego*, 70.
107. John M. McPartland to Commissioners, Statement Delivered at NYC Board of Estimate, December 10, 1982. Reprinted in *LIFE with les(s) ego*, 70.
108. Jean Rioux to Mayor Edward I. Koch, December 14, 1983. Reprinted in *LIFE with les(s) ego*, 81.
109. Barry Benepe to Miriam Friedlander, Council Member, September 12, 1984. Reprinted in *LIFE with les(s) ego*, 99.
110. James Stewart Polshek to Mayor Edward Koch, October 15, 1984. Reprinted in *LIFE with les(s) ego*, 105.
111. Allen Ginsberg to Mayor Ed Koch, October 9, 1984. Reprinted in *LIFE with les(s) ego*, 104.
112. The Students and Faculty of Southern California Institute of Architecture to Mayor Edward Koch, March 20, 1985. Reprinted in *LIFE with les(s) ego*, 115.
113. Lloyd Kramer to 'To Whom It May Concern,' August 16, 1985. Reprinted in *LIFE with les(s) ego*, 137.
114. Morag Benepe to Mayor Edward I. Koch, March 10, 1982. Reprinted in *LIFE with les(s) ego*, 62.
115. Allen Hirsch to Adam Purple, November 28, 1986. Reprinted in *LIFE with les(s) ego*, 187.
116. Barbera Kirshenblatt-Gimblett to Judge Vincent Broderick, August 21, 1985. Reprinted in *LIFE with les(s) ego*, 138.
117. Dr. Judith Harik to Mayor Edward Koch, January 13, 1986. Reprinted in *LIFE with les(s) ego*, 164.

118. Richard E. "Rambo" Sloan to Adam Purple, August 12, 1984. Reprinted in *LIFE with les(s) ego*, 96.
119. McPartland to Commissioners.
120. Kirschenblatt-Gimblett to Judge Broderick.
121. Polshek to Mayor Koch.
122. Purple, "*The Garden of Eden*: An Environmental 'Radical Transformation'" (paper), 1, 5. Reprinted in *LIFE with les(s) ego*, 117, 121.
123. les(s) ego, *LIFE with les(s) ego*, 33.

designs.[124] The submissions came from Hungary, India, Japan, Israel, and the United States, and included local architects Lebbeus Woods and Bill Lane.[125] The design most faithful to Adam's original vision was created by architect Ludmilla Pavlova and rendered by artist Tony Saunders. It vividly depicted the ninth circle of greenhouses and the expansion across Eldridge Street (Figure 8).

One can imagine that, today, had The Garden been permitted to survive and thrive, it would certainly be surrounded by luxury condominiums. Much of the Lower East Side has undergone a staggering transformation. When asked about this in a 2006 interview, Adam responded, "Well, I said at the time, and I still feel that it would have been better to kill me and leave The Garden because, well, that's the way I view it." [126] In fact, Adam felt that The Garden was targeted for destruction by the city, which could not bear Adam's message. Adam wrote:

> "The vandalism of The Garden of Eden was not some "garden variety" accident by a few "careless" bureaucrats, but rather what I have to classify as having been a carefully planned govERRnme(a)ntal micro-ecocide of an ANTI-establishment eARThWORK. I spoke with The Garden of Eden and when city, state, and federal govERRnme(a)nts destroyed The Garden, it was the equivalent of cutting out my tongue. So much for freedom of speech." [127]

A bulldozer leveled the 4-foot-high Connecticut drystone walls on the east, south and north-west sides of The Garden on September 24 and 25, 1985: walls that Adam described as "protective." The Eldridge Street (eastern) wall supported "the city's largest public black raspberry patch." [128] A few months later, on January 8, 1986, between 7 and 8:15 a.m., a vehicle that Adam described as a "large four-rubber-tired highway construction machine with front-end scoop" [129] cleared the rest of The Garden. None of the plantings or materials were salvaged, relocated, or recycled. The new housing project did not include an apartment for Adam or space for a new garden.[130]

In terms of his revolutionary ideas about sustainability and living as humble members of the natural world, Adam was (and is) ahead of his time, or "timeternity," as he would call it. Despite sharing some common ground with the Land Art movement, it was perhaps his ideological stance that ultimately alienated him from his artistic contemporaries, denying his earthwork the wider recognition from the art world that it deserved and still deserves.

In her book Earthworks: Art and the Landscape of the Sixties, Suzaan Boettger articulates the factors in the emergence of earthworks in the 1960s, many of which were also motivating factors for Adam. She cites the emergence of environmentalism, the antiwar movement, and social disorder,[131] as well as the countercultural goal of circumventing conventional systems of marketing

124. Brian O'Donoghue, "Deny Court Pleas to Stop Demolition of The Garden of Eden," The Villager (New York), August 9, 1984. Reprinted in LIFE with les(s) ego, 94.
125. Douglas C. McGill, "Gallery to the Rescue of The Garden of Eden," The New York Times, October 5, 1984. Reprinted in LIFE with les(s) ego, 102.
126. Purple, StoryCorps interview.
127. Adam Purple, e-mail message to author, February 17, 2007.
128. Adam Purple, e-mail message to author, March 17, 2007.
129. Adam Purple, e-mail message to author, March 17, 2007.
130. Adam Purple, e-mail message to author, January 16, 2006.
131. Suzaan Boettger, Earthworks: Art and the Landscape of the Sixties (Berkeley: University of California Press, 2002), 43.

and distributing works of art, as a form of resistance to producing commodities.[132] As Adam Purple stated in a 2006 interview:

> "And, incidentally earth works and performance art, as I understand … art history … are referred to as Anti-Establishment for the very simple reason, obviously, that the 'Owning' Class cannot buy them and put them in a gallery somewhere and make them unavailable to the general public. There's a lot of artwork that's in private hands that the public never sees. And, so when you do something that is free, open and costs nothing in terms of money, except human labor, you are a threat. That is Anti-Establishment. And, obviously, I was aware of that."[133]

Boettger described Robert Smithson's *Spiral Jetty* as an "artistically mediated place to be experienced rather than an object of contemplation, decoration, or potential ownership."[134] The same could be said of *The Garden of Eden*. However, unlike his predecessors, Adam was not interested in cultivating an art career. By contrast, well-known land artist Michael Heizer, by one account, "seethed with ambition."[135] Adam's work was not in dialogue with art theory or the gallery setting. Boettger argues that artists like Smithson wanted to distance themselves from political activism and resisted creating work with overt political or environmental messages.[136] Earth artists were not necessarily concerned with environmental issues *per se*, which *were* at the core of Adam's work. Also absent in much of the work of the earth artists of that time was the revolutionary spirit in Adam's work. Boettger characterizes Earthworks as "strikingly *un*pastoral, suggesting an eruption of the pastoral's latent content: melancholy."[137] In *The Garden of Eden*, Adam rejected melancholy in favor of possibility, and he created a sculpture that also was a working prototype of a solution, primed for widespread adoption. *The Garden of Eden* represented a distinctly different artistic response to the same socio-political upheavals that motivated the first earth artists of the 1960s.

Interestingly, in the book *Land and Environmental Art*, Jeffrey Kastner writes that the first Land Artists were a "macho" bunch, and that the movement was characterized by "diesel and dust."[138] However, after these muscular beginnings, the first generation of earth artists were succeeded by other, more accurately called "environmental" artists, who had a wholly different relationship to the landscape. For some Environmental artists, reclamation of the landscape was central. In this case, whereas Adam Purple may have been a latecomer to "earth works" in the sense of what was first seen in the exhibition by that name at the Dwan Gallery in 1968, in terms of environmental art, he was a pioneer. Artists Alan Sonfist and Agnes Denes created earthworks in New York City dealing with environmental awareness; Sonfist replanted an indigenous forest on the corner of Houston and LaGuardia Place (*Time Landscape*™, 1965-78),[139] and Denes planted a two-acre wheatfield in lower Manhattan (*Wheatfield – A Confrontation*, summer 1982).[140] Adam's work in *The Garden of Eden* is at least

132. Boettger, *Earthworks: Art and the Landscape of the Sixties*, 211.
133. Purple, StoryCorps interview.
134. Boettger, *Earthworks: Art and the Landscape of the Sixties*, 211.
135. Boettger, *Earthworks: Art and the Landscape of the Sixties*, 210.
136. Boettger, *Earthworks: Art and the Landscape of the Sixties*, 217.
137. Boettger, *Earthworks: Art and the Landscape of the Sixties*, 225.
138. Jeffrey Kastner and Brian Wallis, *Land and Environmental Art* (London: Phaidon Press, 1998), 15.
139. Kastner, *Land and Environmental Art*, 150.
140. Kastner, *Land and Environmental Art*, 160.

as important as either of these, and all could be seen as forerunners of the work of contemporary artists like Fritz Haeg, whose work is designed to show Americans how they can replace their lawns – decorative, unhealthy monocultures – with productive, food-producing gardens.[141]

It is certainly time for Adam Purple's work, *The Garden of Eden*, to take its proper place in art history, and for Adam to be recognized and respected as an artist. And yet, no one title can accurately describe Adam or his work. Both defy easy categorization, at least in the Aristotelian sense. As Adam recently wrote, "Traditional Balinese needed no word for 'art' or 'artist' because creativity qualified as a natural way to honor the gods and serve the c<u>omm</u>u<u>nity</u>." [142] According to Adam,[143] this is how he would like to be remembered: "Well, Benjamin Franklin said on his tomb stone 'Printer.' […] 'Thinker' I guess is a good title, 'Philosopher', which is a search for truth – discover truth – and if you don't do that what are you doing?"

— *January 27, 2011*

141. Randy Malamud, "A Sustaining Environment for Environmental Art," *The Chronicle of Higher Education* (Washington DC), November 7, 2008.
142. Adam Purple, e-mail message to author, January 24, 2011.
143. Purple, StoryCorps interview.

Bibliography

Baykal, Sheyla. Speech, Board of Estimate, New York, New York, January 13, 1983. Reprinted in *LIFE with les(s) ego*, 74-76.

Benepe, Barry to Miriam Friedlander, Council Member. September 12, 1984. Reprinted in *LIFE with les(s) ego*, 99.

Boettger, Suzaan. *Earthworks: Art and the Landscape of the Sixties*. Berkeley: University of California Press, 2002.

Derocker, Rob. "The Garden of Eden Is Threatened." *The Villager* (New York), March 11, 1982. Reprinted in *LIFE with les(s) ego*, 63.

ego, les(s). *Zentences! Meditation Manual for Mini-minds & Mystics!* New York, 1971. *Reprinted in LIFE with les(s) ego*, 12.

ego, les(s). *LIFE with les(s) ego*. New York, 1983.

el, incidentally, and rev les ego. "C.U.M. to World Orgy I." *Inner City Light* (New York), July/August 1979, Vol. 1. No. 2 ed. Reprinted in *LIFE with les(s) ego*, 38.

Empedocles II. "1980 People's Telephome Ko." *Inner City Light* (New York), February/March 1980, Vol 1, No. 5 ed. Reprinted in *LIFE with les(s) ego*, 42.

The Friends of the Garden of Eden and David Wilkie a/k/a Adam Purple v Anthony Gliedman, et. al, Order, Docket No. 85-6278 (US Court of Appeals for the Second Circuit May 15, 1986). Reprinted in *LIFE with les(s) ego*, 176.

The Friends of the Garden of Eden and David Wilkie a/k/a Adam Purple v Anthony Gliedman, et. al, Order to Show Cause, Docket No. 85-6278 (US Court of Appeals for the Second Circuit March 13, 1986). Reprinted in *LIFE with les(s) ego*, 170.

General Zen to Letters Editor, *The New York Times*. September 11, 1985. Unpublished. Reprinted in *LIFE with les(s) ego*, 143.

General Zen to Richard Ropiak. September 21, 1982. Reprinted in *LIFE with les(s) ego*, 68.

General Zen to Victor Navasky, January 2, 1984. Reprinted in *LIFE with les(s) ego*, 83.

Ginsberg, Allen to Mayor Ed Koch. October 9, 1984. Reprinted in *LIFE with les(s) ego*, 104.

Green, Norman. "The Purple People." *New York* Magazine, August 27, 1979. Reprinted in *LIFE with les(s) ego*, 40.

Hager, Steven. "How One Man's Garden Grows." *Daily News* (New York), February 25, 1981. Reprinted in *LIFE with les(s) ego*, 48.

Harik, Dr. Judith, to Mayor Edward Koch. January 13, 1986. Reprinted in *LIFE with les(s) ego*, 164.

Hirsch, Allen to Adam Purple. November 28, 1986. Reprinted in *LIFE with les(s) ego*, 187.

Hiss, Tony. "The Talk of The Town: Green Notes and Comment." *The New Yorker*, June 26, 1978. Reprinted in *LIFE with les(s) ego*, 34.

Howard, Ebenezer, and Frederic J. Osborn. *Garden Cities of To-morrow*. Cambridge, MA: M.I.T. Press, 1965. Reprinted in *LIFE with les(s) ego*, 2, 4.

Inner City Light (New York). "General Zen Strikes Again." May/June 1981, Vol. 2, No. 4 ed. Reprinted in *LIFE with les(s) ego*, 49.

Inner City Light (New York). "Land Use Versus Land Abuse At *The Garden of Eden*." September/October 1980. Reprinted in *LIFE with les(s) ego*, 44.

Kastner, Jeffrey, and Brian Wallis. *Land and Environmental Art*. London: Phaidon Press, 1998.

Kirshenblatt-Gimblett, Barbara to Judge Vincent Broderick. August 21, 1985. Reprinted in *LIFE with les(s) ego*, 138.

Kramer, Lloyd to 'To Whom It May Concern.' August 16, 1985. Reprinted in *LIFE with les(s) ego*, 137.

Lewis, John. "'Riddle Man' Sees Life As Garden of Delights." *Daily News*, June 6, 1976. Reprinted in *LIFE with les(s) ego*, 26.

Lippard, Lucy R. to 'To Whom It May Concern.' Statement to the NYC Planning Commission, October 13, 1982. Reprinted in *LIFE with les(s) ego*, 70.

Lysis T. Rata II to Katharine Gates. January 1, 1984. Reprinted in *LIFE with les(s) ego*, 82.

Lysis T. Rata II to Lewis Lapham. December 10, 1980. Reprinted in *LIFE with les(s) ego*, 45.

Malamud, Randy. "A Sustaining Environment for Environmental Art." *The Chronicle of Higher Education* (Washington, DC), November 7, 2008.

McGill, Douglas C. "Gallery to the Rescue of *The Garden of Eden*." *The New York Times*, October 5, 1984. Reprinted in *LIFE with les(s) ego*, 102.

McKinley, Jesse. "An Unreconstructed Hippie Takes on the City's 'Pinheads.' When Is He Going to Get Some Respect?" *The New York Times*, February 22, 1998. Reprinted in *LIFE with les(s) ego*, 233-234.

McKinley, Jesse. "A Rare, Classic Volume, All One Square Inch of It." *The New York Times*, February 22, 1998. Sidebar to "An Unreconstructed Hippie Takes on the City's 'Pinheads.' When Is He Going to Get Respect?" by Jesse McKinley. Reprinted in *LIFE with les(s) ego*, 233.

McPartland, John M. to Commissioners. Statement Delivered at NYC Board of Estimate, December 10, 1982. Reprinted in *LIFE with les(s) ego*, 70.

Morag Benepe to Mayor Edward I. Koch. March 10, 1982. Reprinted in *LIFE with les(s) ego*, 62.

New York City Department of Cultural Affairs. March 1, 1982. Artist Certification. Reprinted in *LIFE with les(s) ego*, 61.

O'Donoghue, Brian. "Court Asks the City to Explain Destruction of Garden." *The Villager* (New York), March 20, 1986. Reprinted in *LIFE with les(s) ego*, 173.

O'Donoghue, Brian. "Deny Court Pleas to Stop Demolition of *The Garden of Eden*." *The Villager* (New York), August 9, 1984. Reprinted in *LIFE with les(s) ego*, 94.

O'Donoghue, Brian. "Destruction Seems to Be Future for 'The Garden of Eden'" *The Villager* (New York City), July 26, 1984. Reprinted in *LIFE with les(s) ego*, 91.

Pine, Georgiana. "Tiny Eden Blooms amid the Rubble." *New York Post*, May 15, 1978. Reprinted in *LIFE with les(s) ego*, 32.

Polshek, James Stewart to Mayor Edward Koch. October 15, 1984. Reprinted in *LIFE with les(s) ego*, 105.

Purple, Adam, and Eve Purple. "The Garden of Eden." *Yipster Times*, March 1978. Reprinted in *LIFE with les(s) ego*, 30.

Purple, Adam, Interview for StoryCorps oral history project. Interview by Amy Brost. November 22, 2006. Booth Location: Concourse of the World Trade Center PATH station, New York, New York.

Purple, Adam. "Statement to the New York City Board of Estimate." Speech, December 16, 1982. Reprinted in *LIFE with les(s) ego*, 72.

Purple, Adam. "*The Garden of Eden*: An Environmental 'Radical Transformation.'" Proposal submitted to the 16th annual meeting of the Environmental Design Research Association, City University of New York Graduate Center, New York, New York, 10-13 June 1985. Reprinted in *LIFE with les(s) ego*, 108.

Purple, Adam, "*The Garden of Eden*: An Environmental 'Radical Transformation.'" Paper presented at the 16th annual meeting of the Environmental Design Research Association, City University of New York Graduate Center, New York, New York, 10-13 June 1985. Reprinted in *LIFE with les(s) ego*, 118.

Rioux, Jean to Mayor Edward I. Koch. December 14, 1983. Reprinted in *LIFE with les(s) ego*, 81.

Sloan, Richard E. "Rambo," to Adam Purple. August 12, 1984. Reprinted in *LIFE with les(s) ego*, 96.

Smith, Howard, and Lin Harris. "Paradise Paved." *The Village Voice* (New York), October 21-27, 1981. Reprinted in *LIFE with les(s) ego*, 53.

Smith, Howard. "Scenes." *The Village Voice* (New York City), April 8, 1971. Reprinted in *LIFE with les(s) ego*, 8.

The Students and Faculty of Southern California Institute of Architecture to Mayor Edward Koch. March 20, 1985. Reprinted in *LIFE with les(s) ego*, 115.

Swertlow, Eleanor. "Good-Will Harvest Saves Garden from Destruction." *Daily News* (New York), October 27, 1976. Reprinted in *LIFE with les(s) ego*, 27.

Taggart, Stewart. "Gardening with Zen and Urban Anarchism." *The Washington Post*, October 31, 1981. Reprinted in *LIFE with les(s) ego*, 52.

Wang, Harvey, photograph of *The Garden of Eden*, March 21, 1979. In 1985 EDRA Conference Report. Reprinted in *LIFE with les(s) ego*, 124.

Wang, Harvey, photograph of *The Garden of Eden*, December 30, 1978. In "A Garden Grows in Manhattan." *Crain's New York Business*, August 12, 1978. Reprinted in *LIFE with les(s) ego*, 133.

Zenger II, John Peter. "Rubble Reclamation." *Garden Magazine*, July/August 1979, 5-8. Publication of the Horticultural Society of New York. Reprinted in *LIFE with les(s) ego*, 37.

THE GARDEN OF EDEN FROM ABOVE

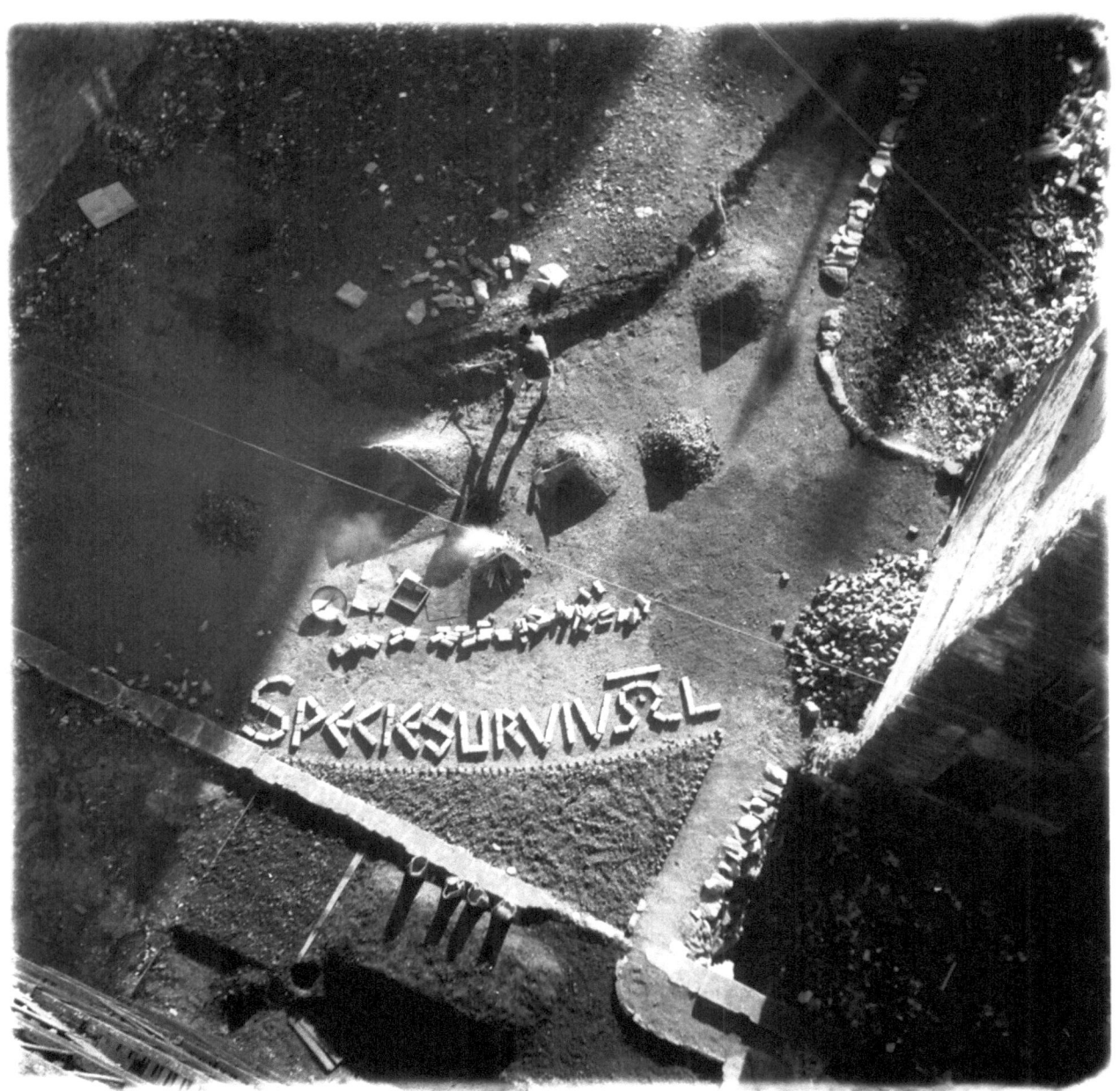

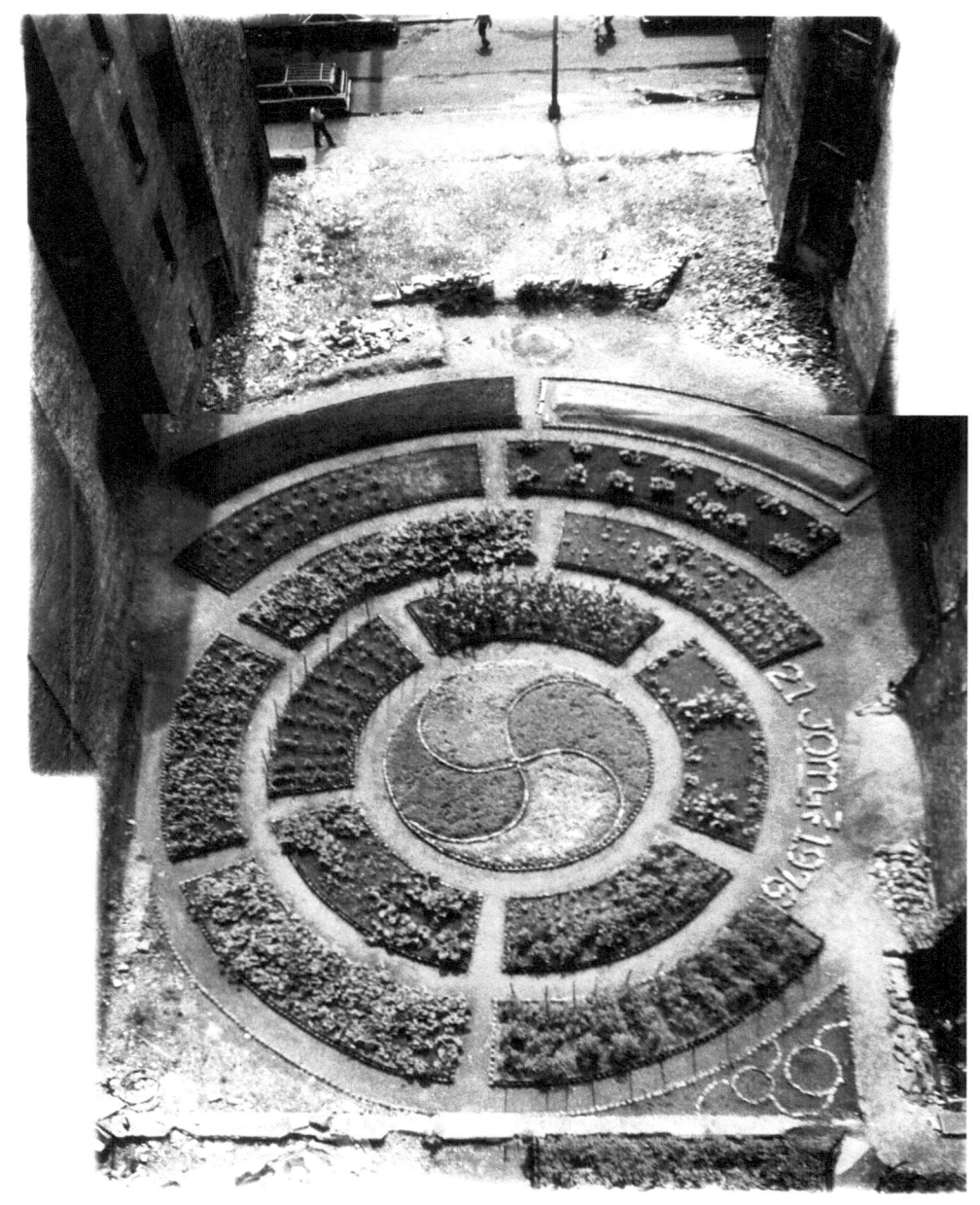

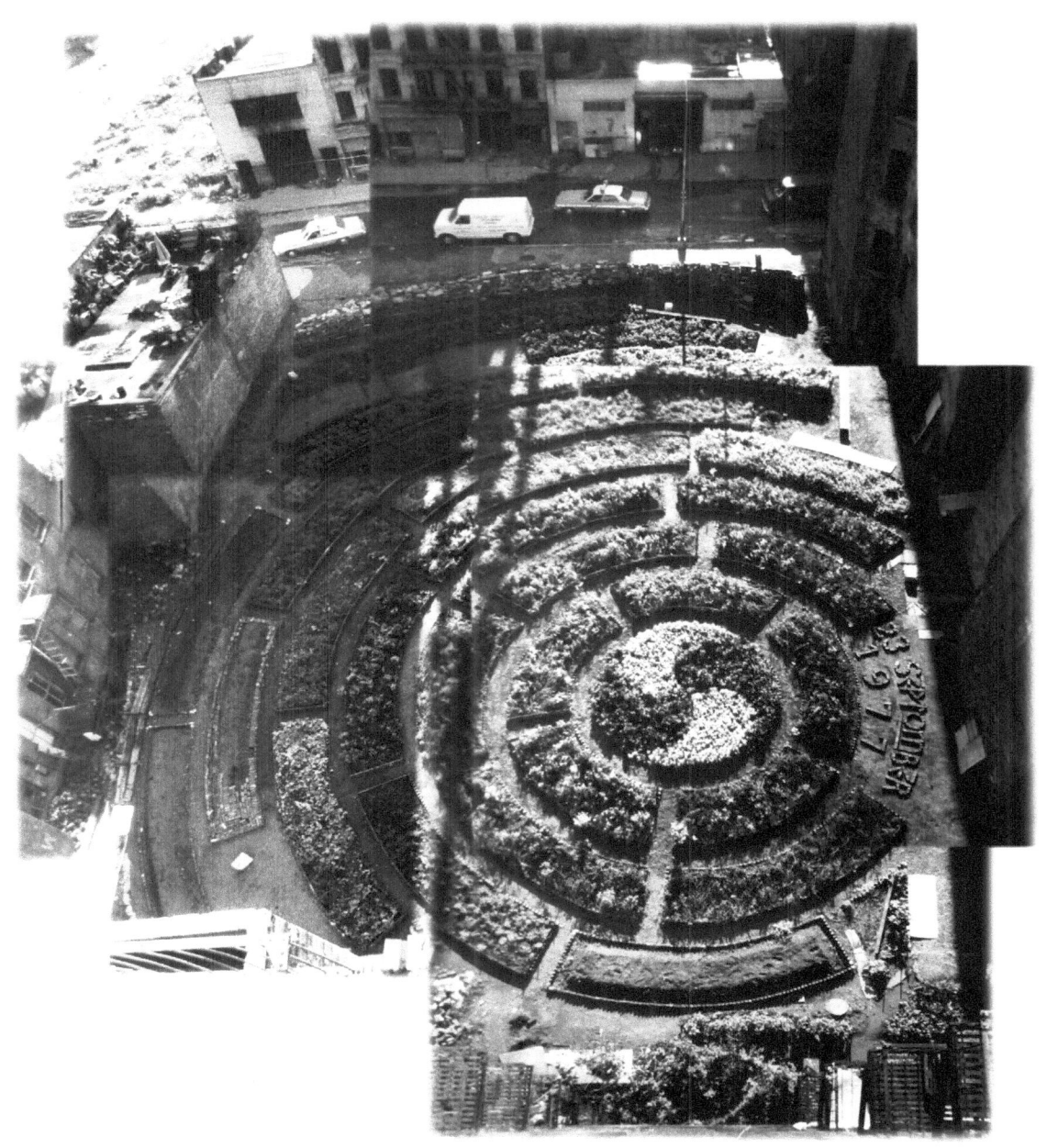

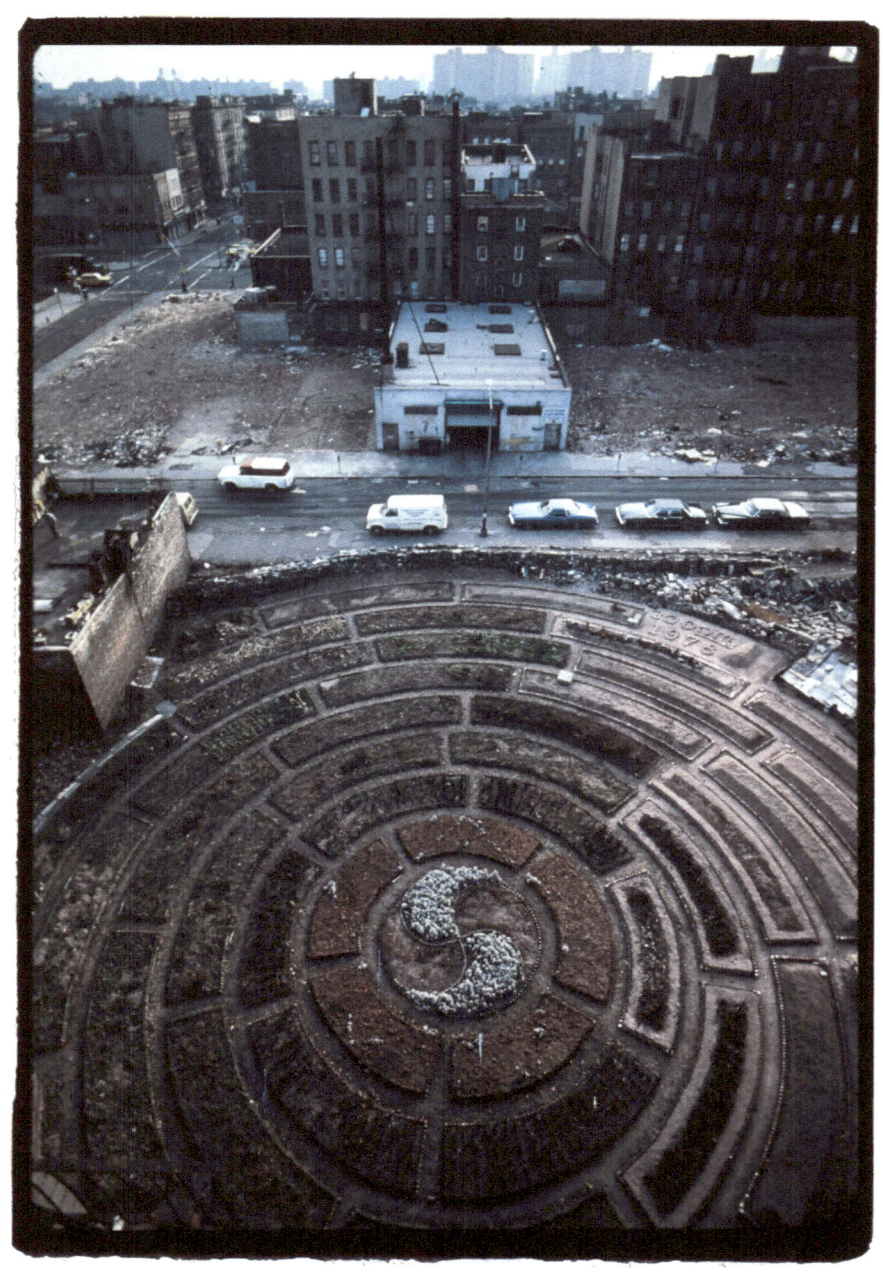

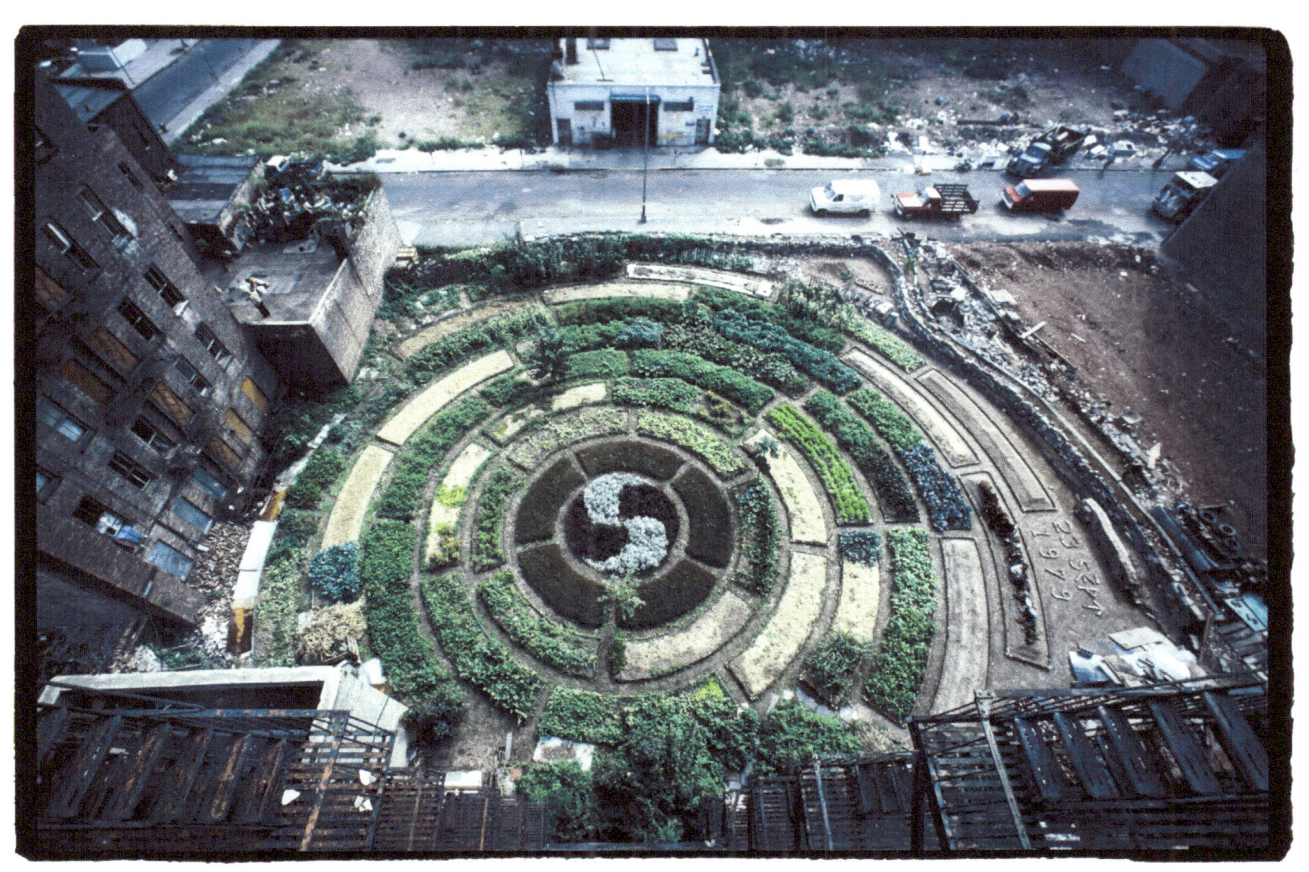

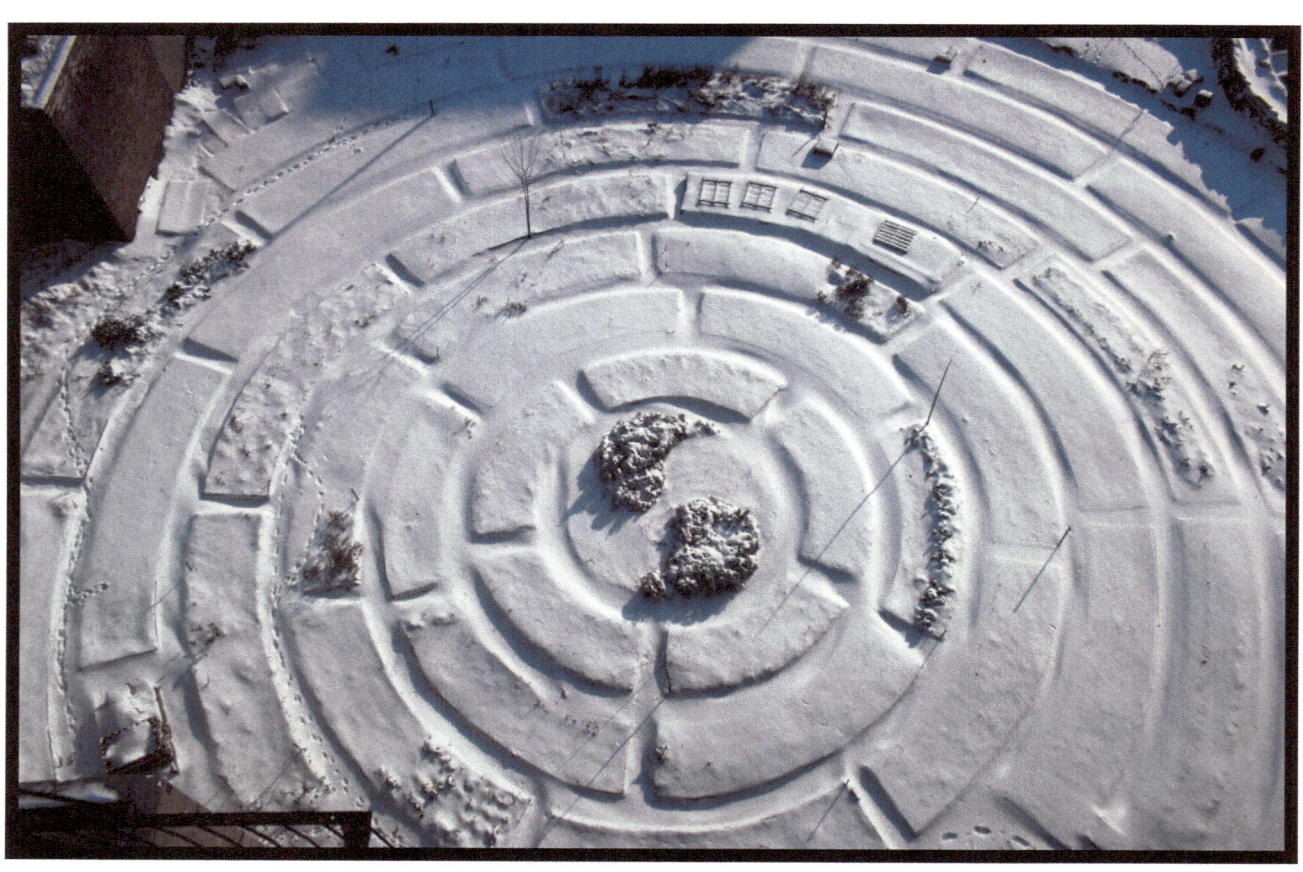

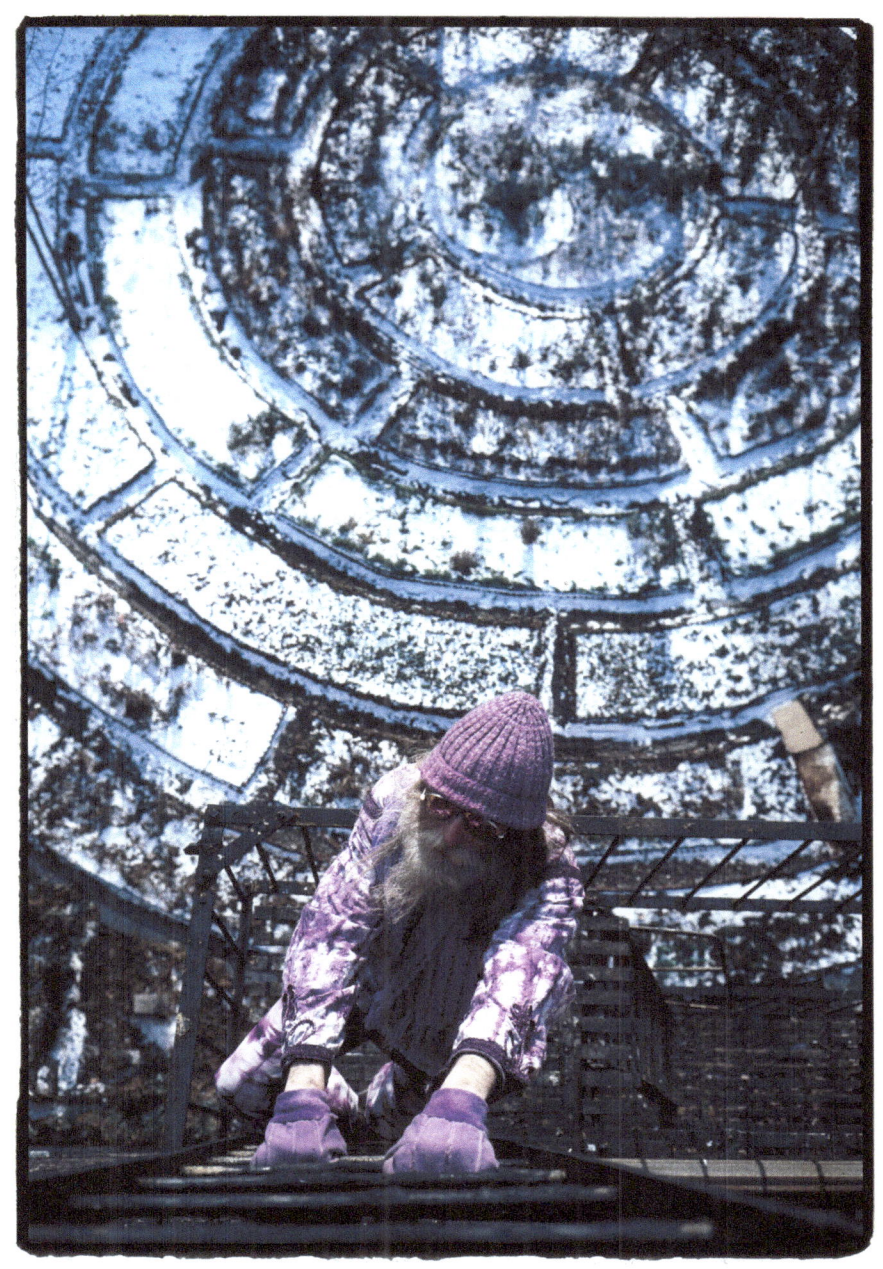

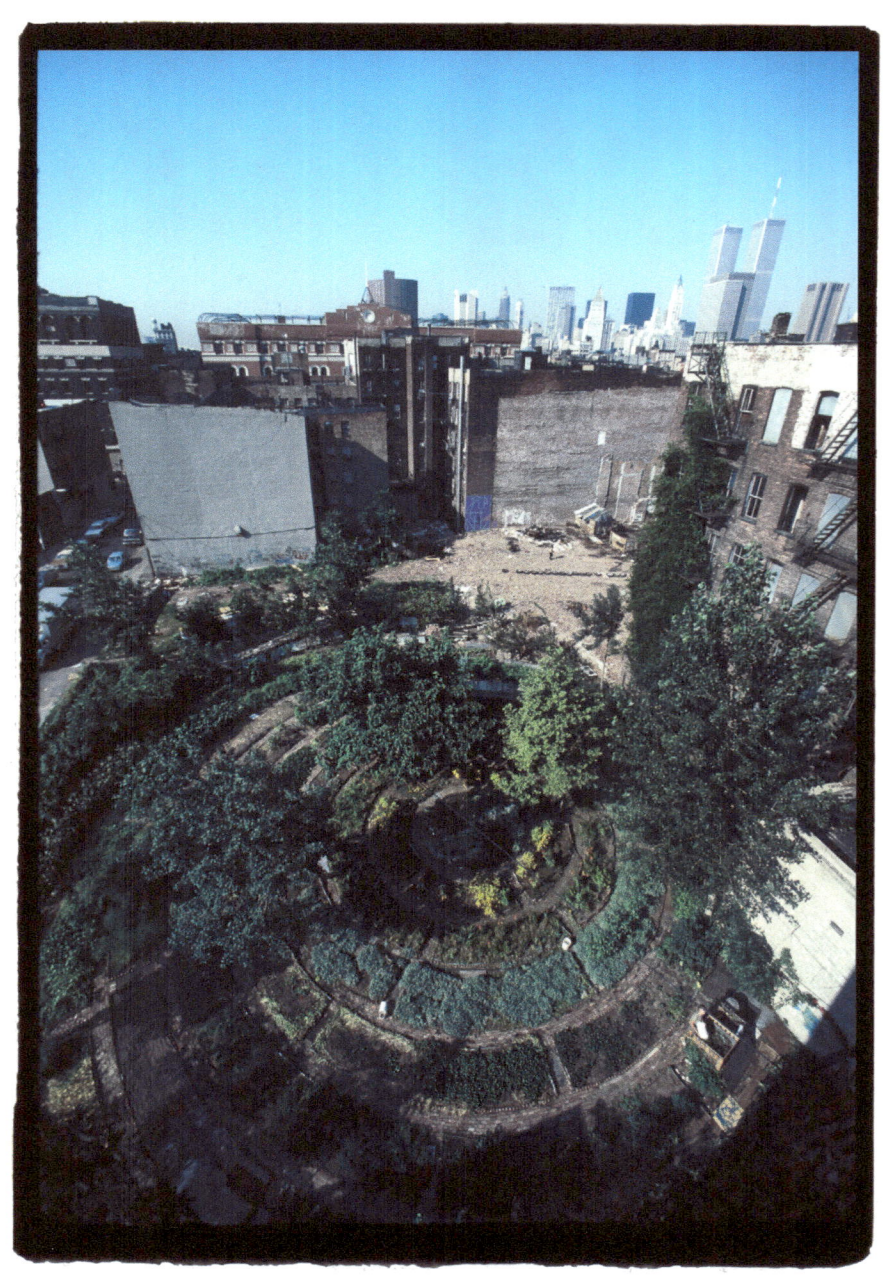

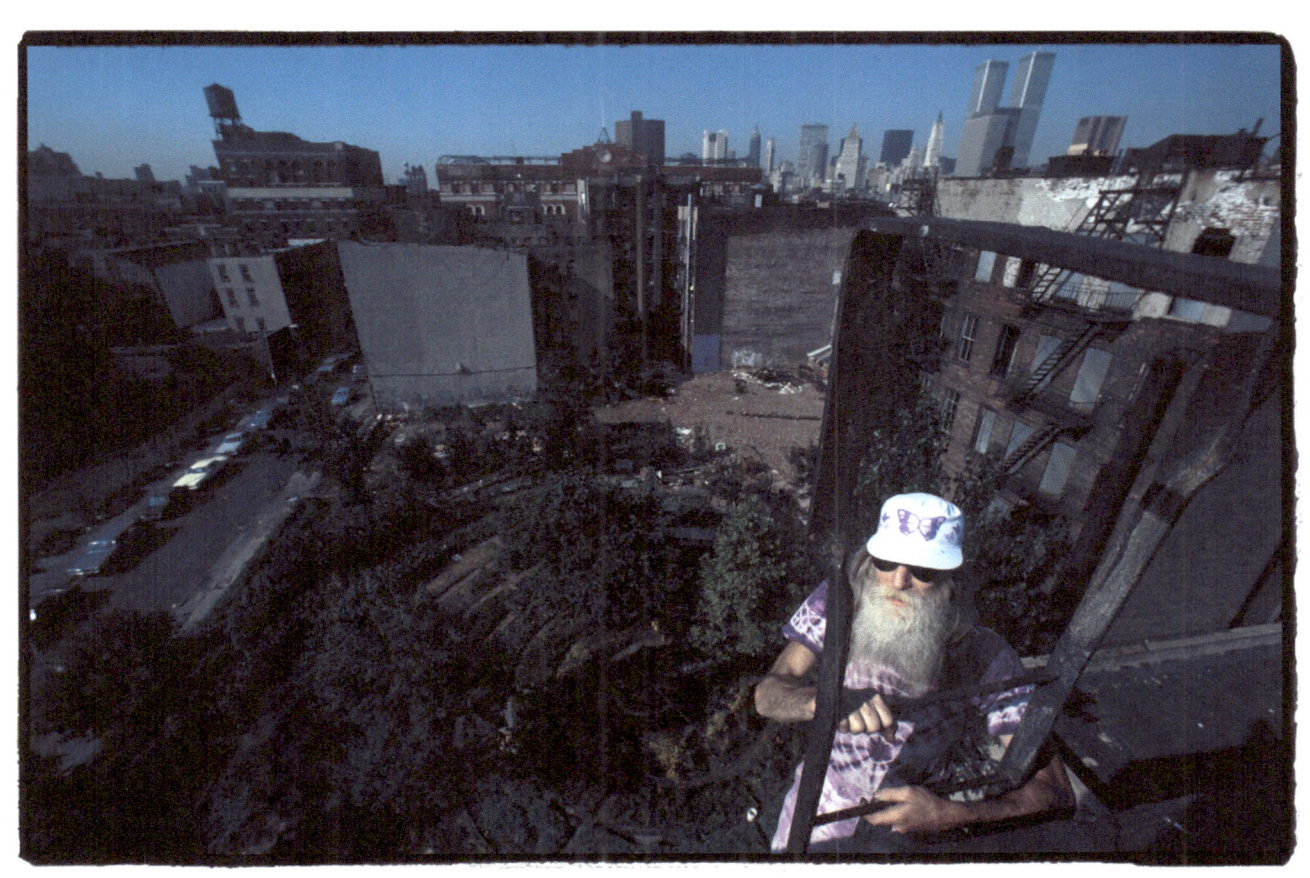

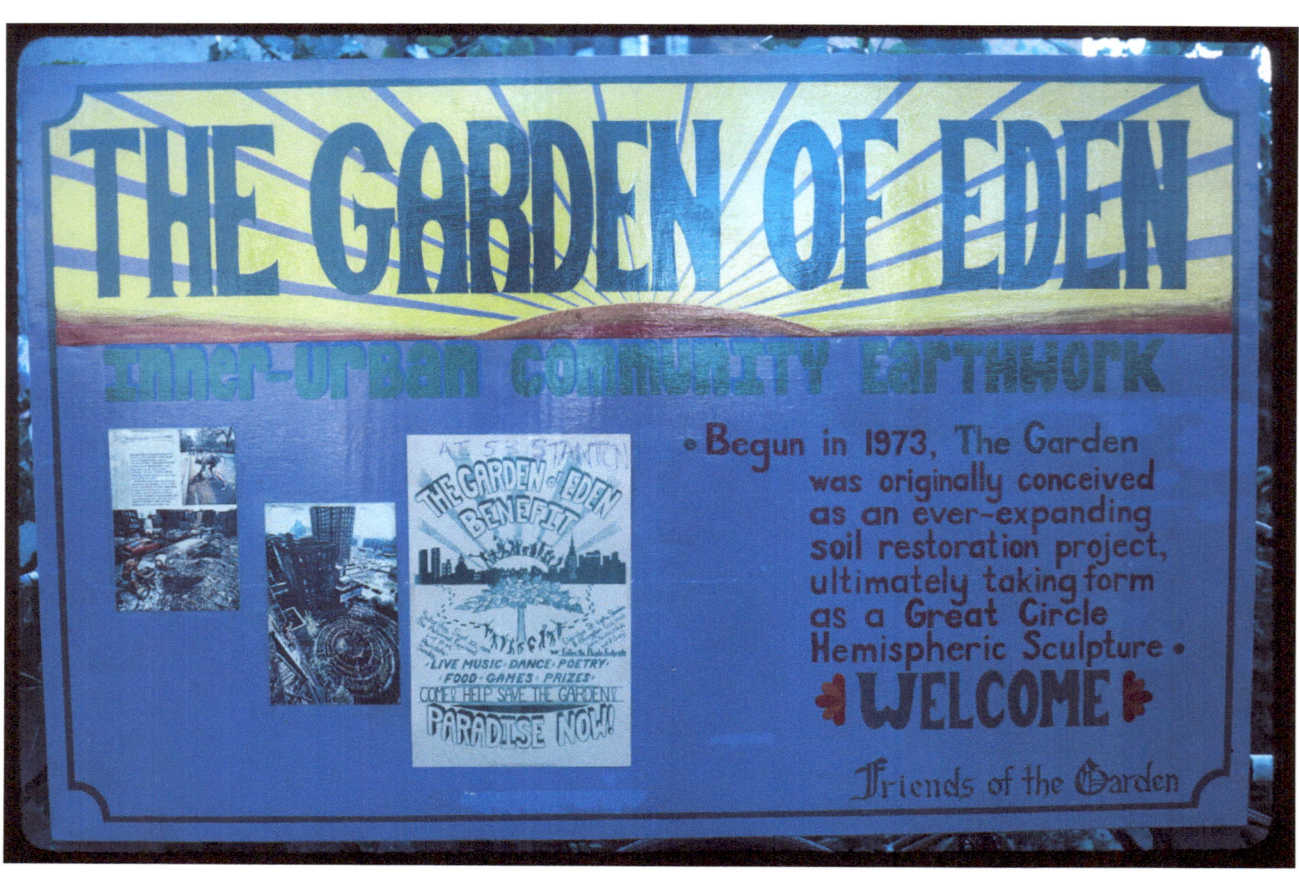

ADAM AT HOME

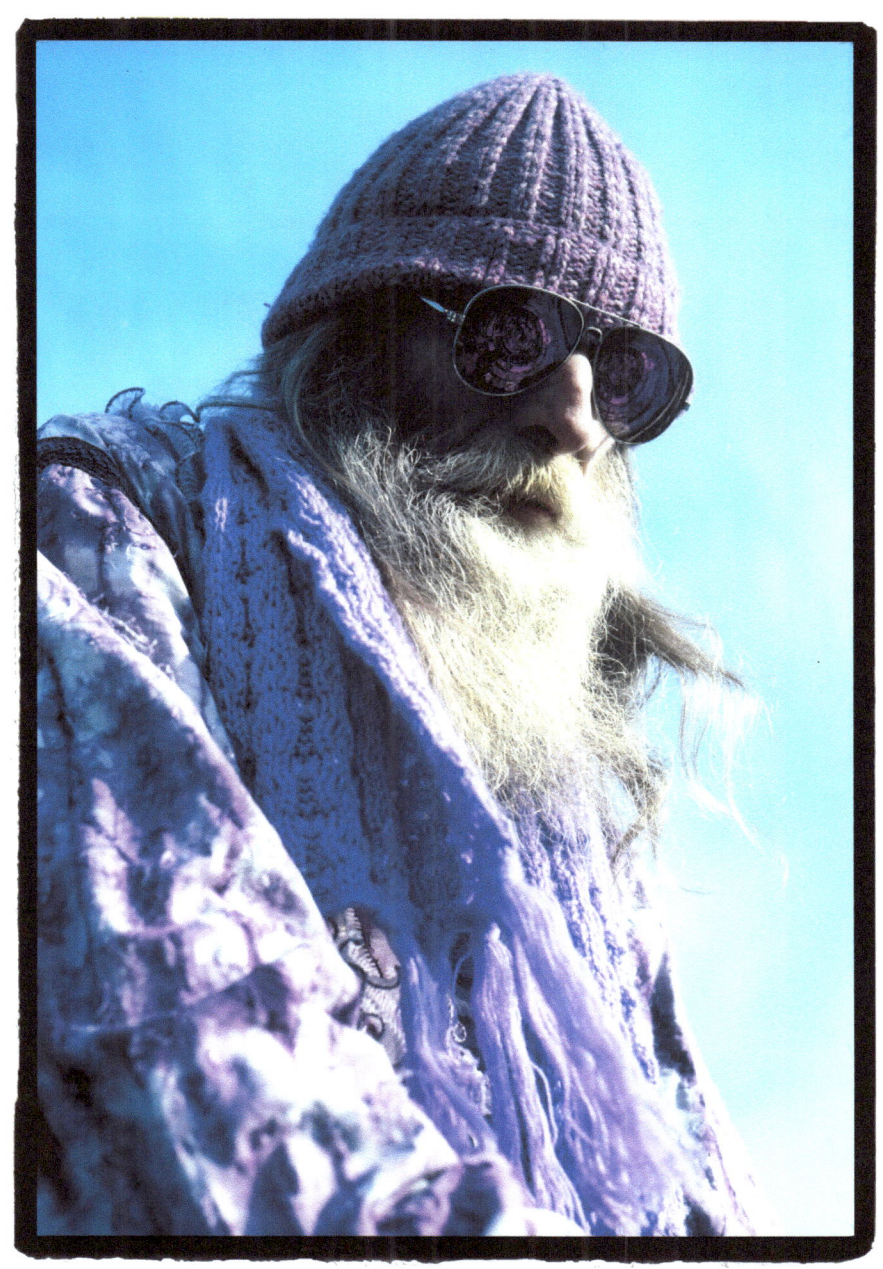

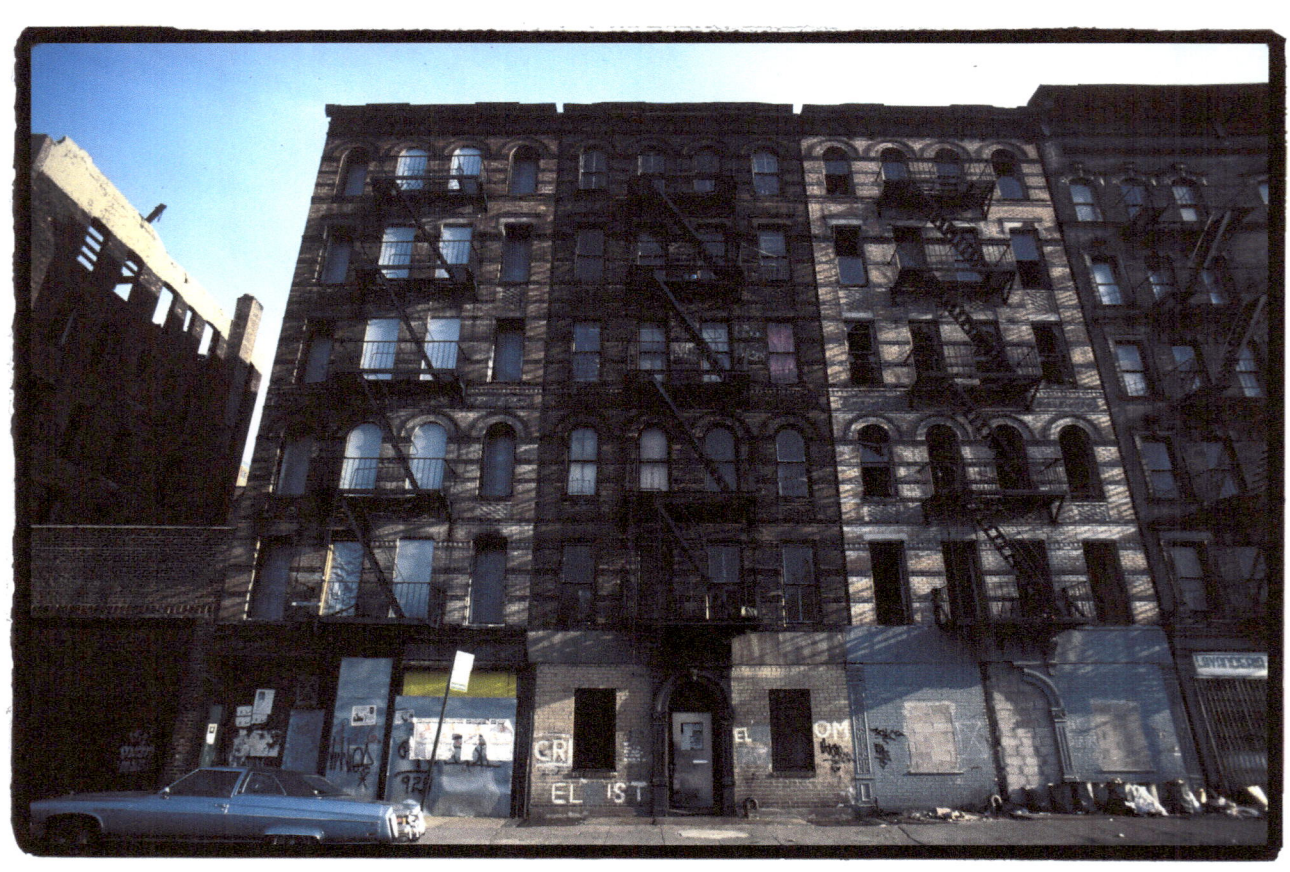

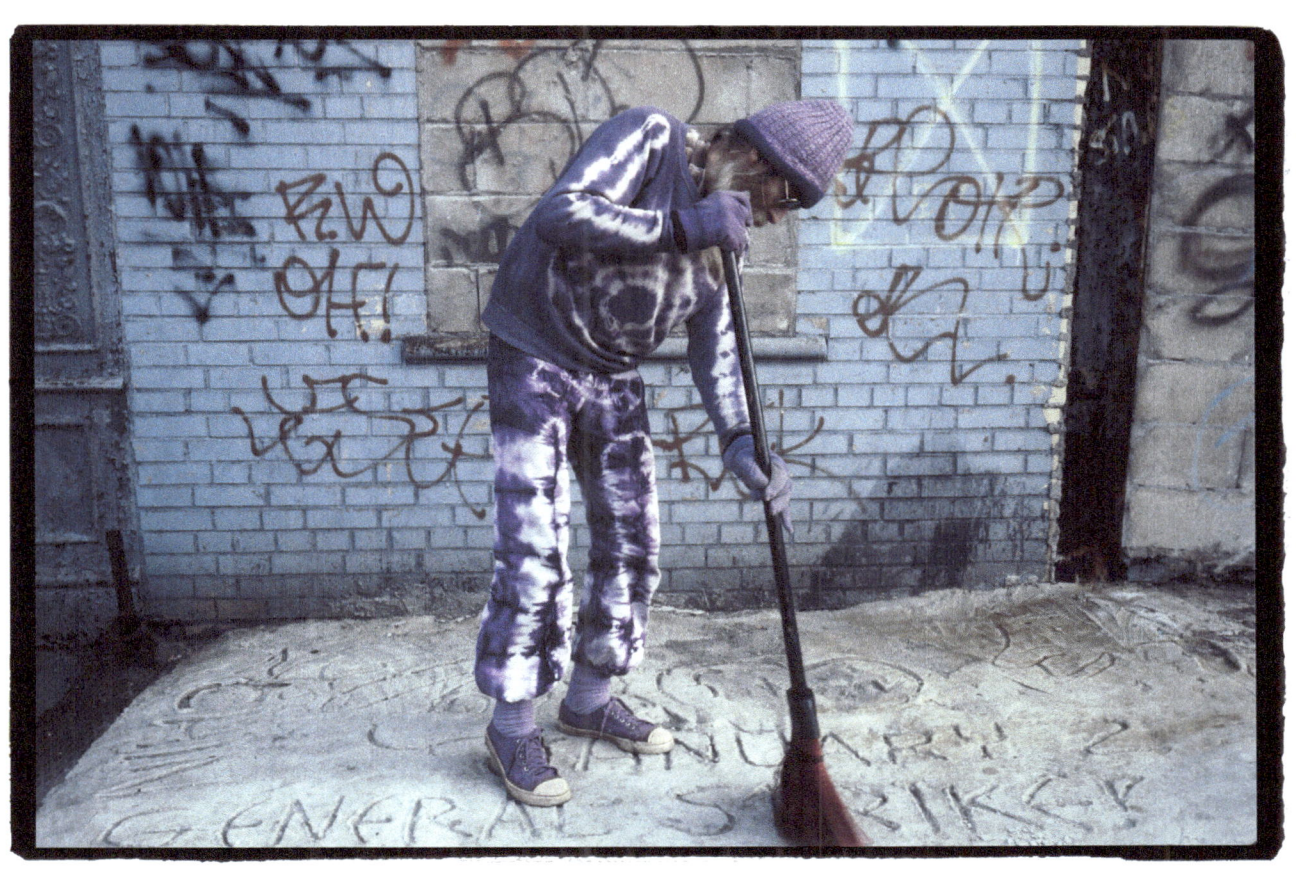

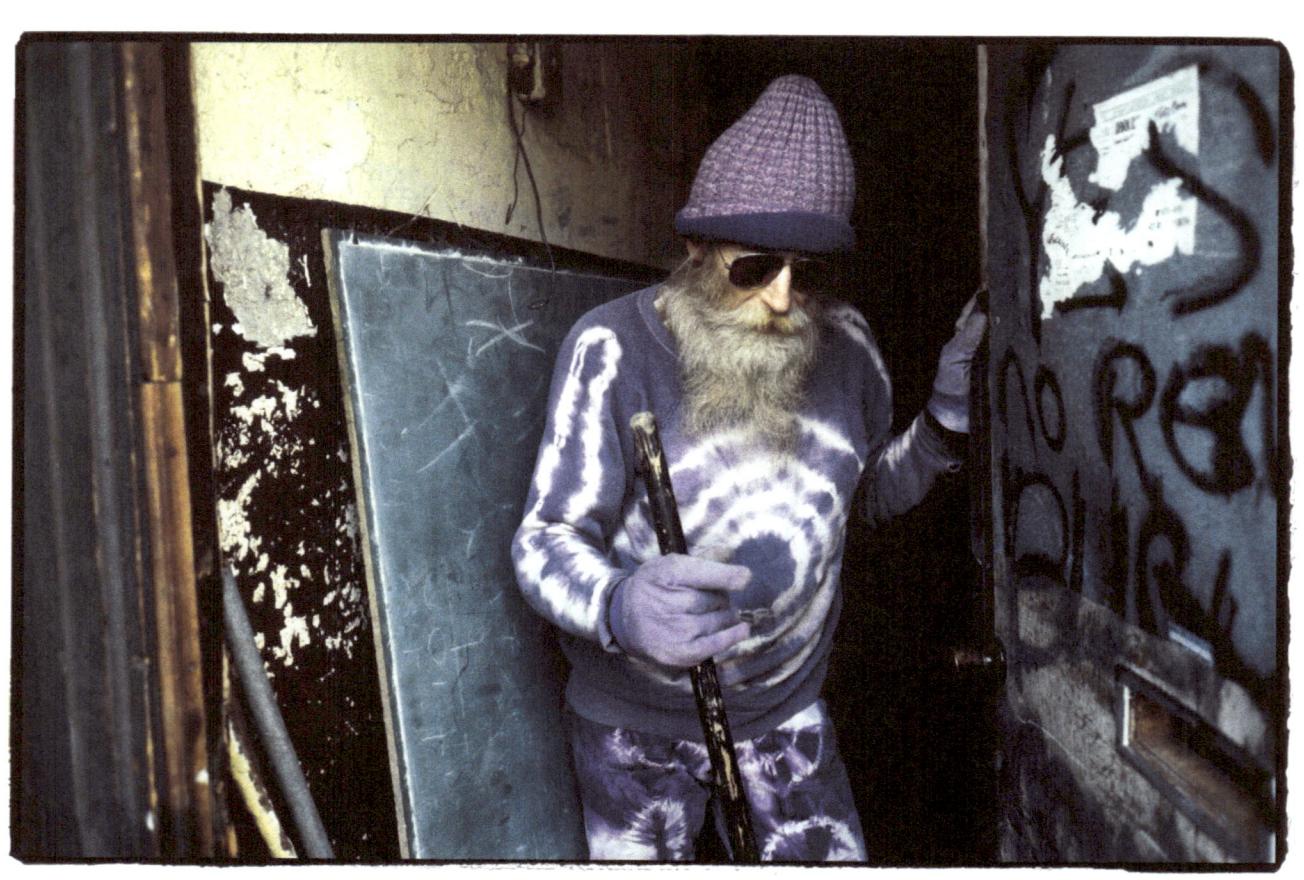

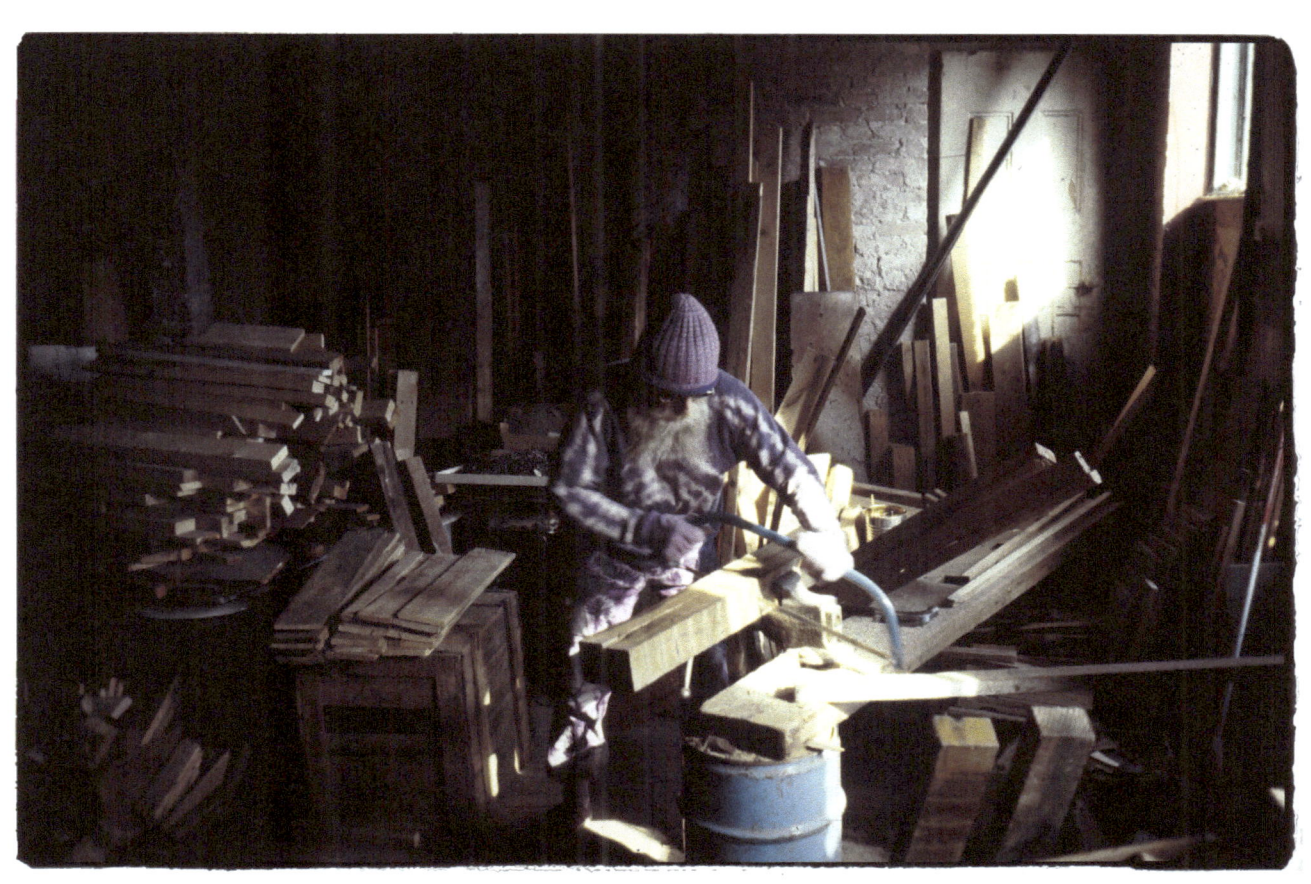

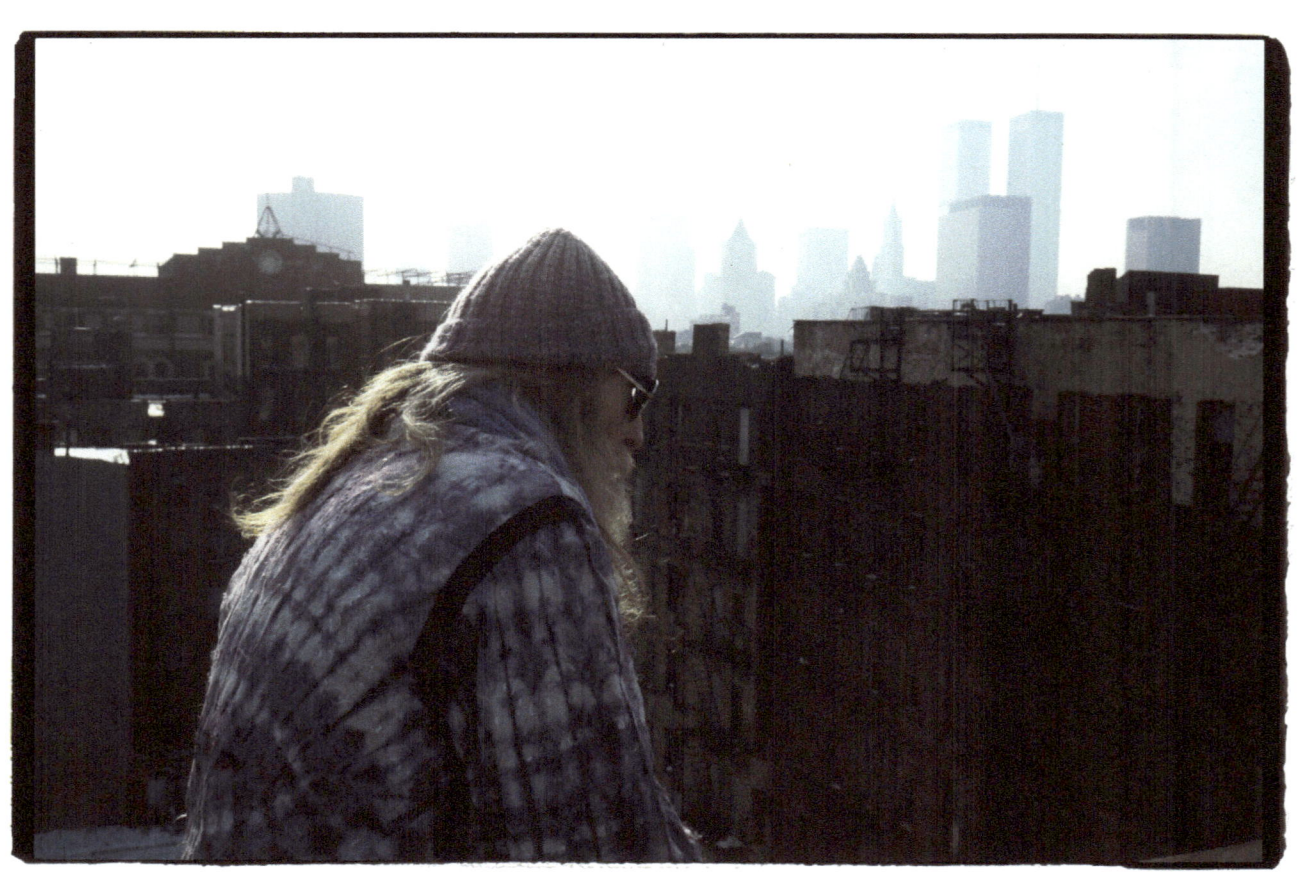

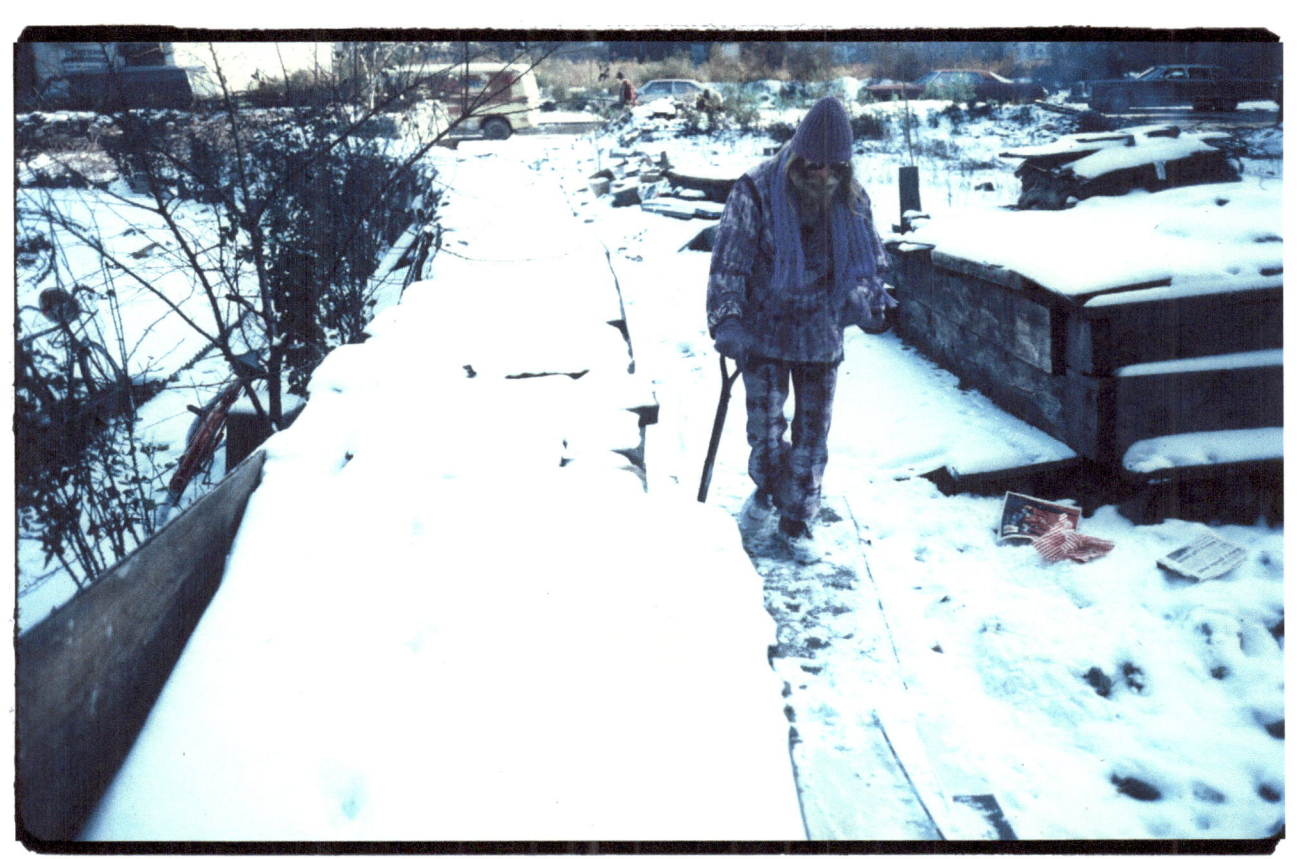

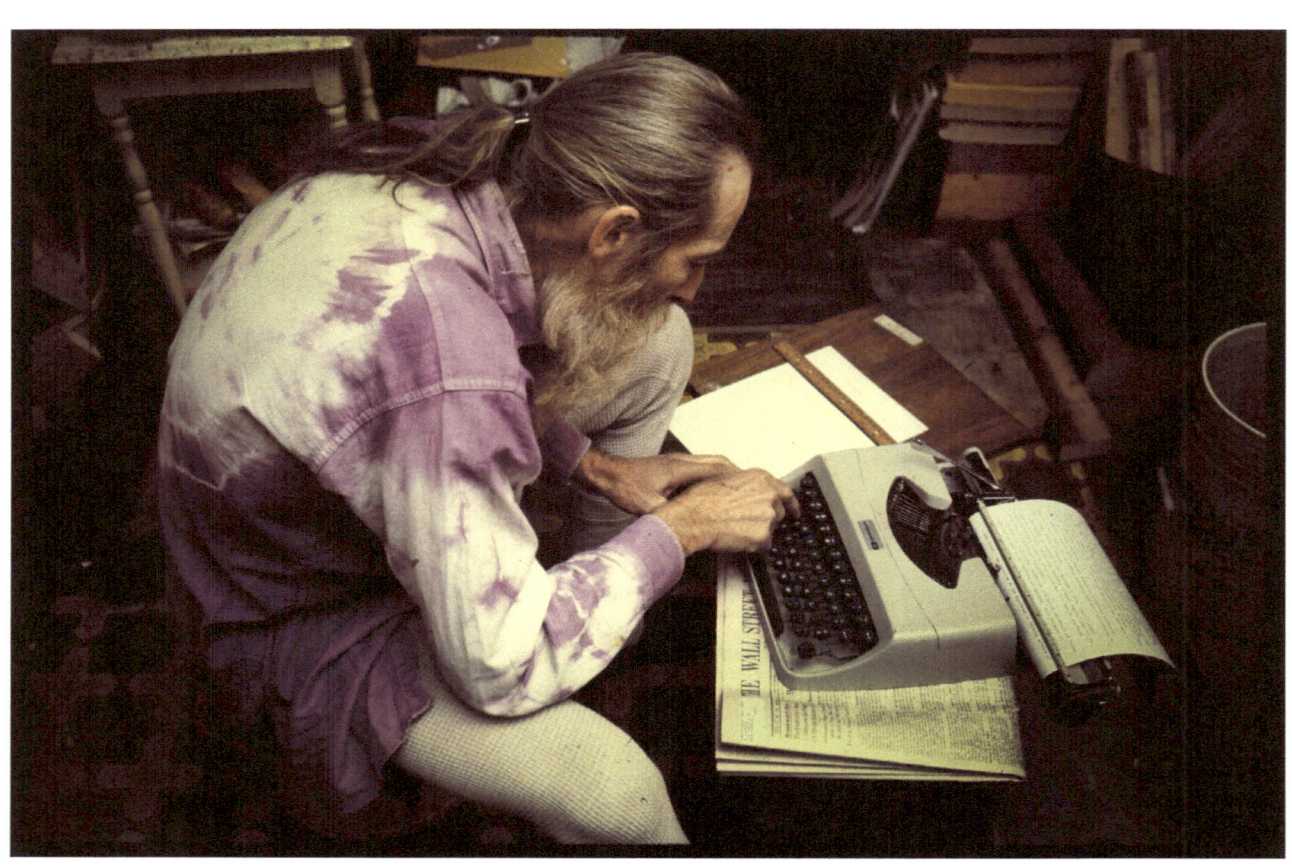

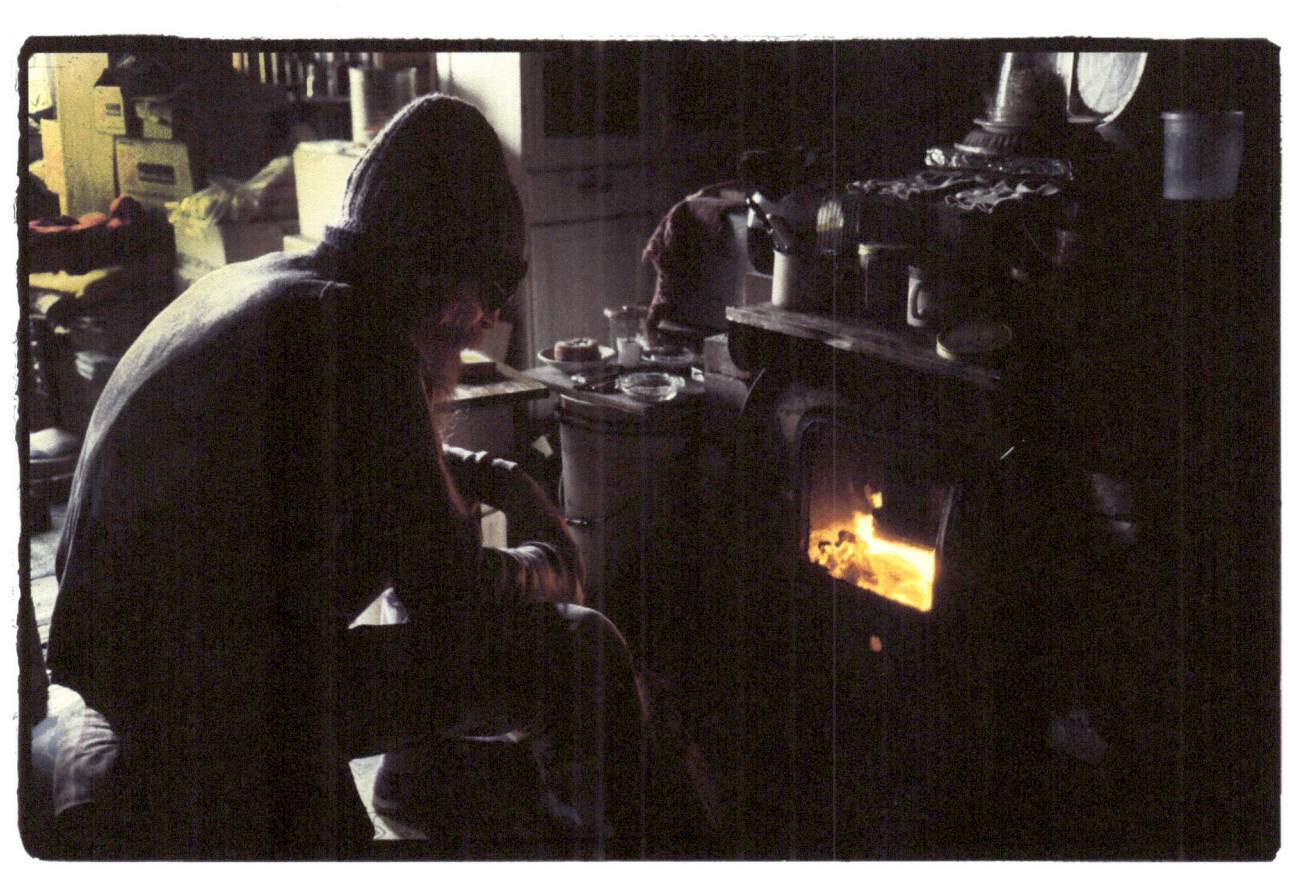

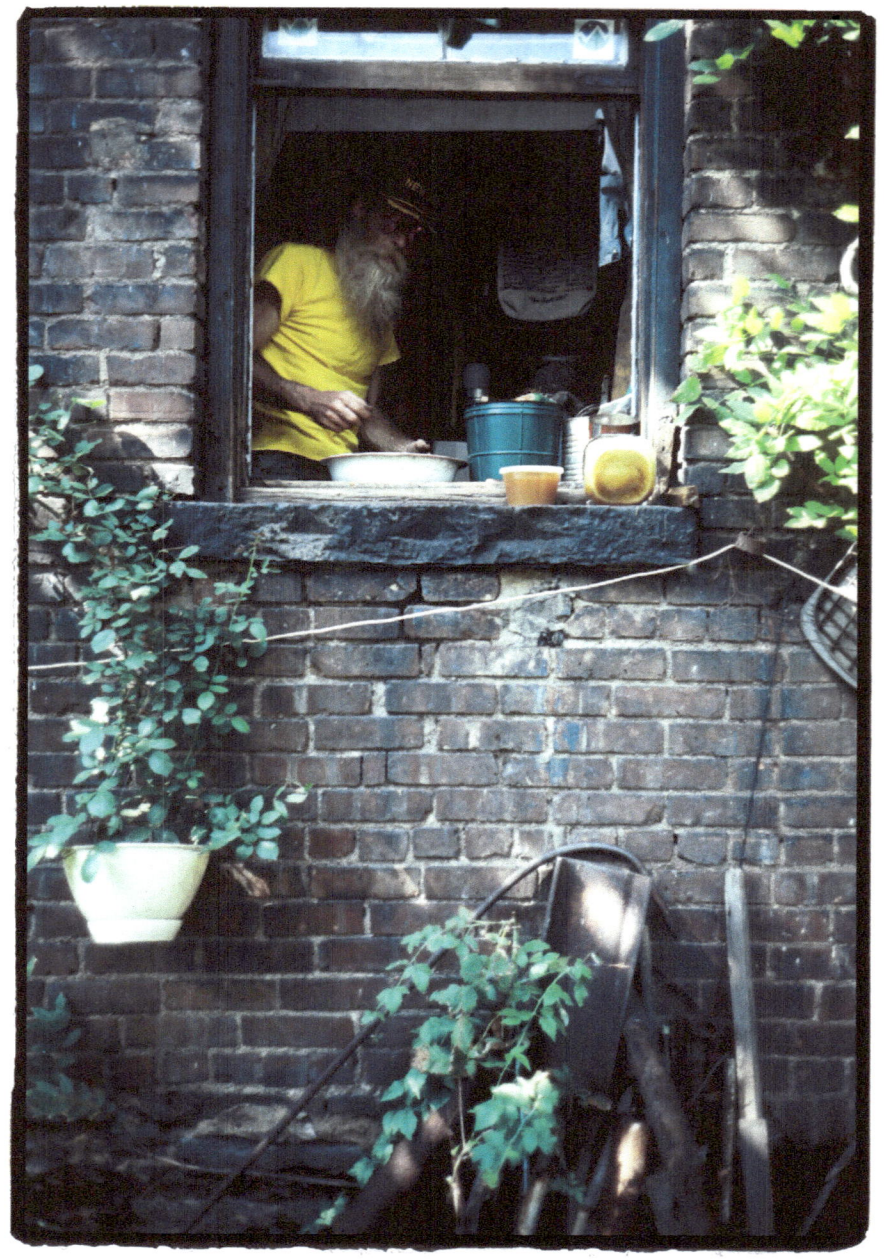

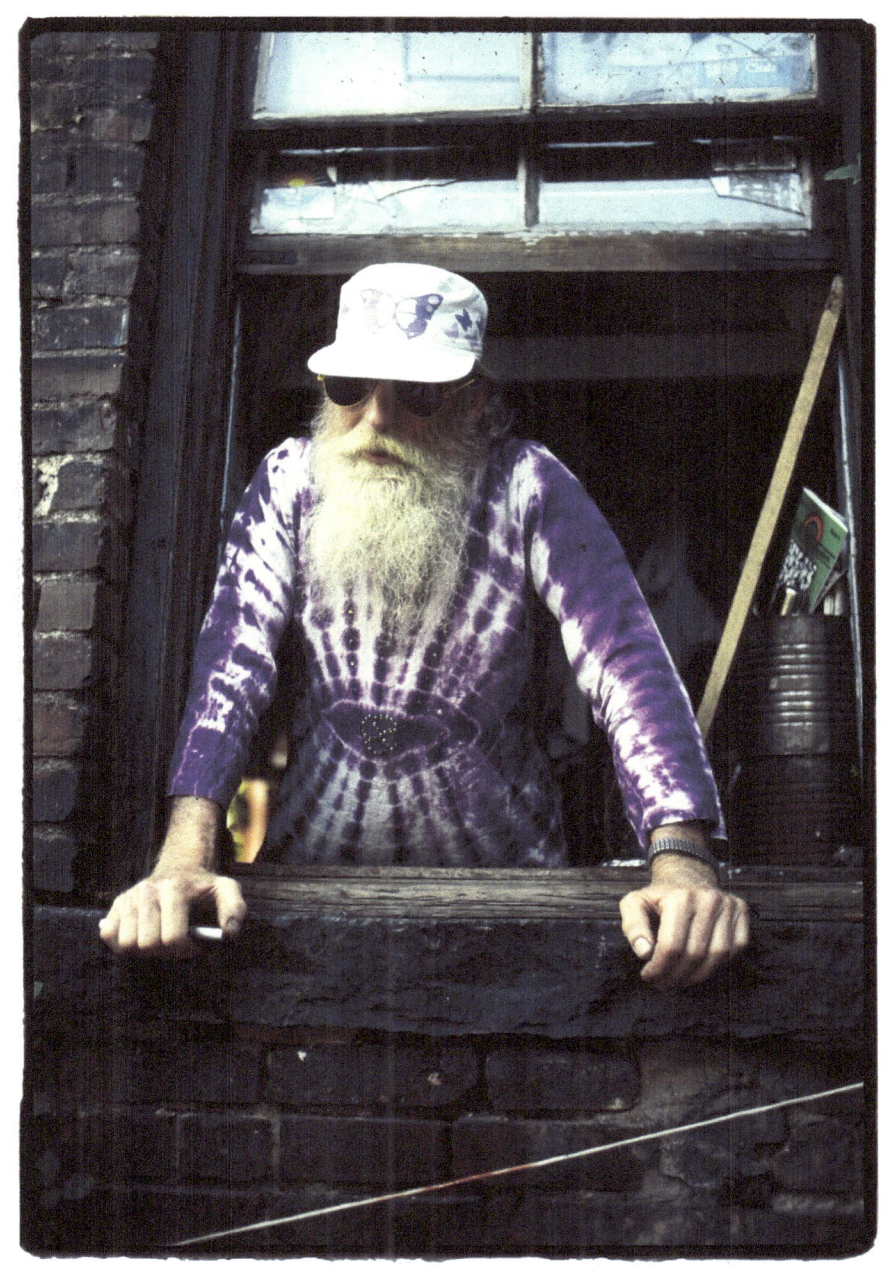

ZENTENCES

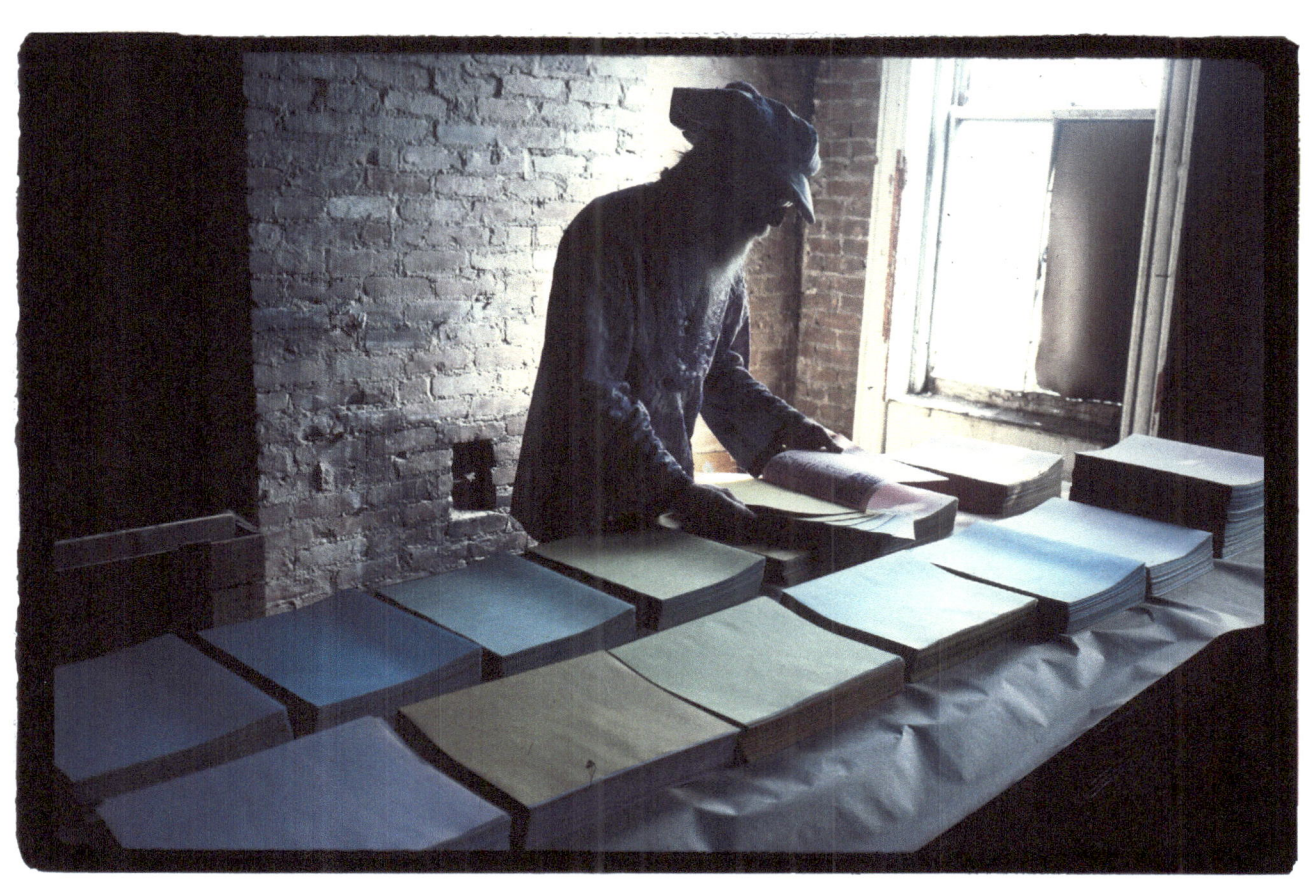

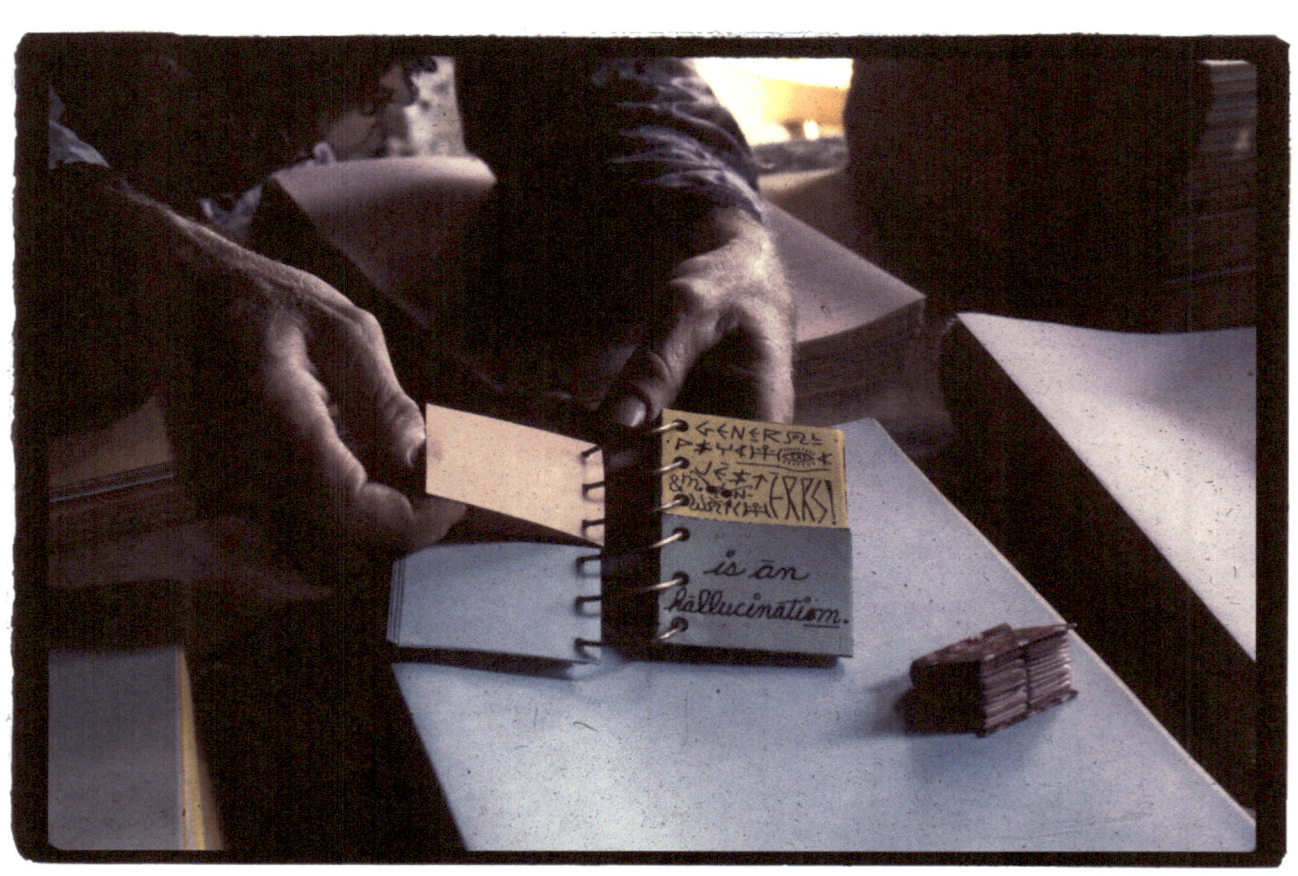

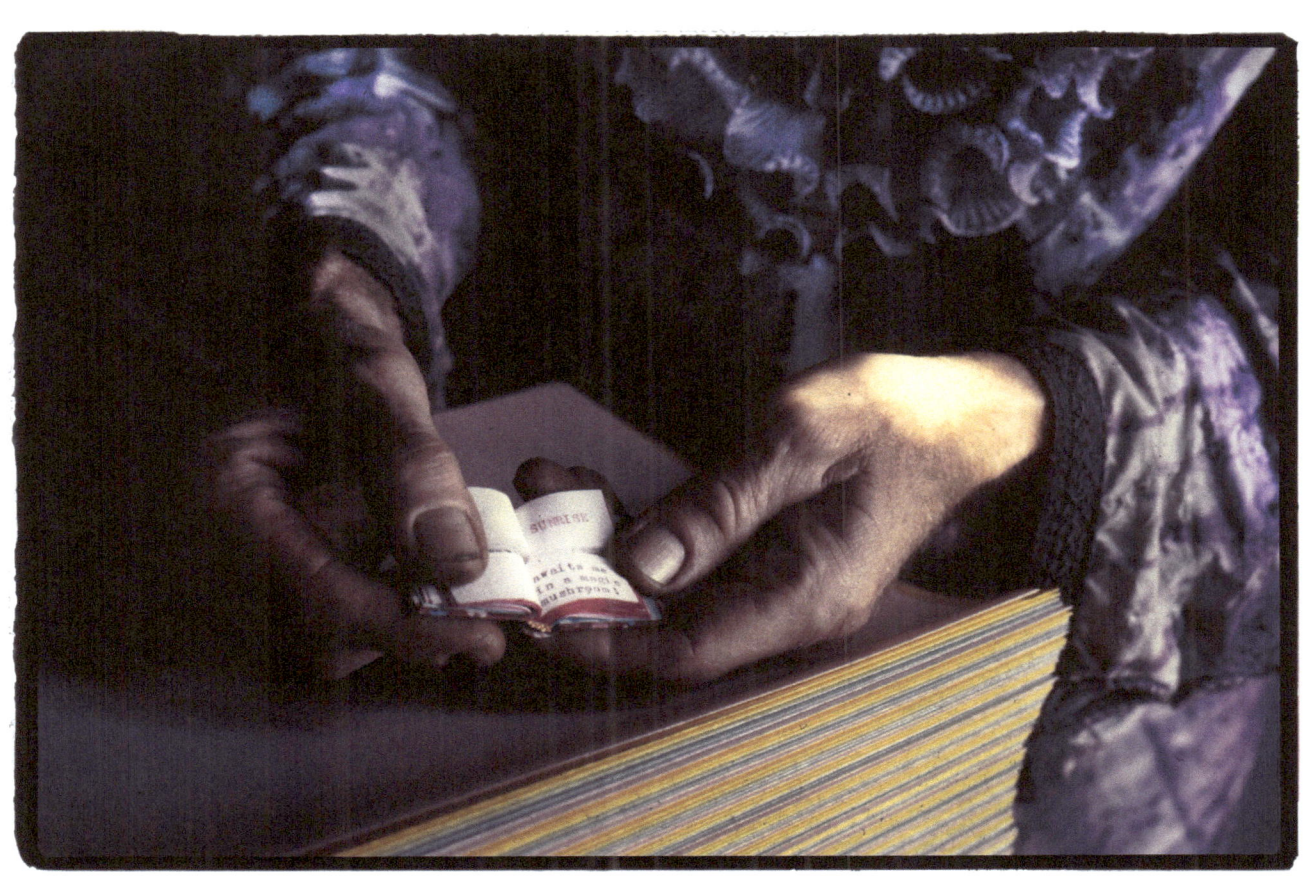

ADAM WORKING

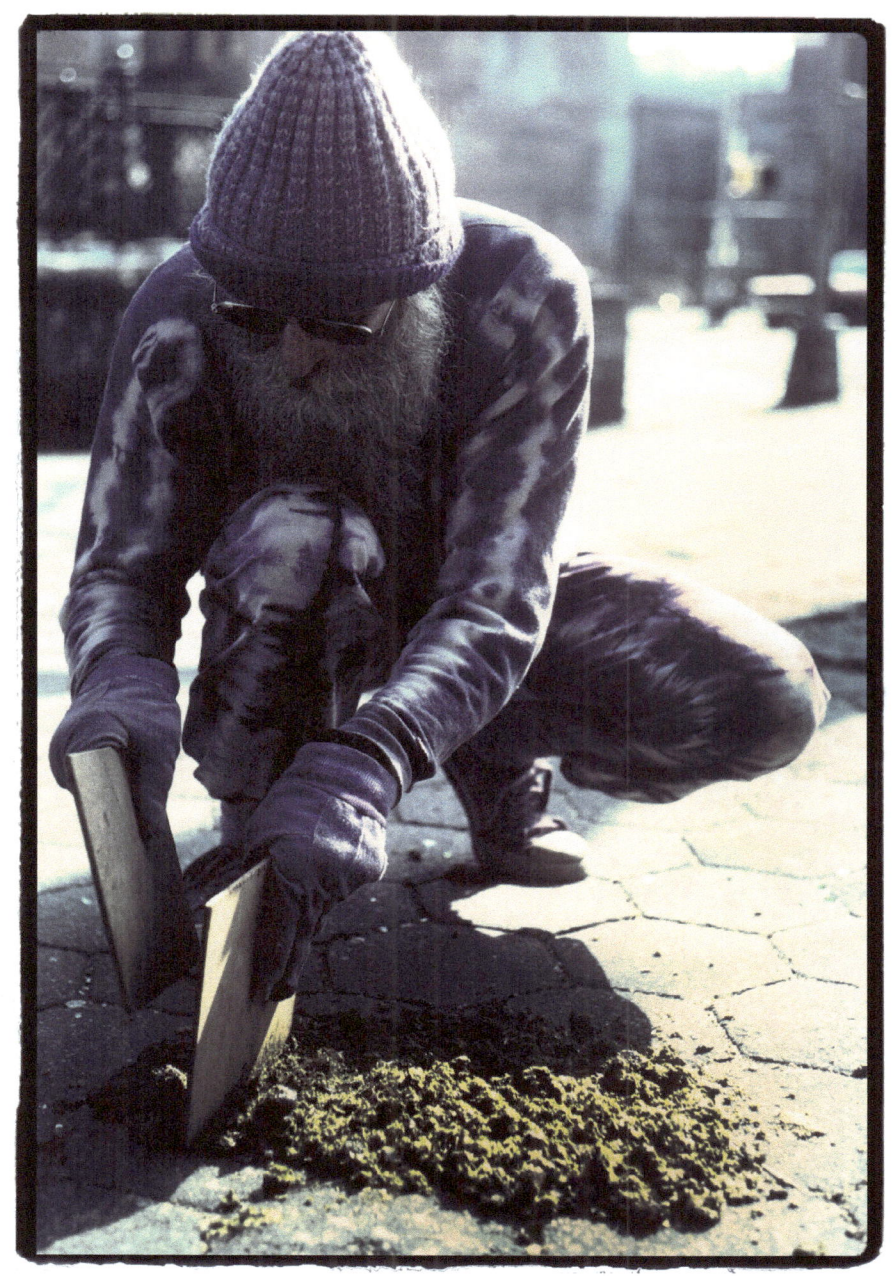

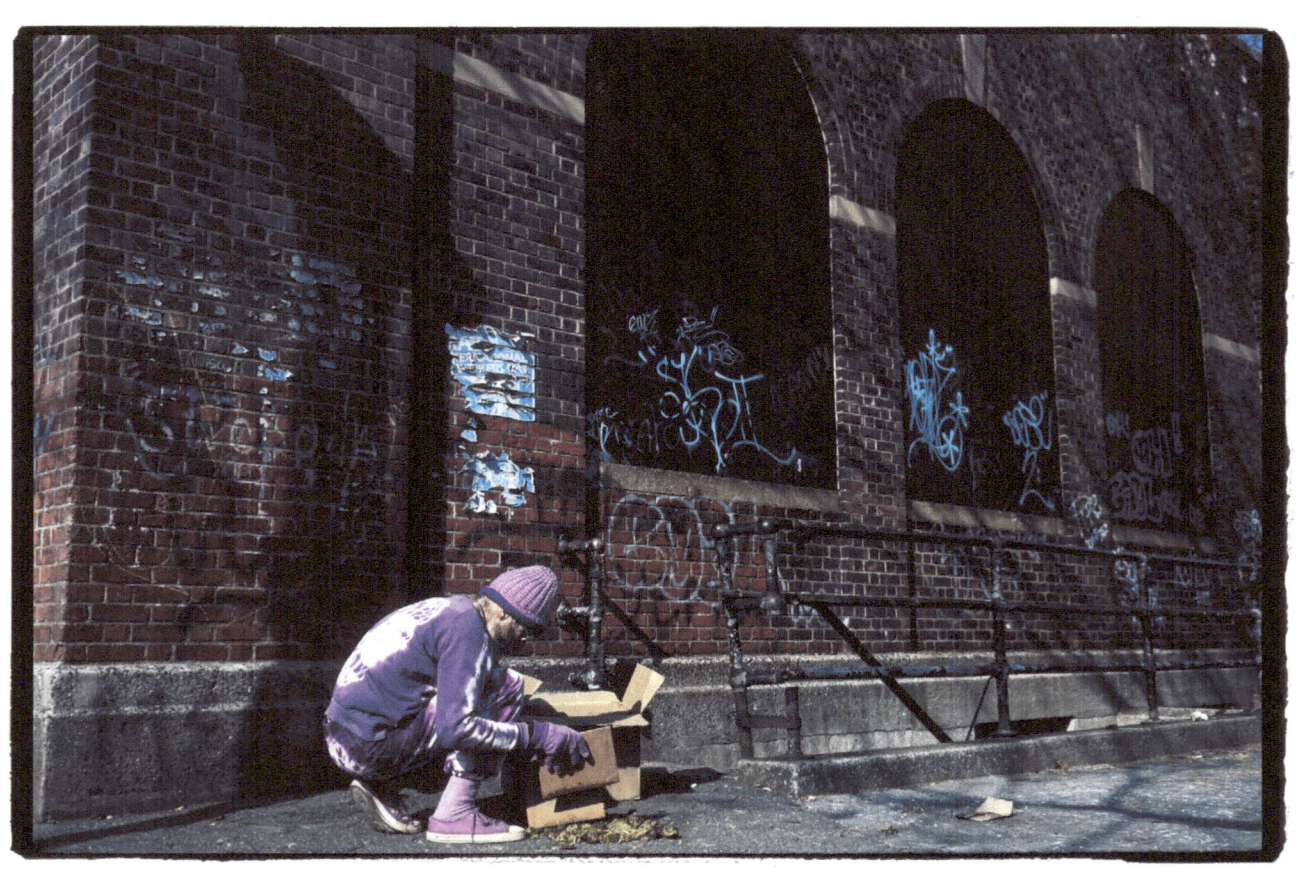

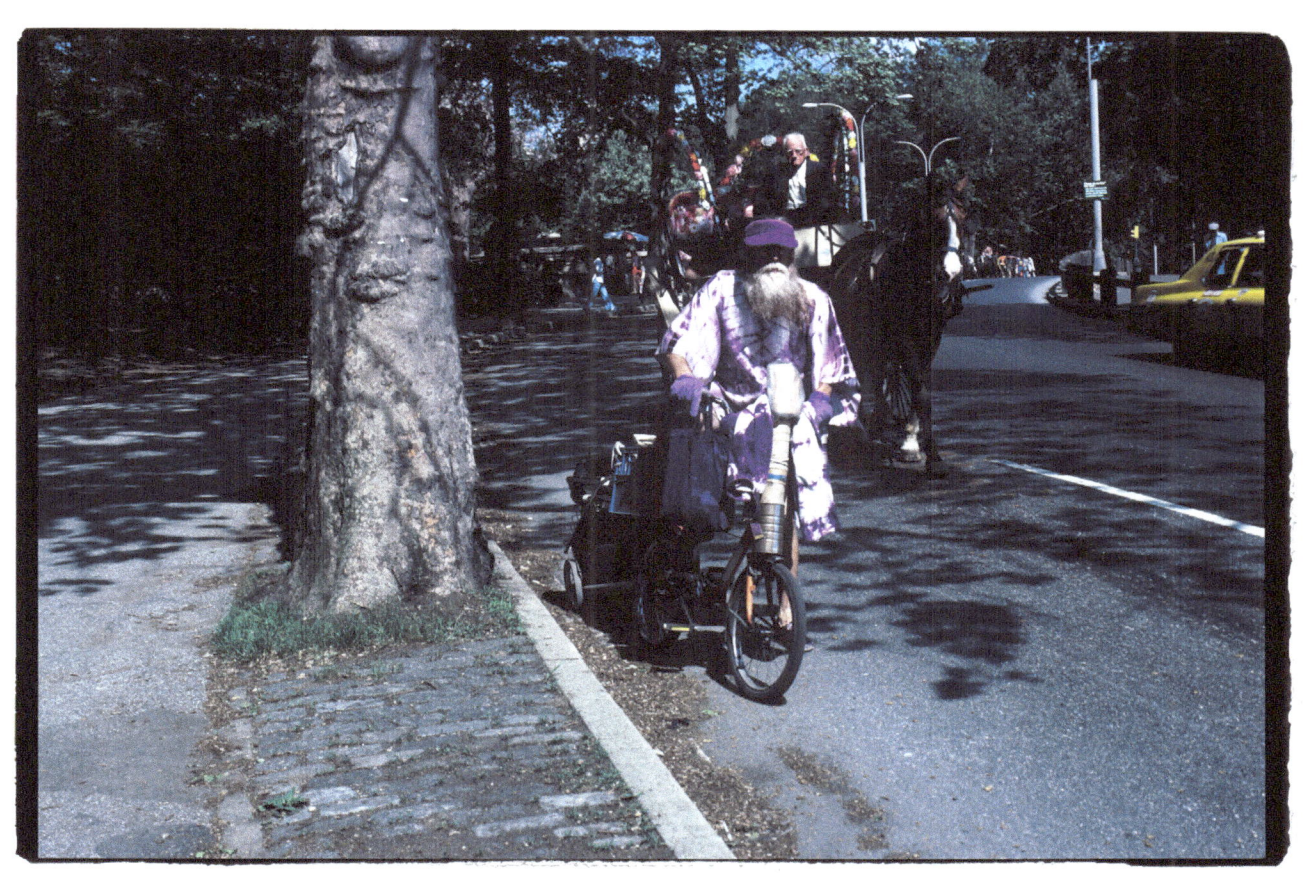

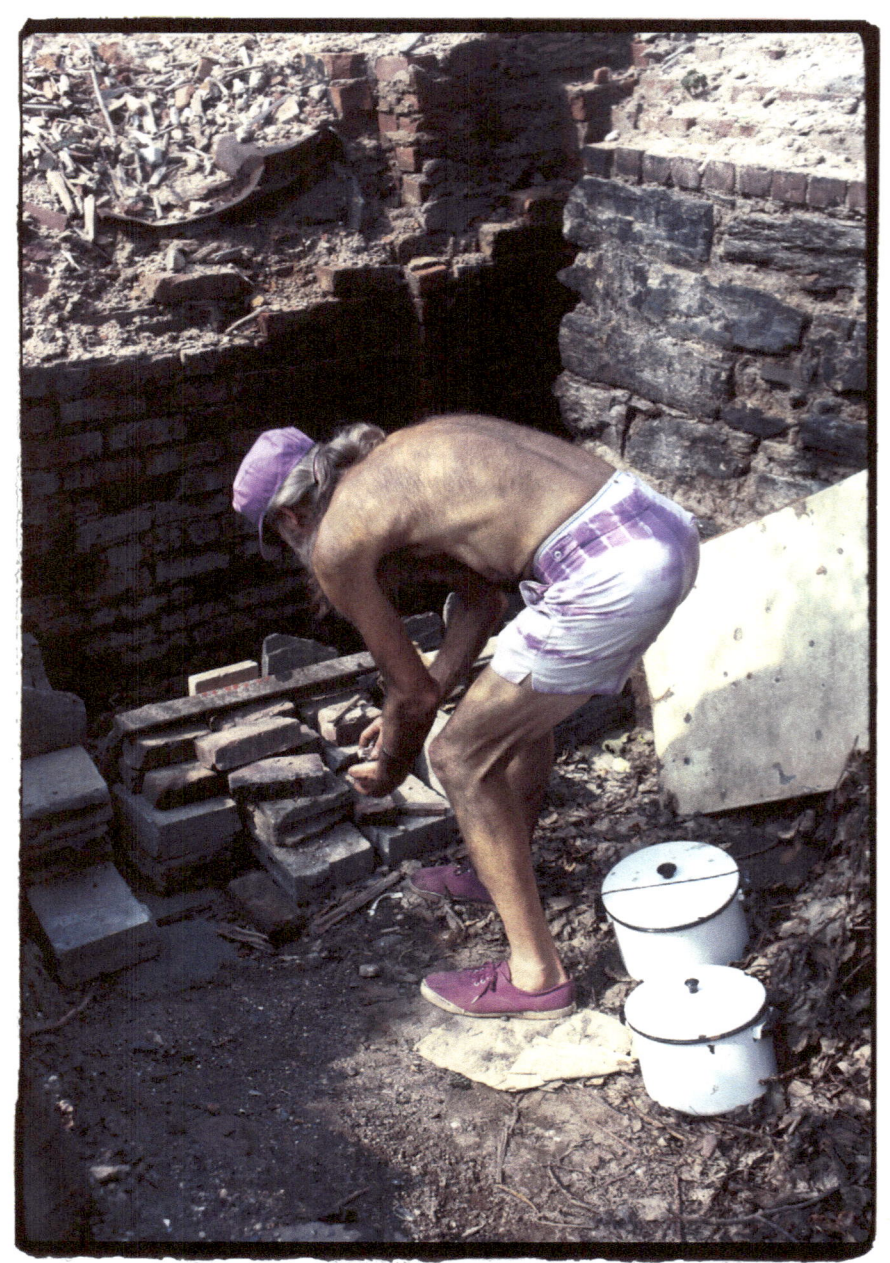

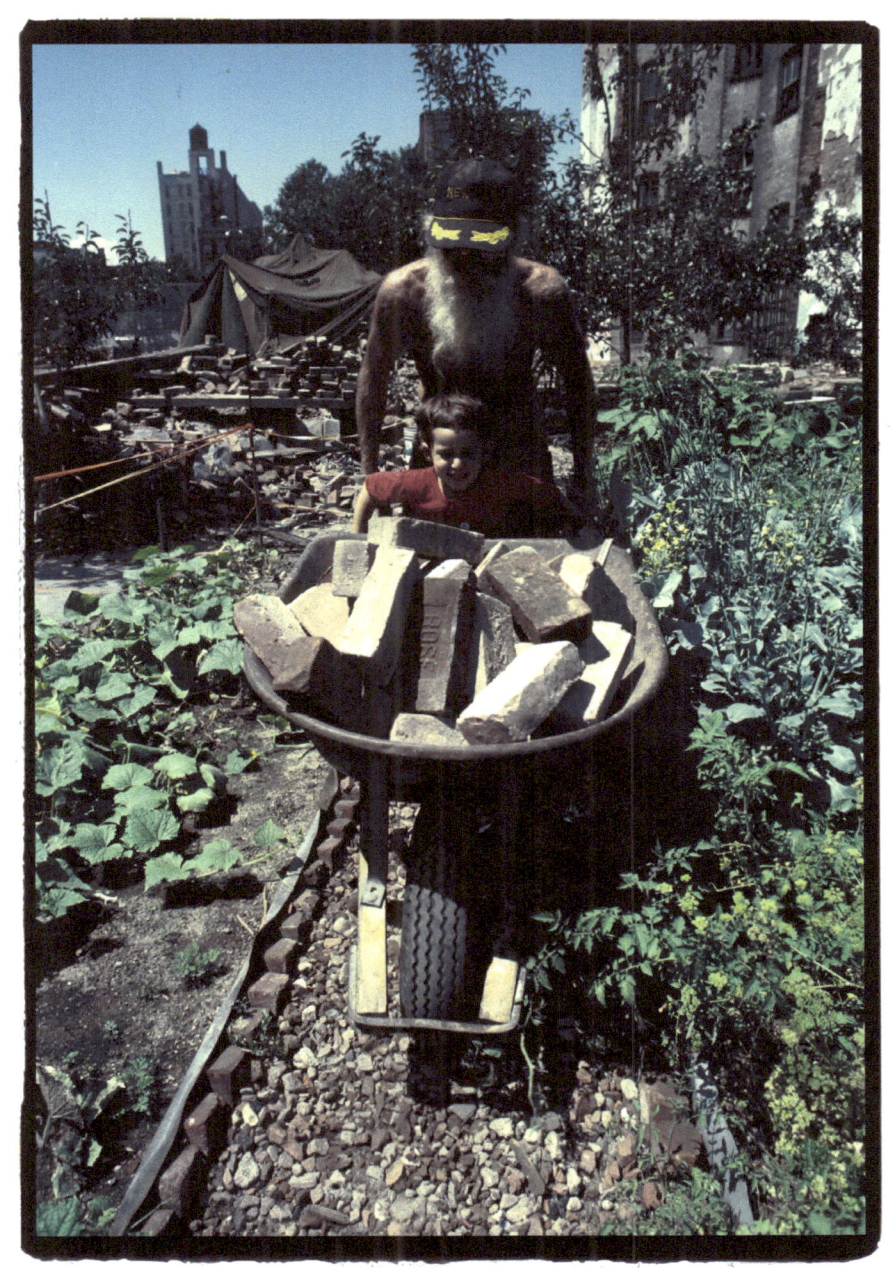

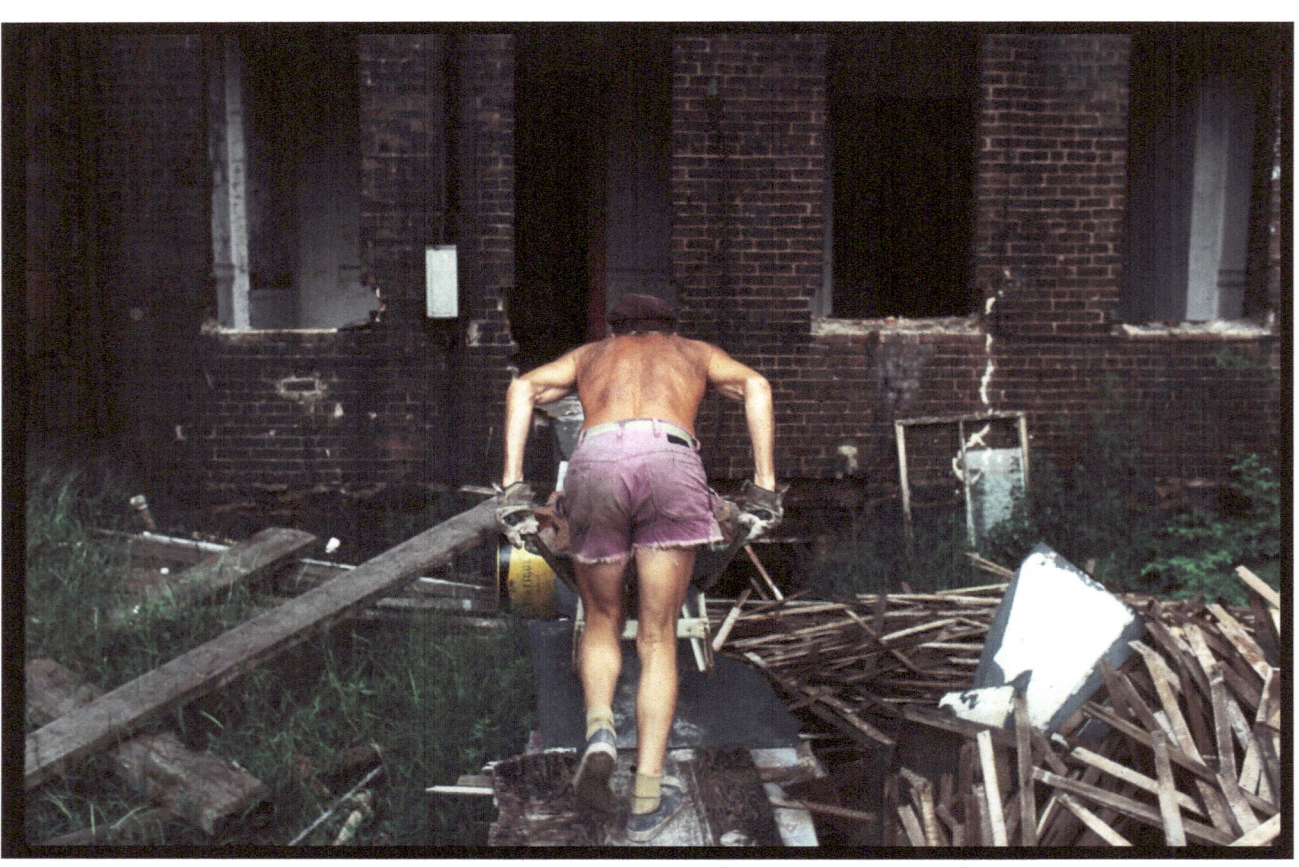

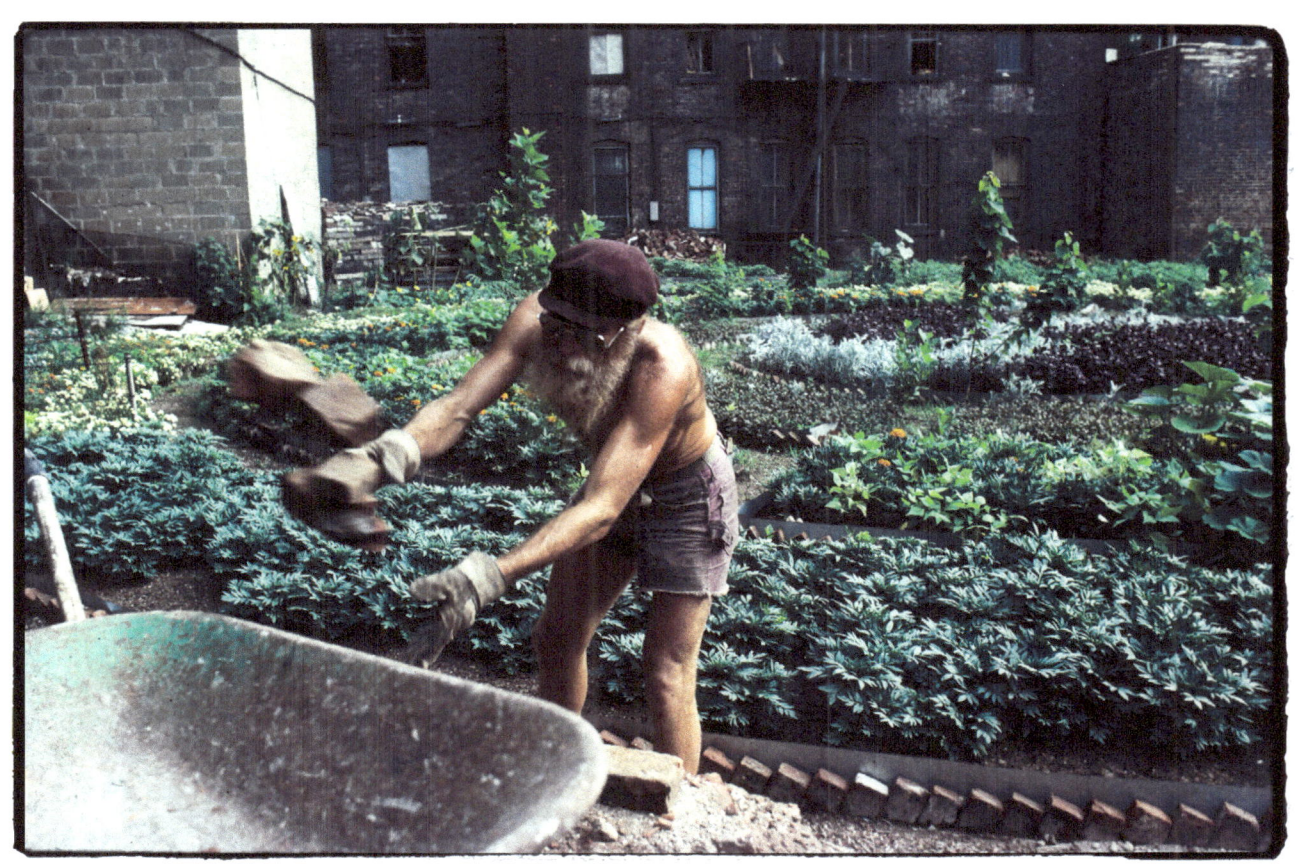

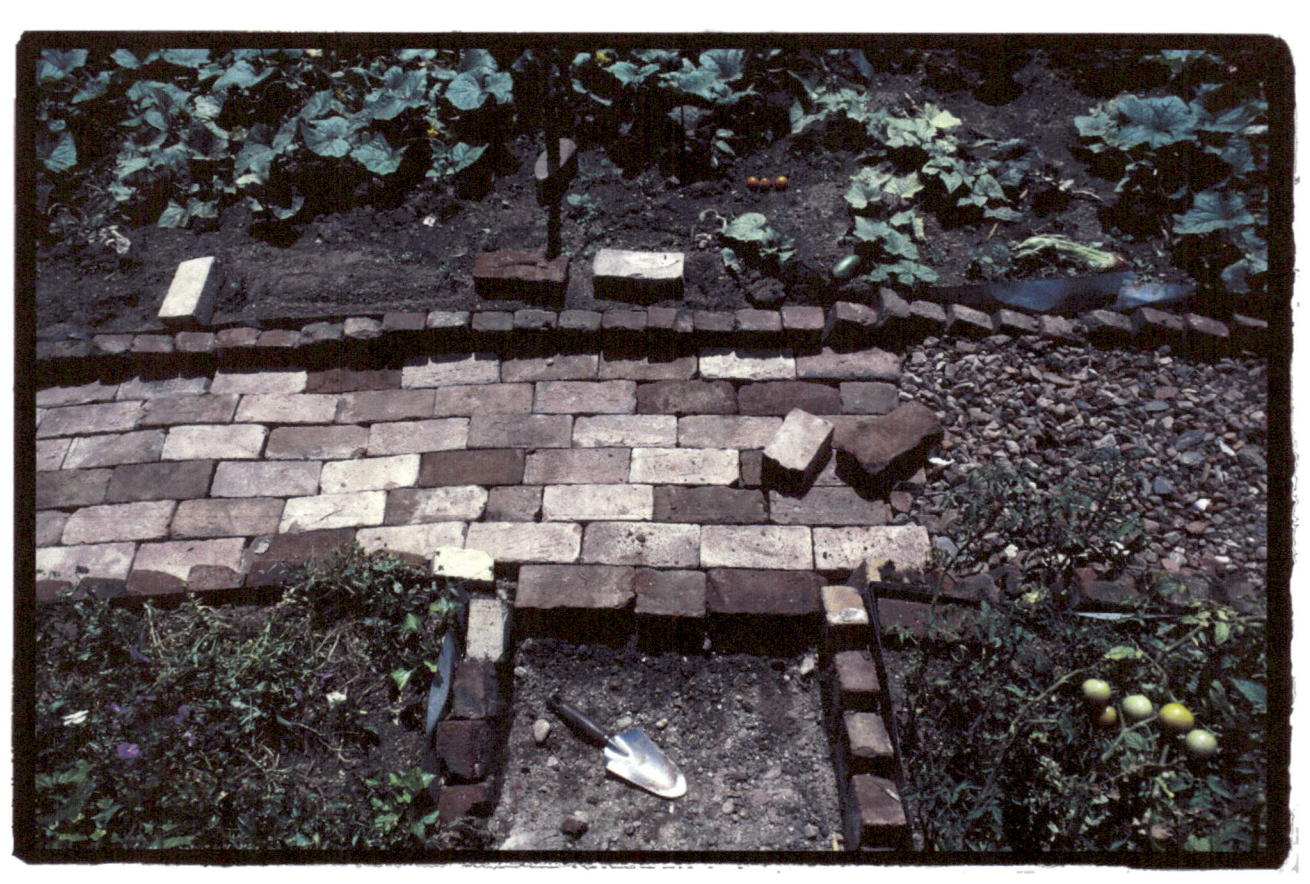

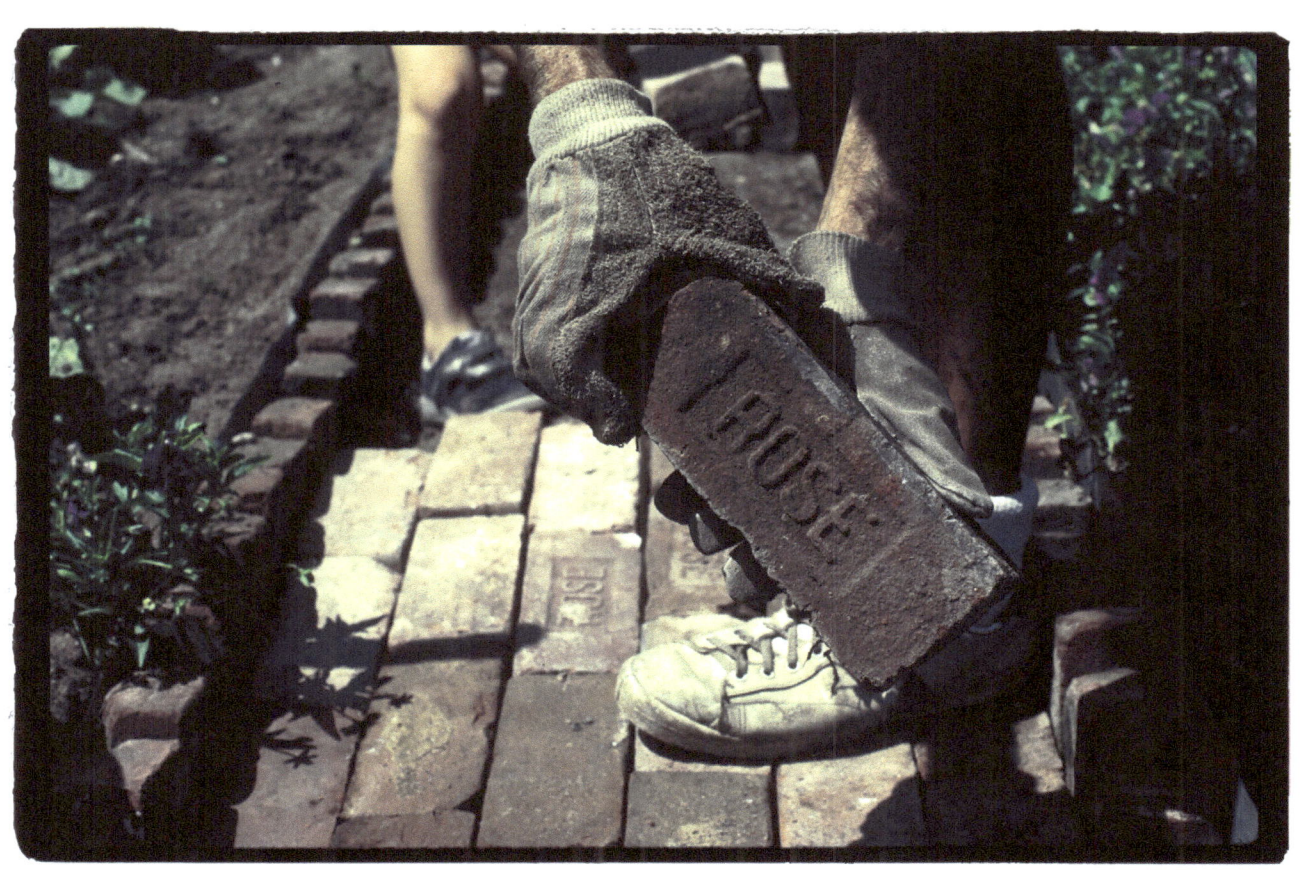

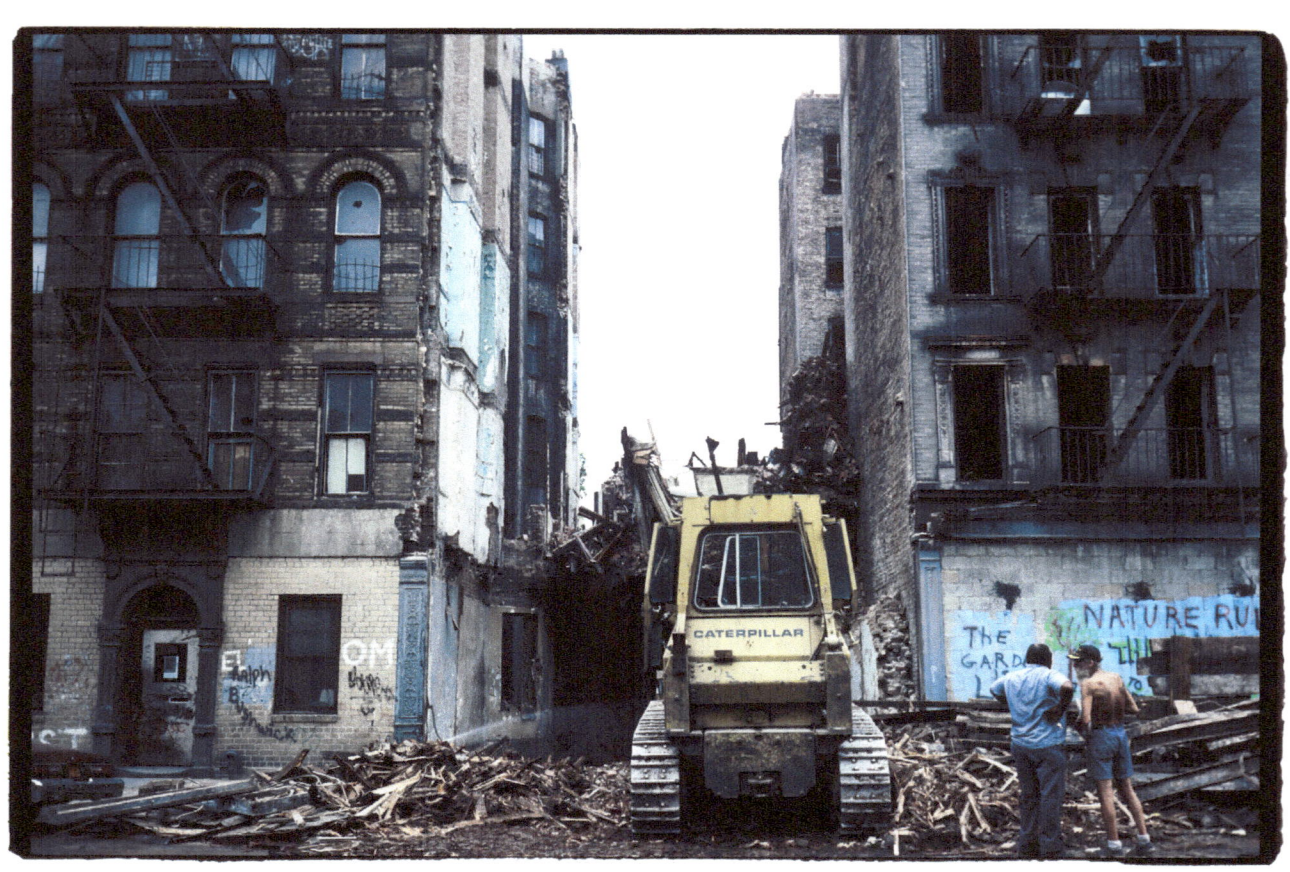

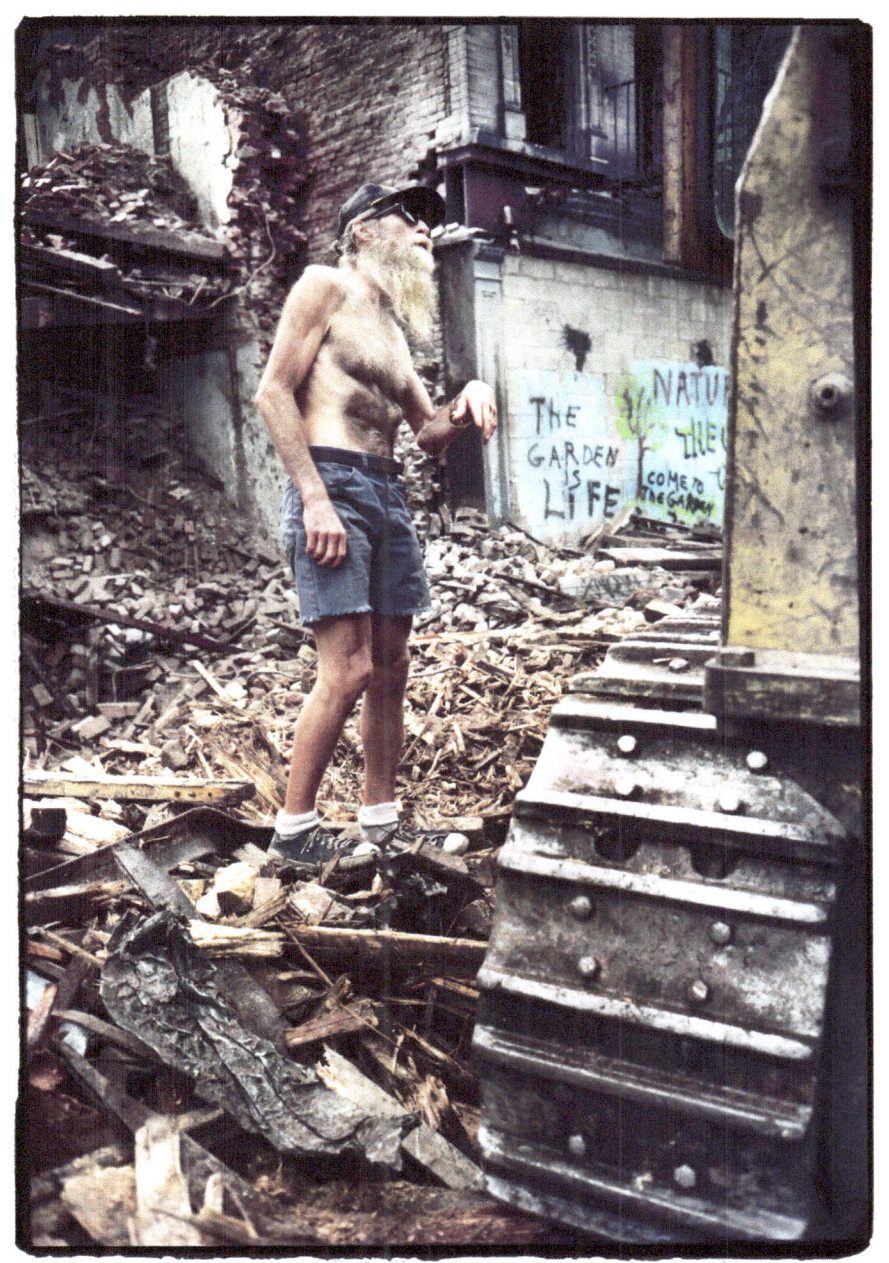

IN *THE GARDEN* OF EDEN

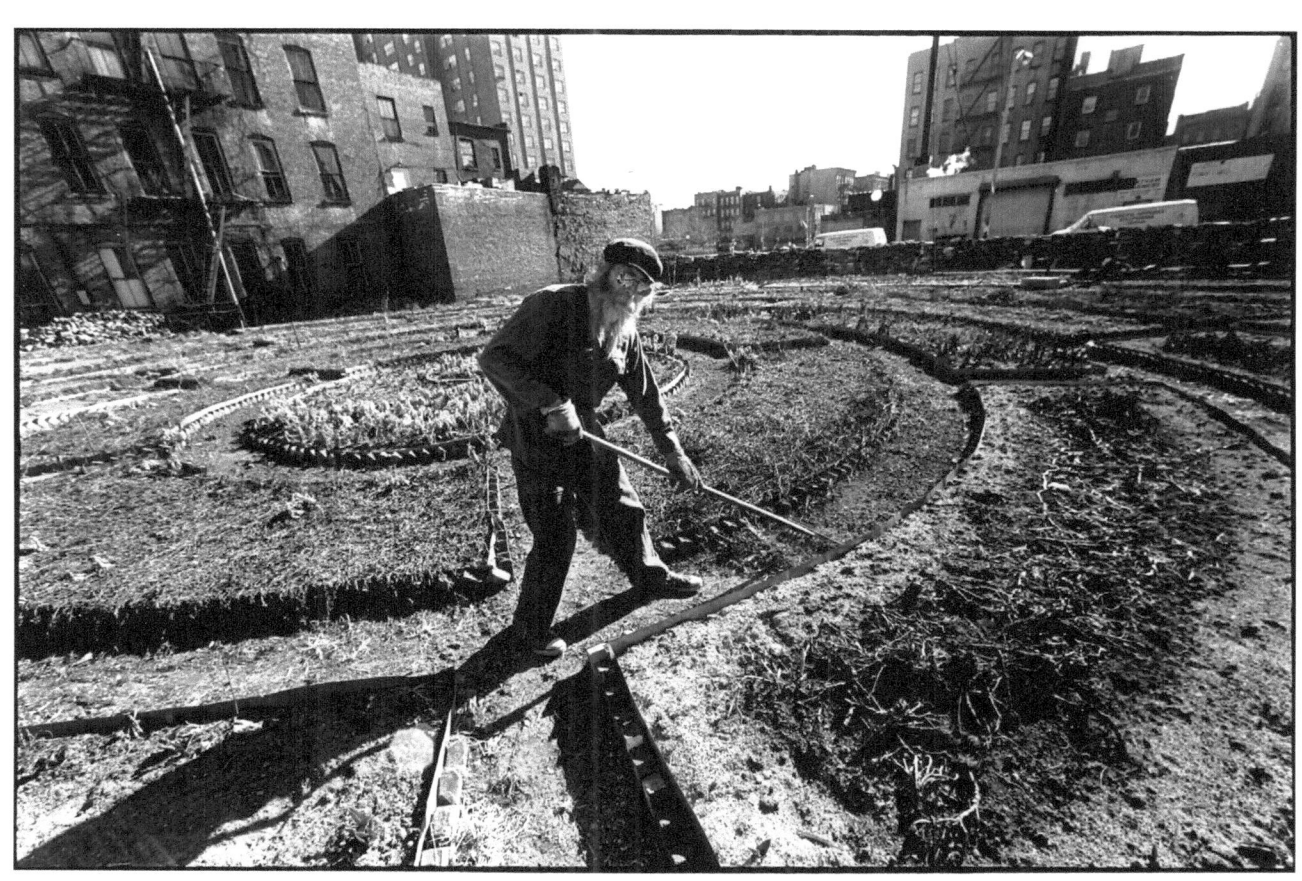

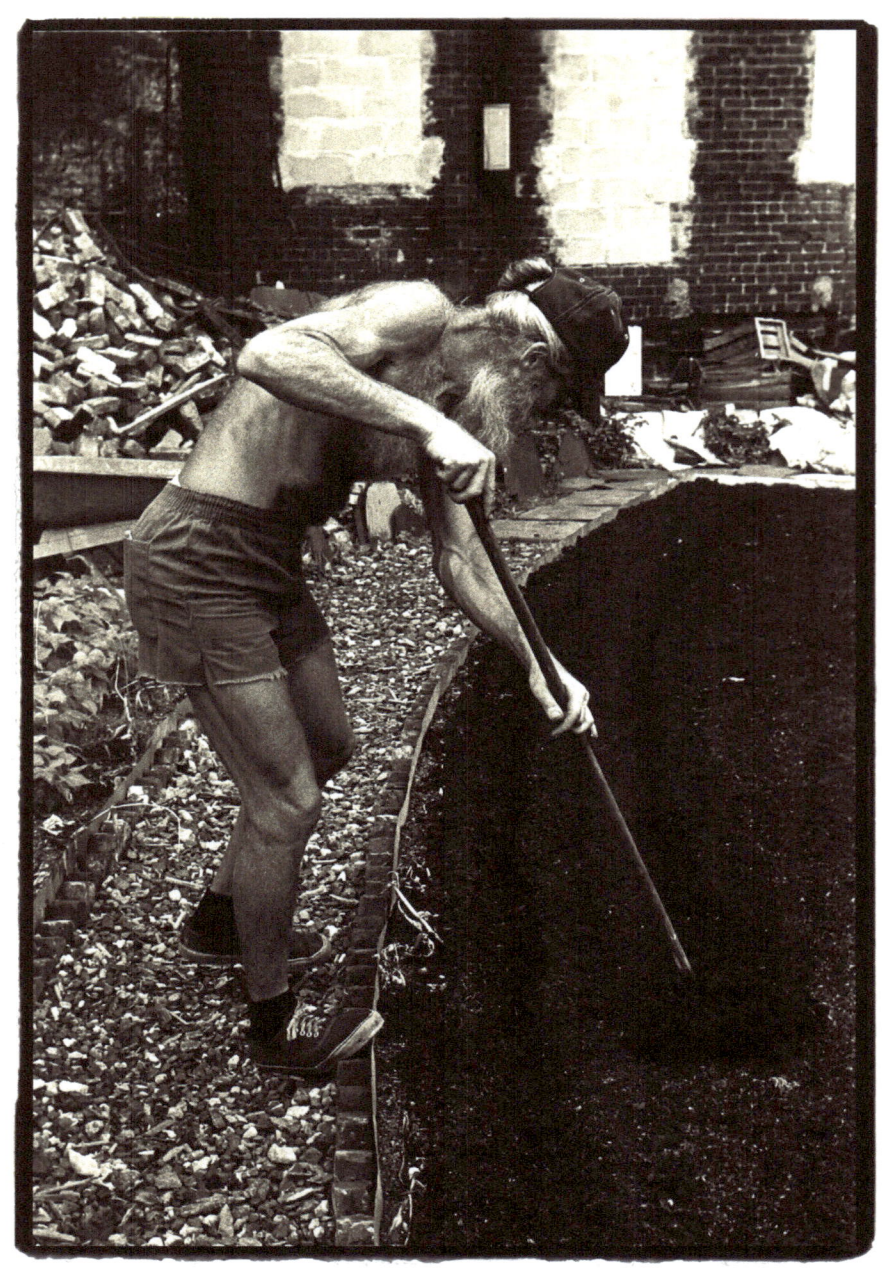

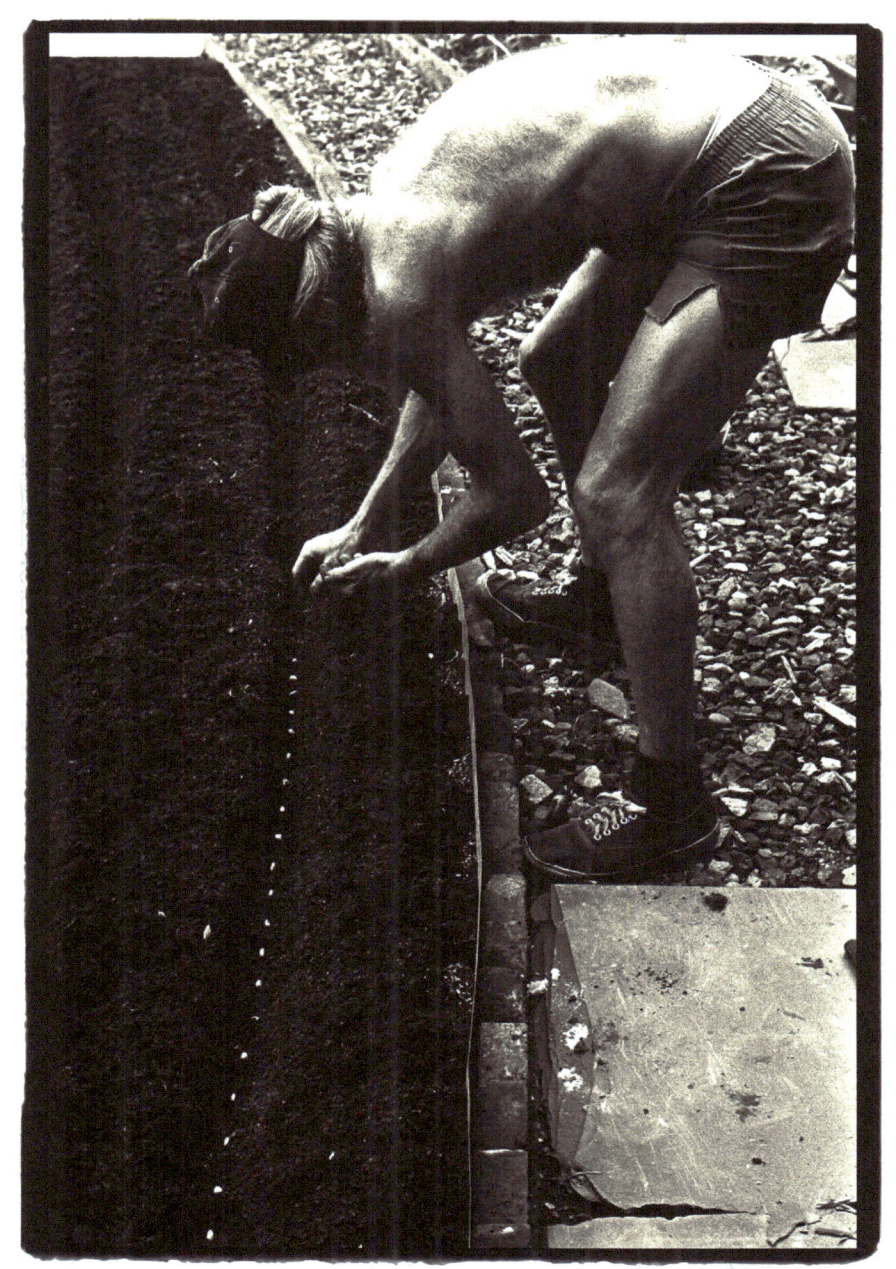

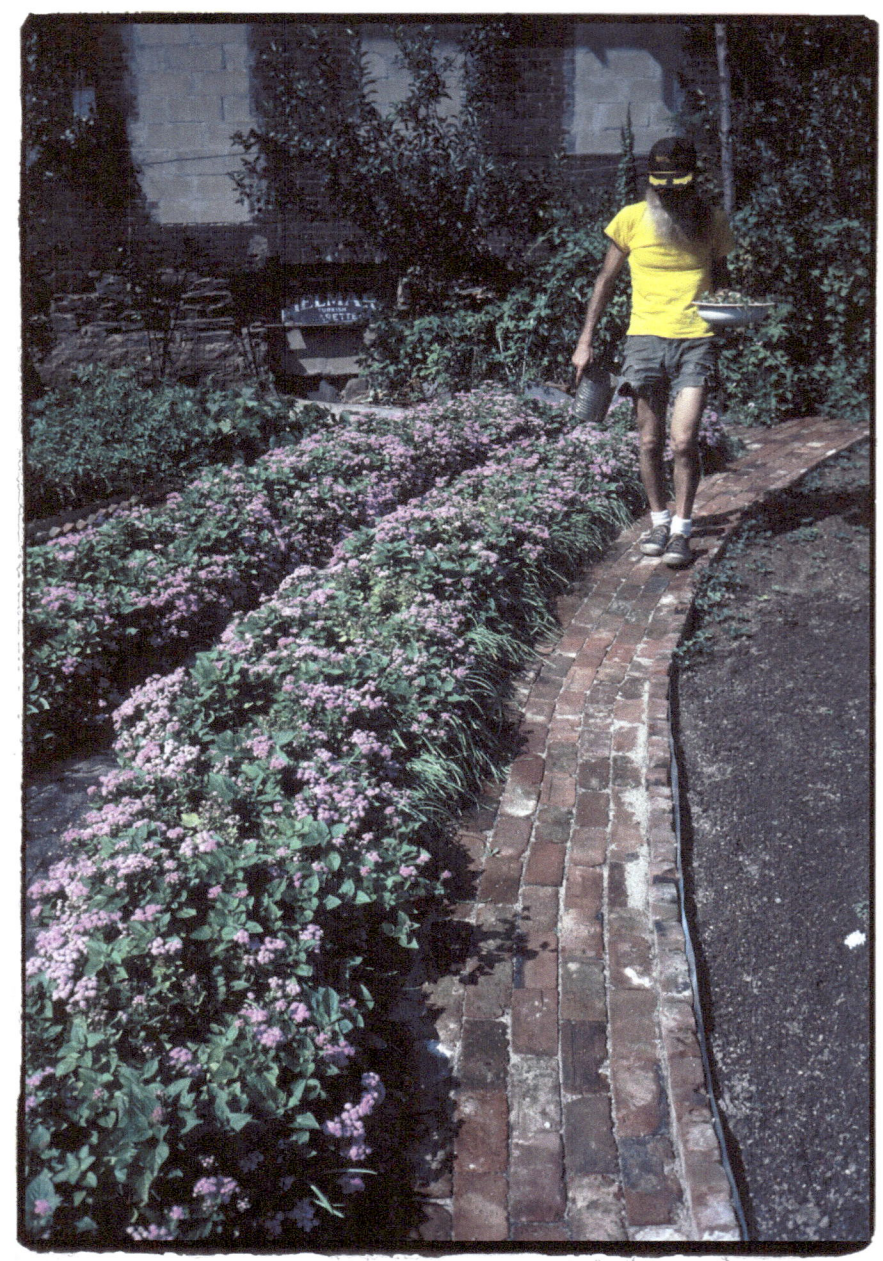

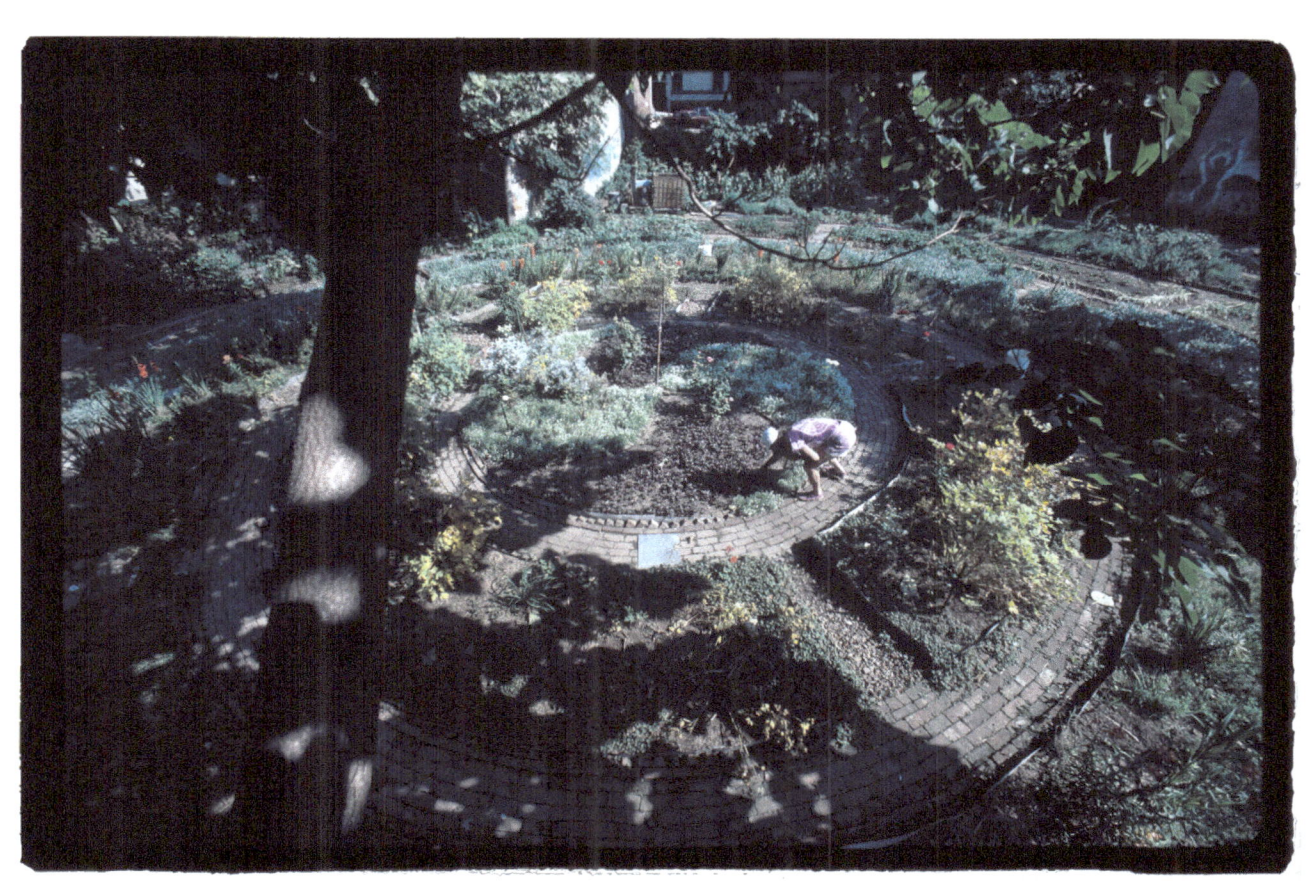

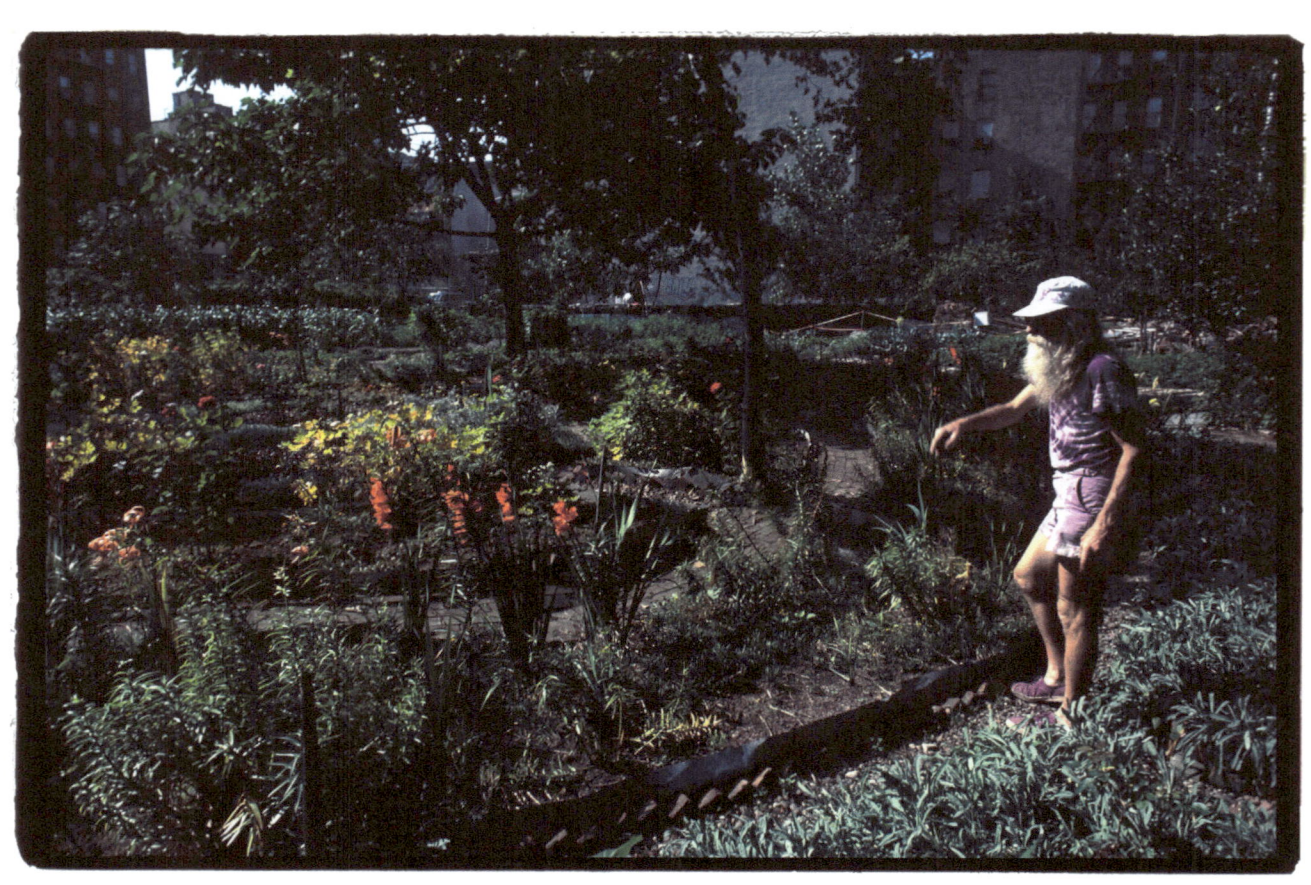

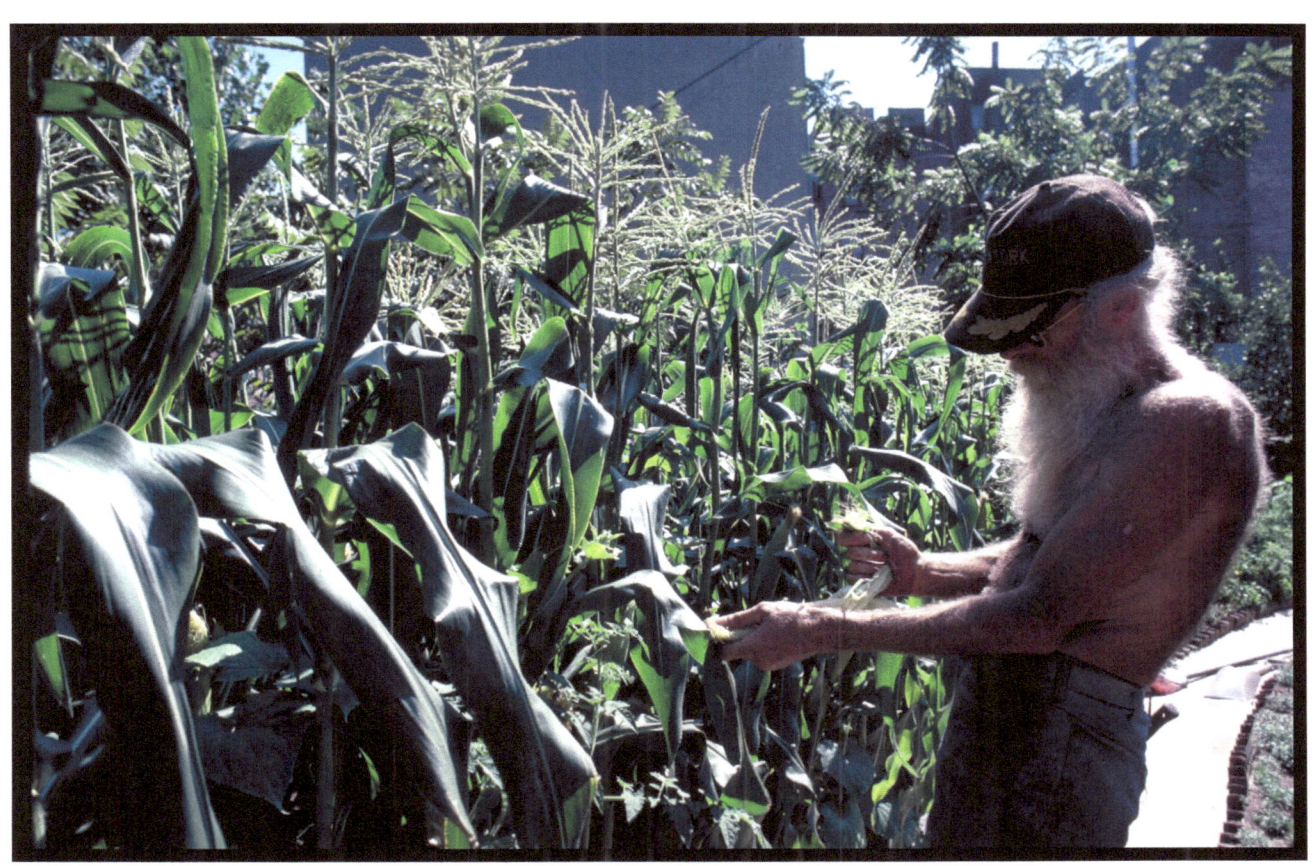

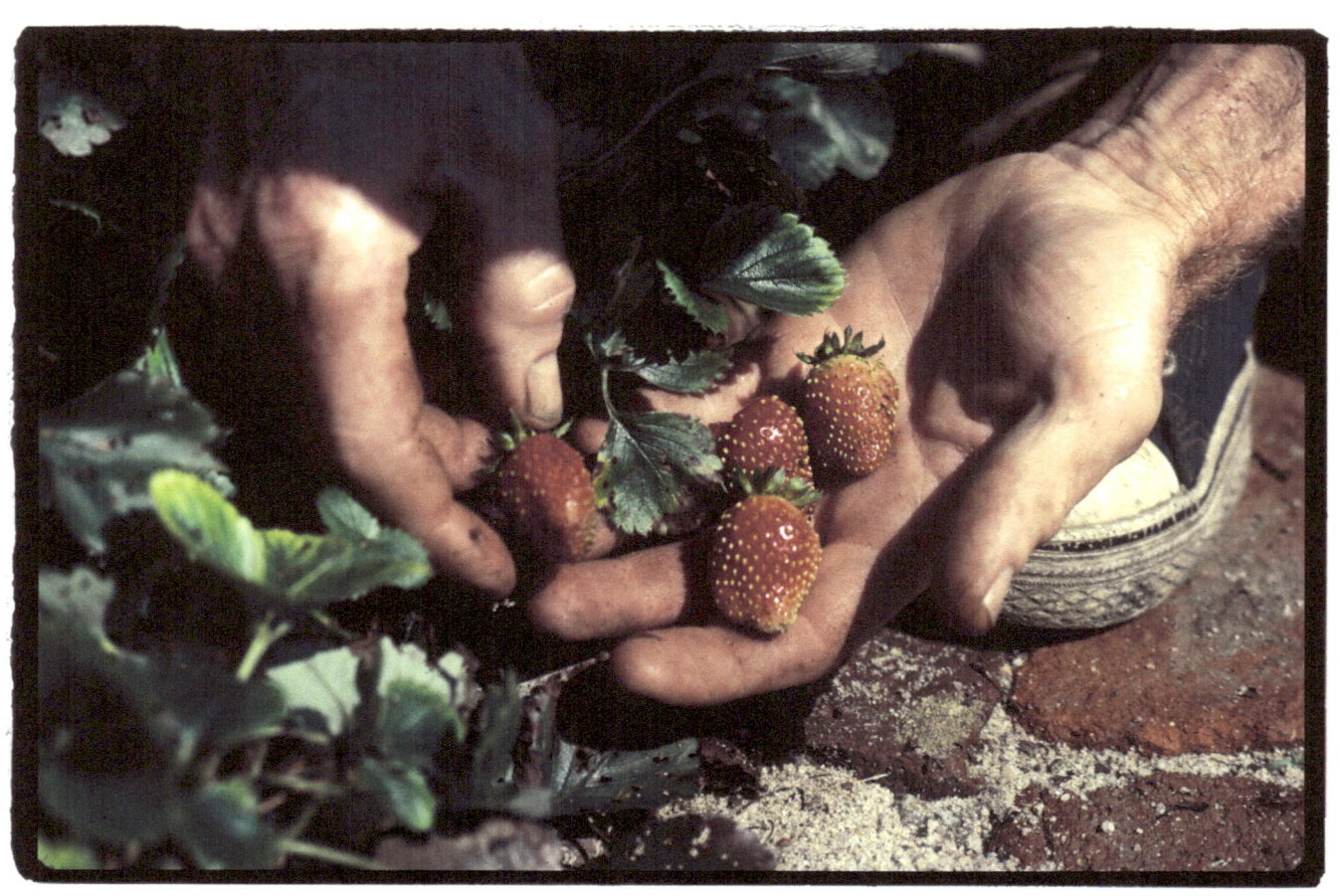

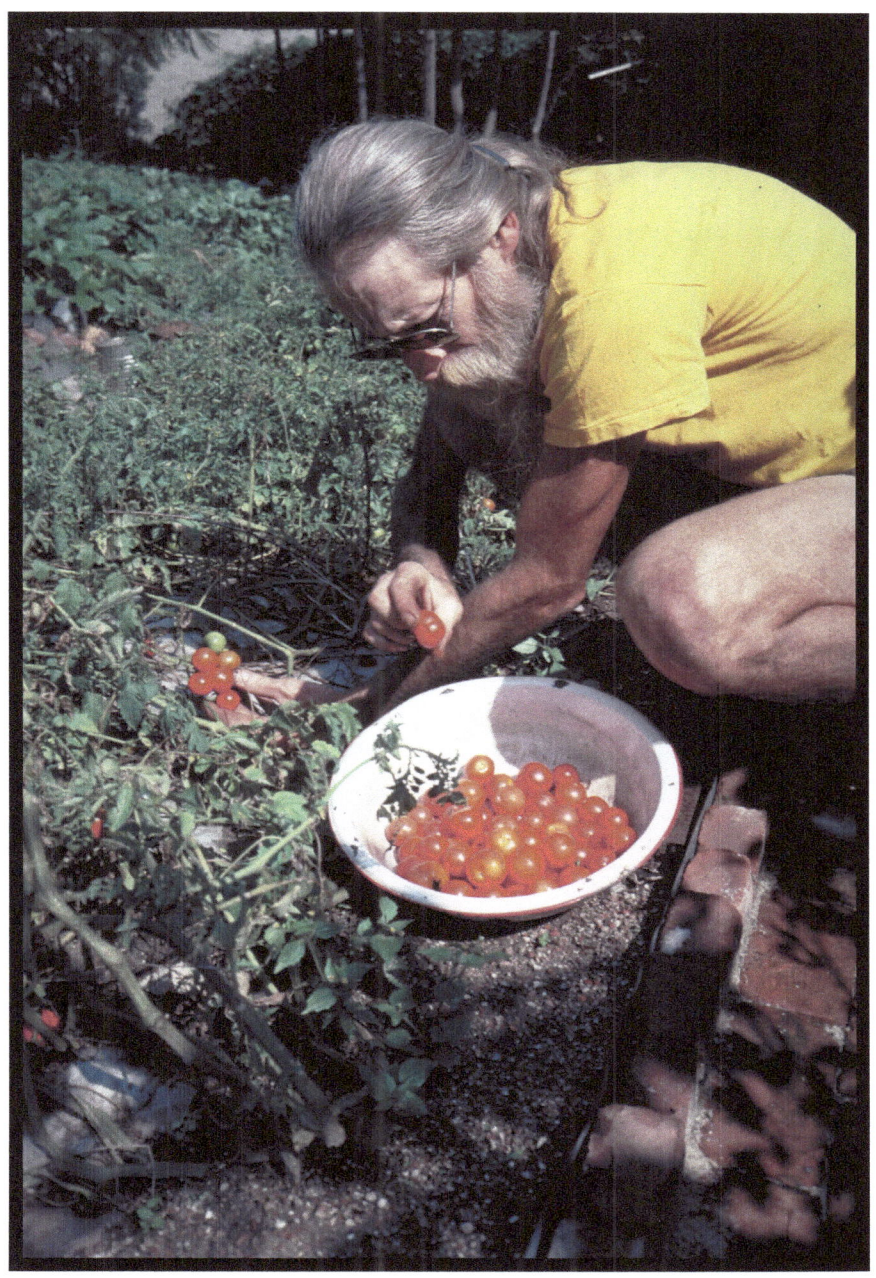

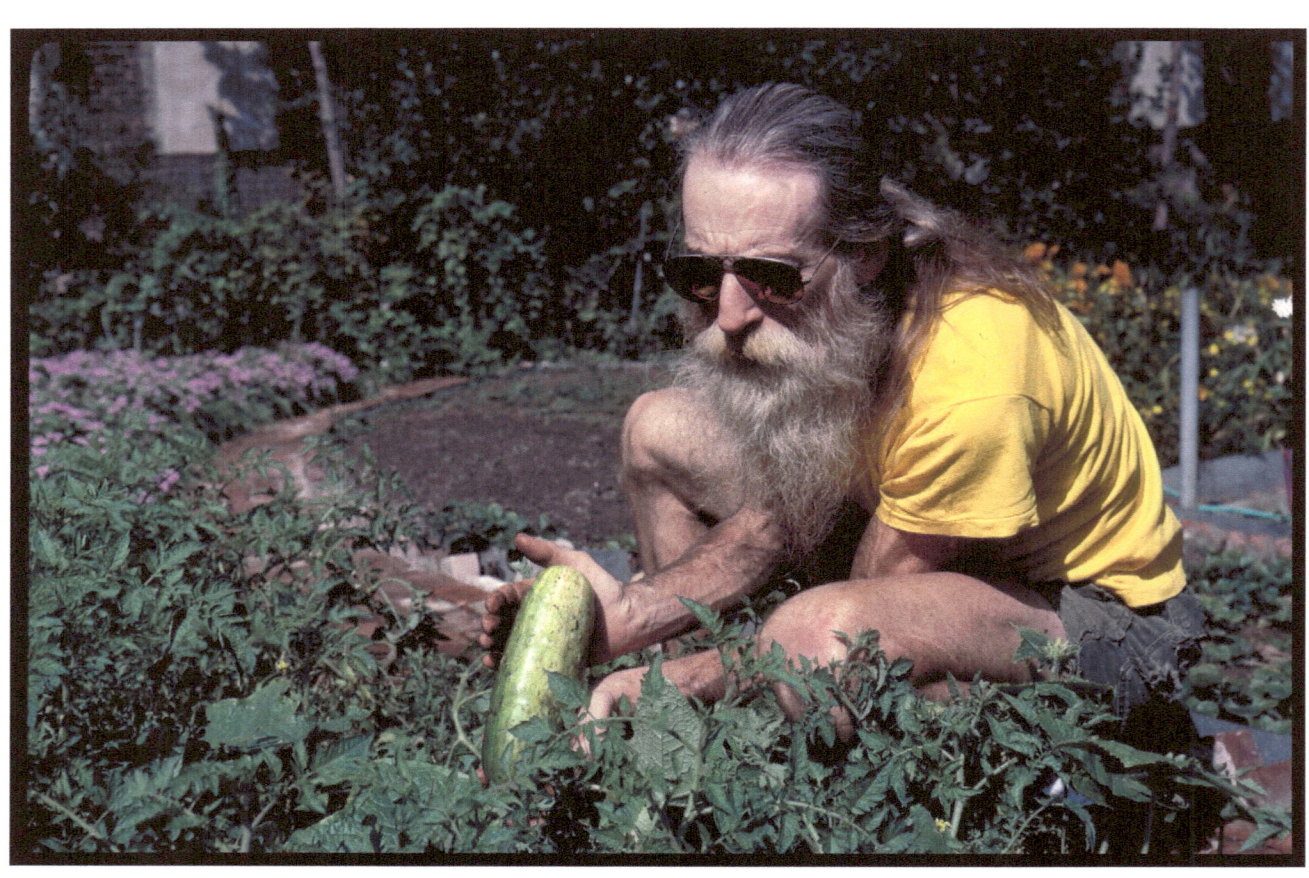

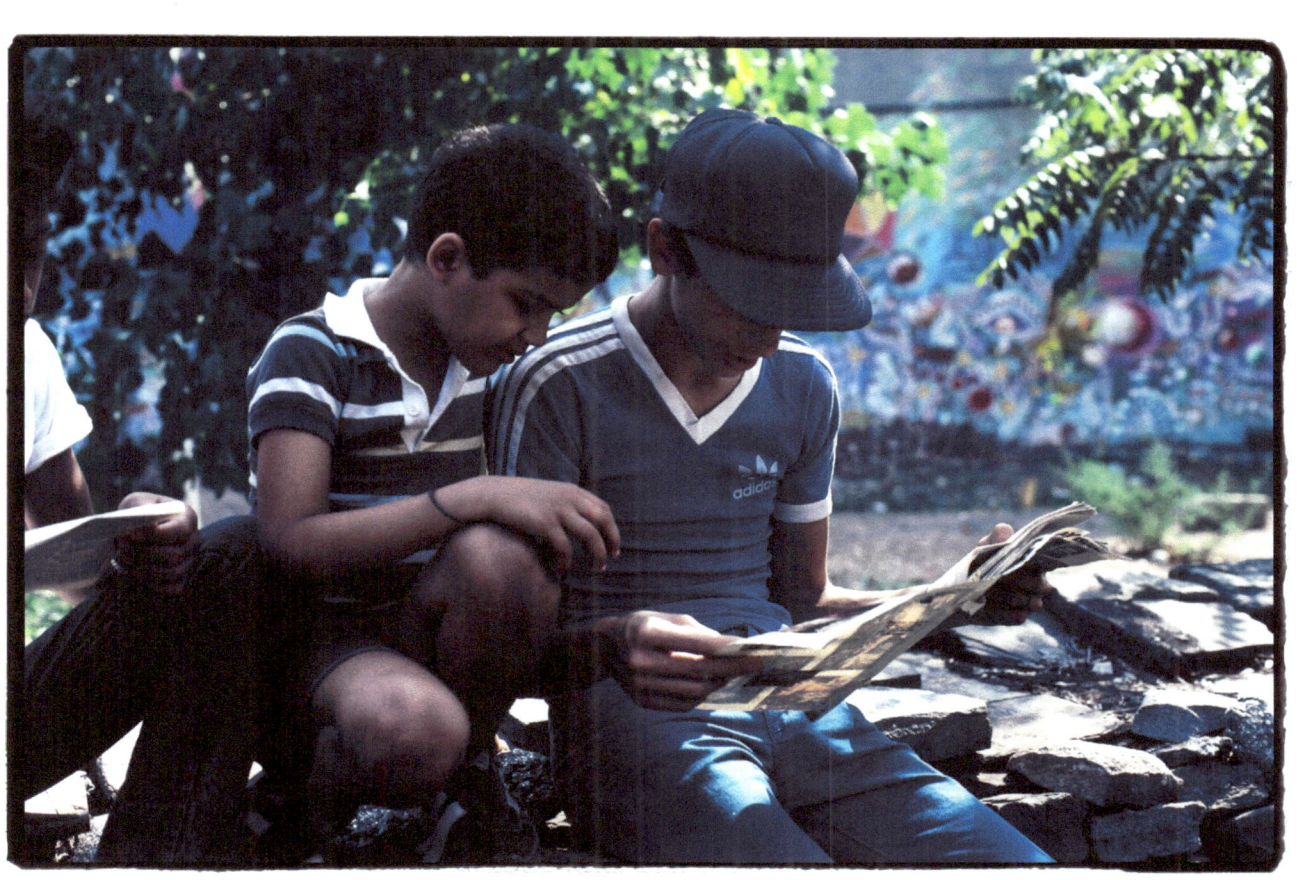

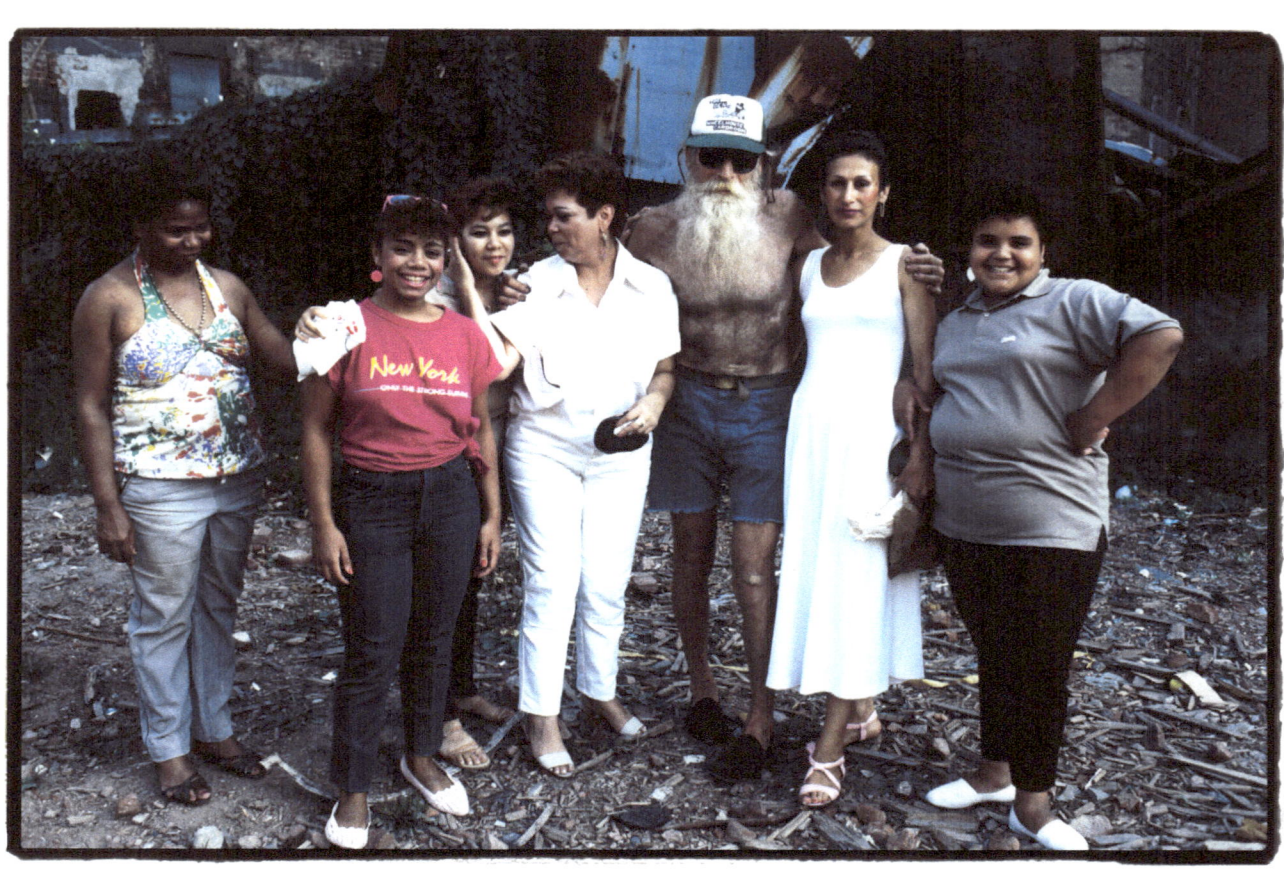

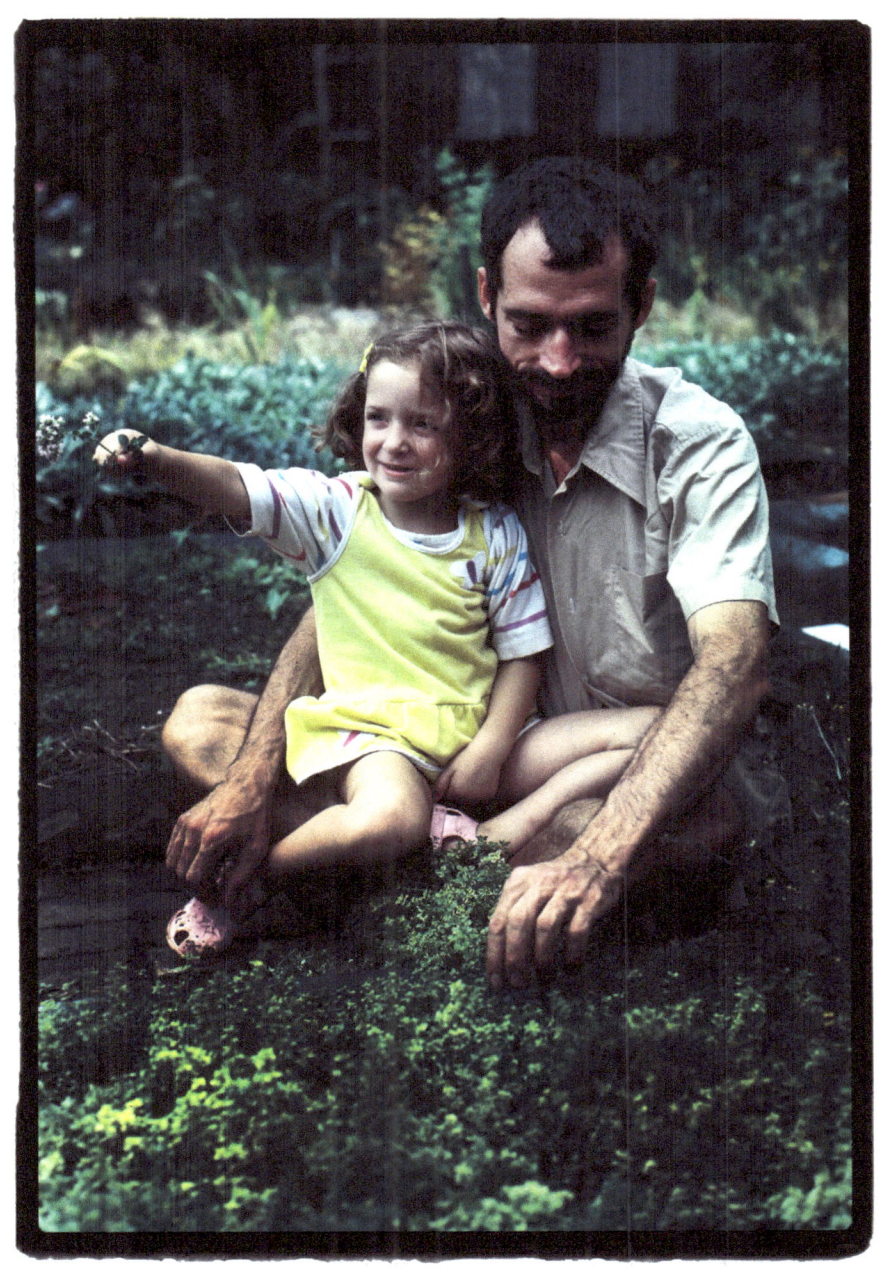

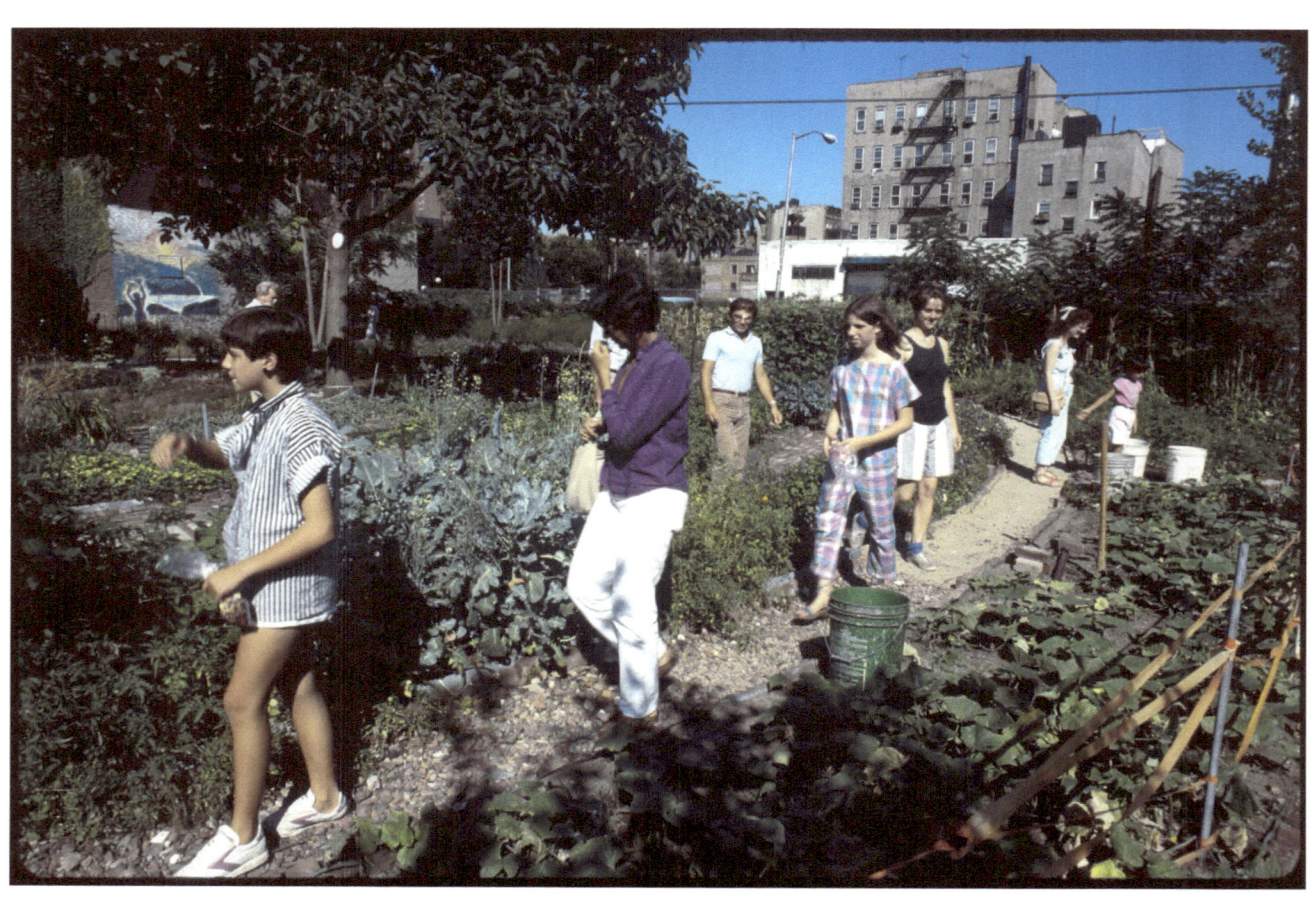

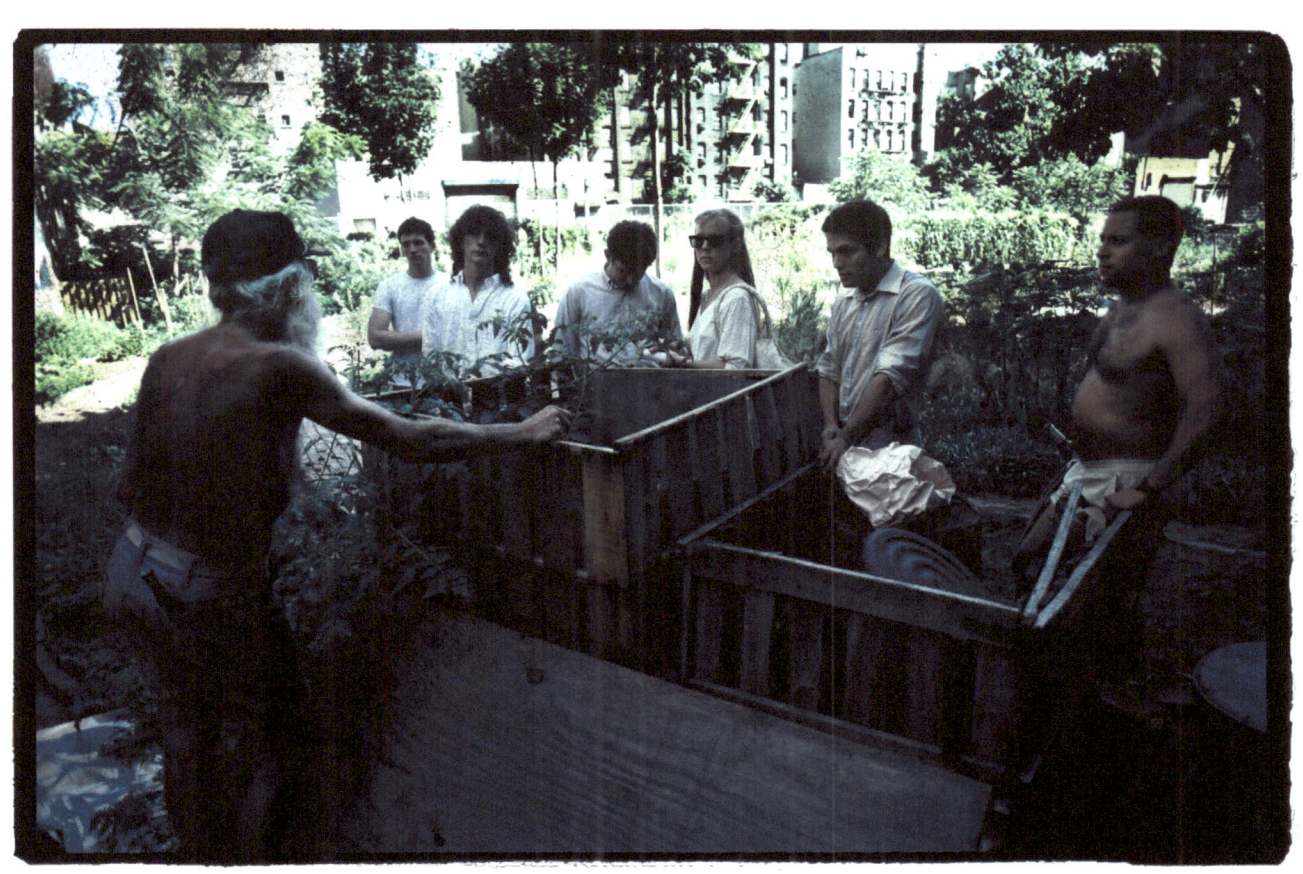

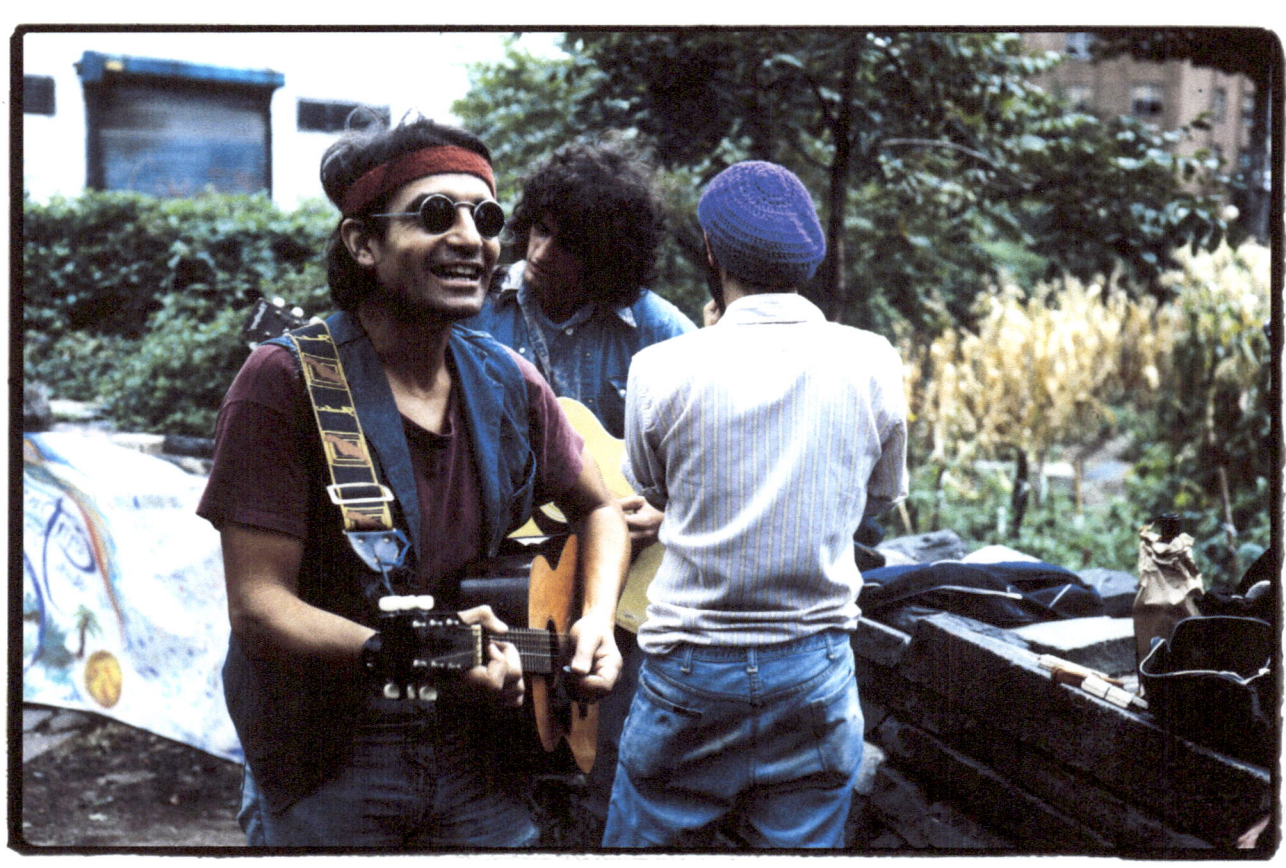

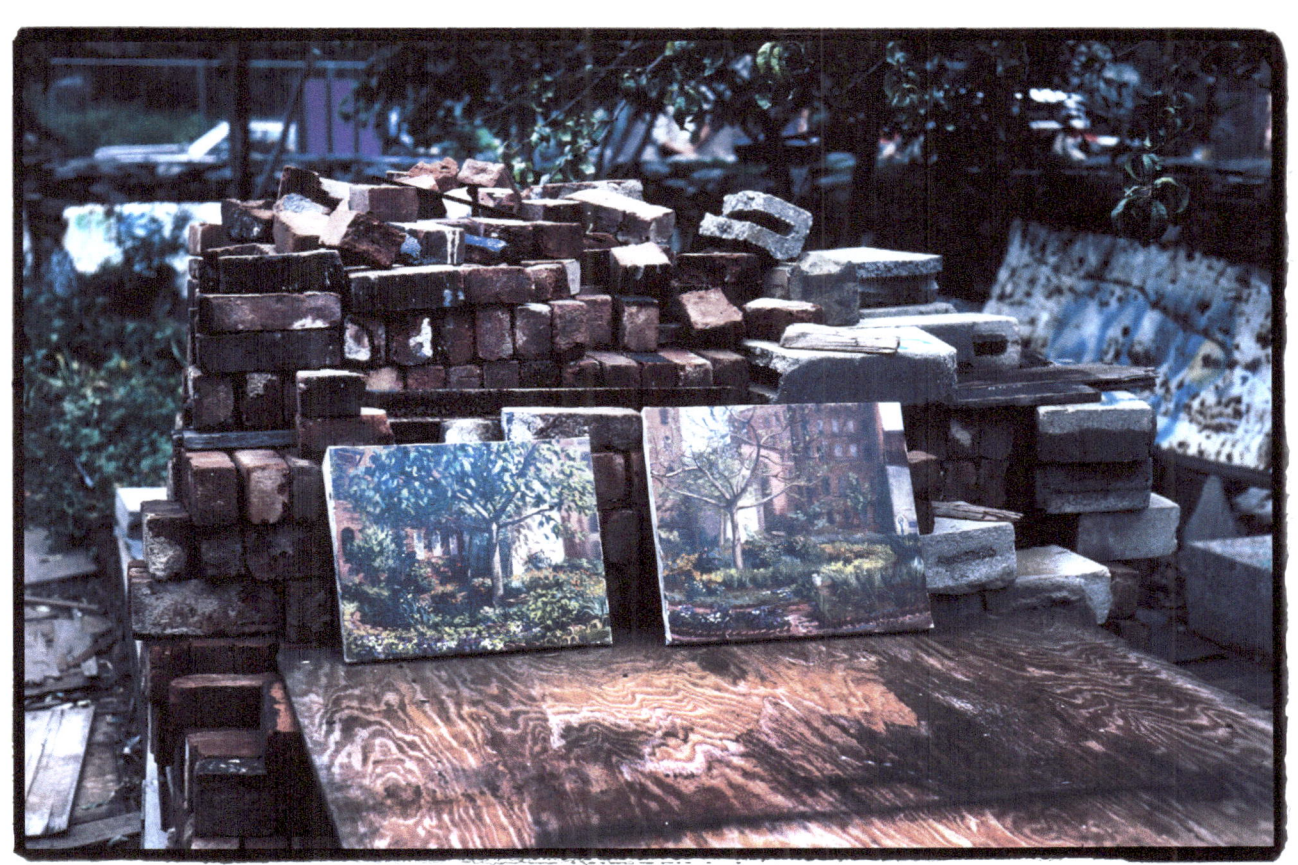

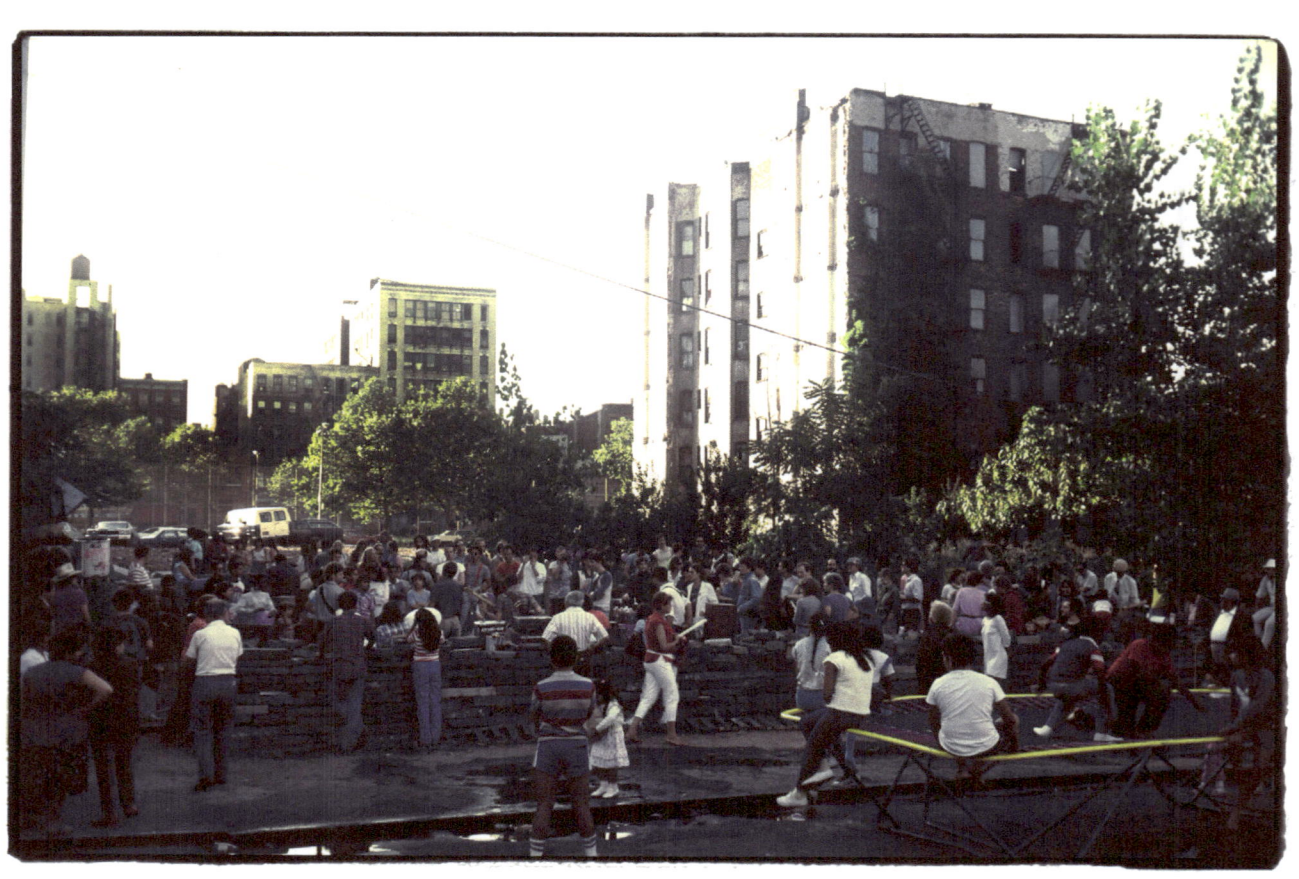

DESTRUCTION

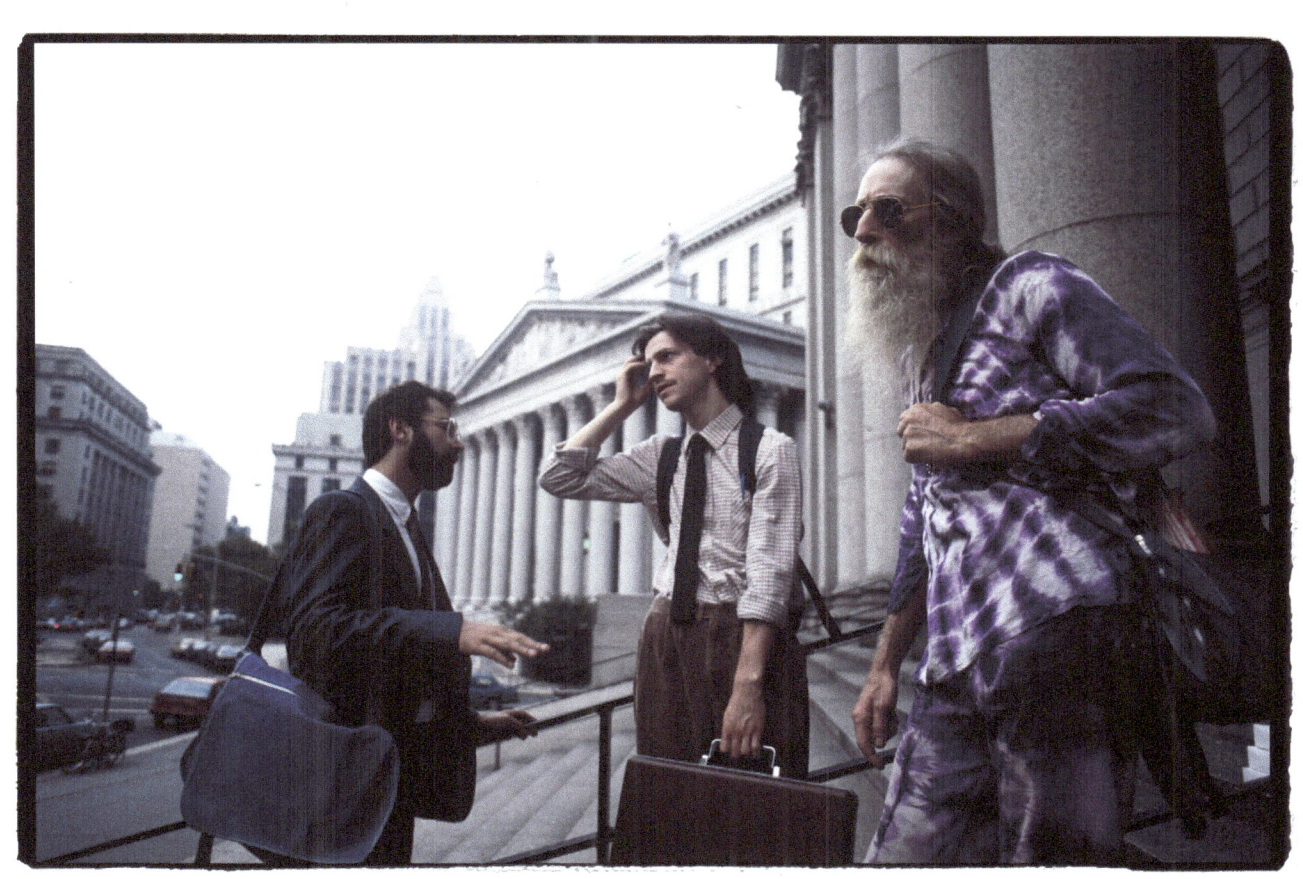

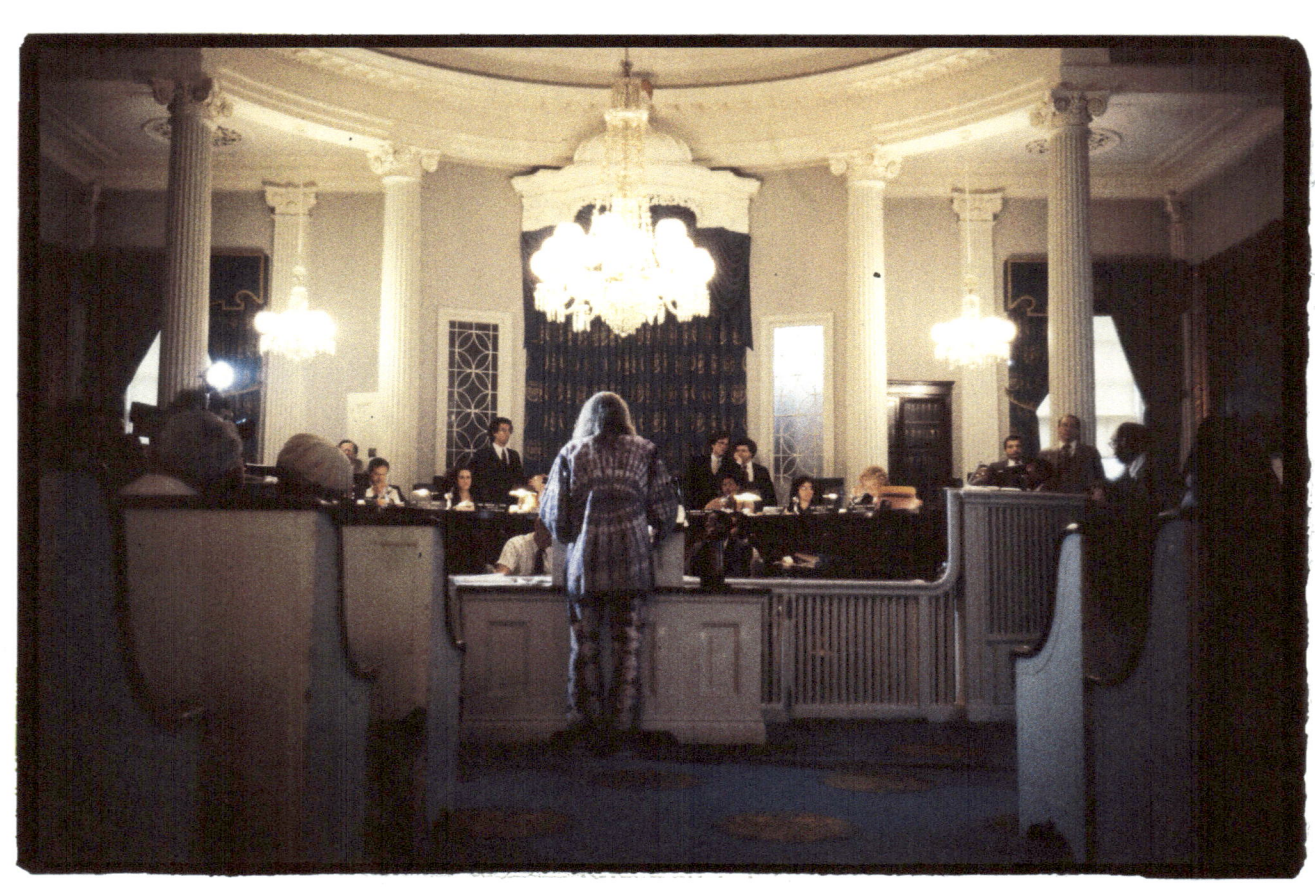

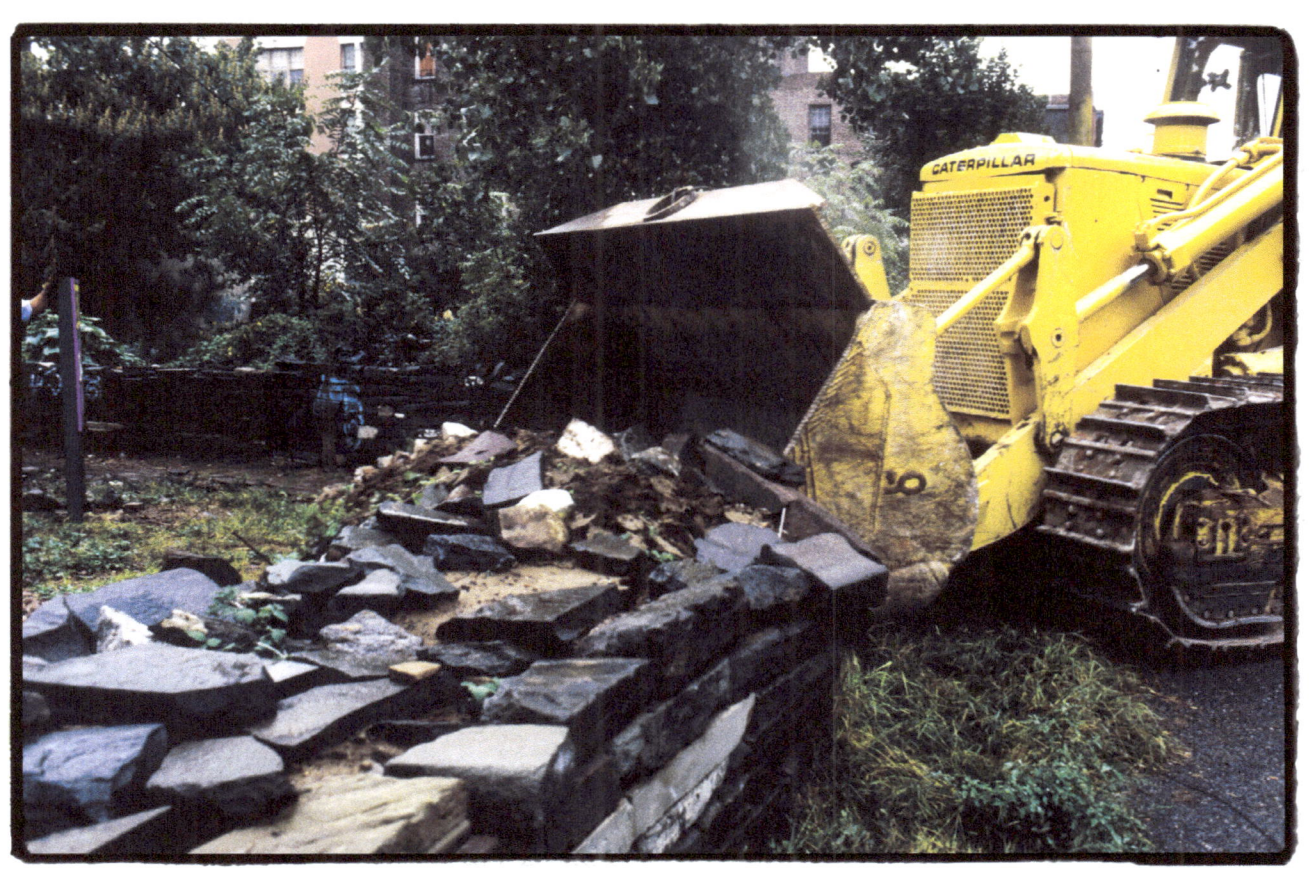

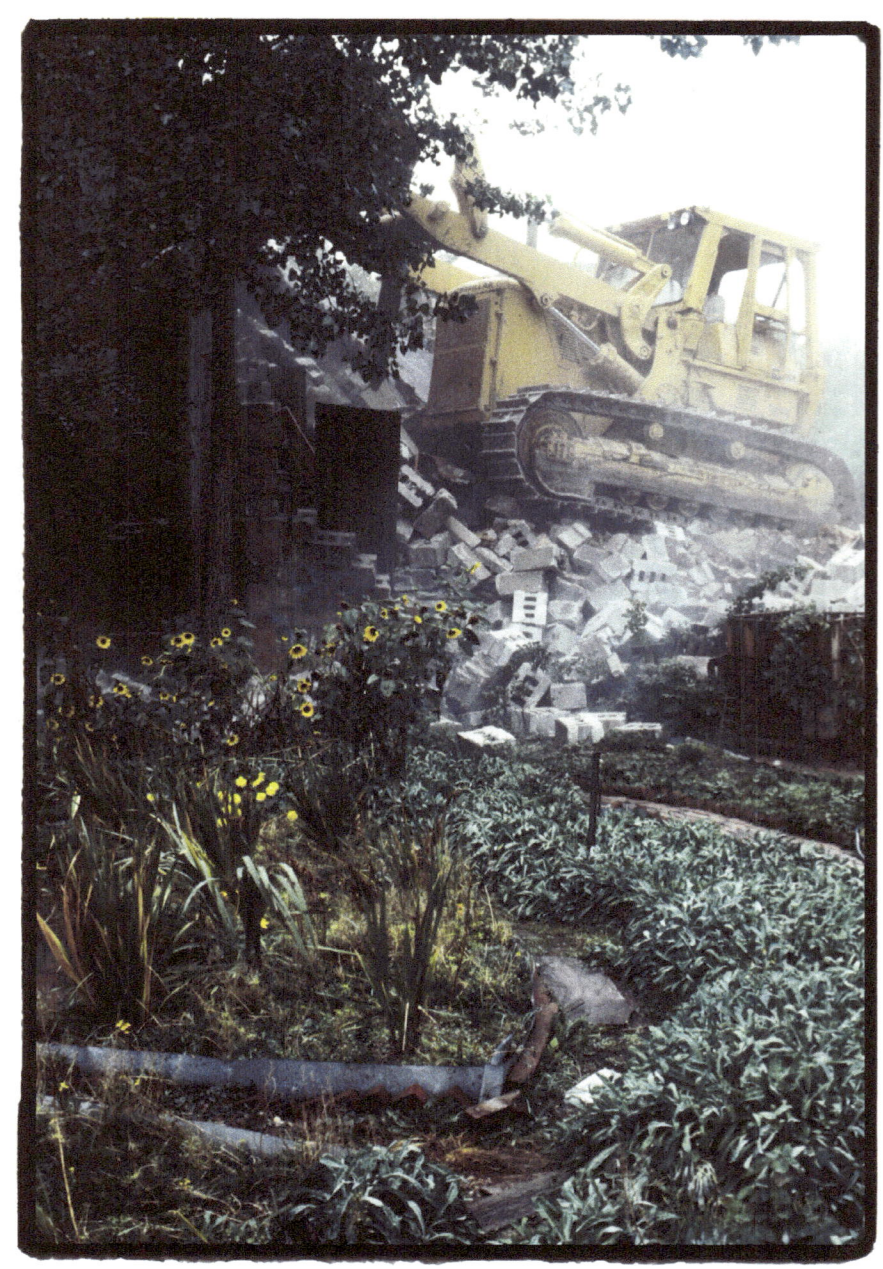

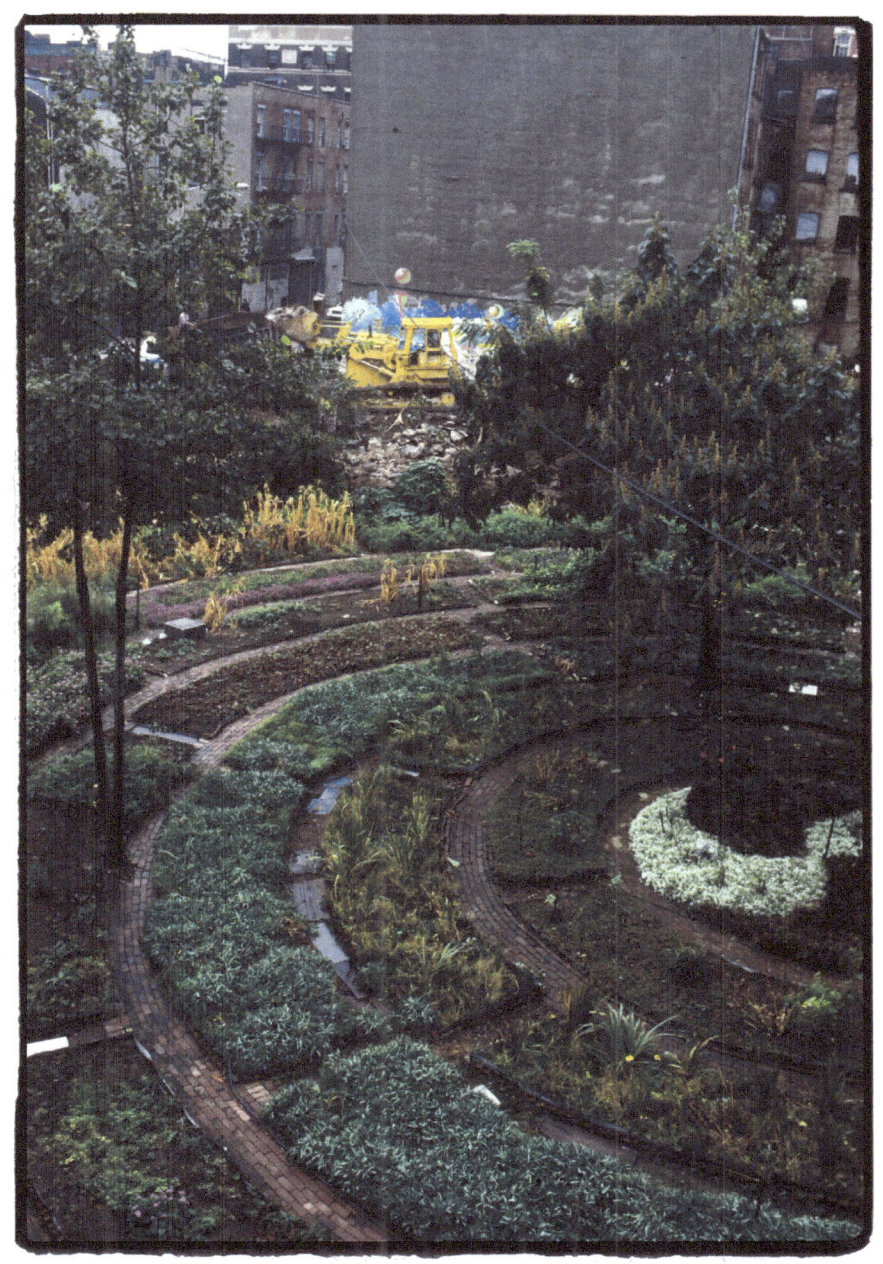

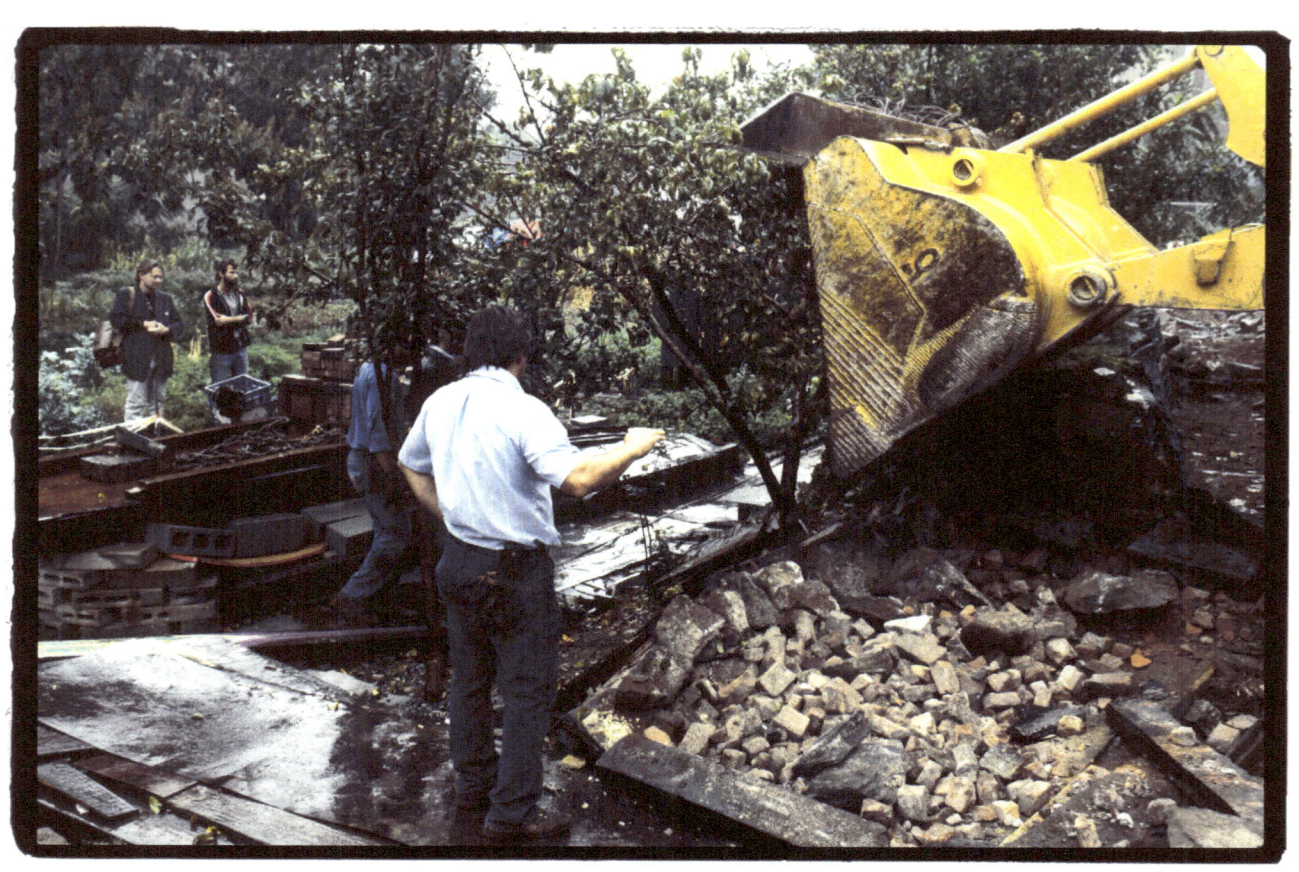

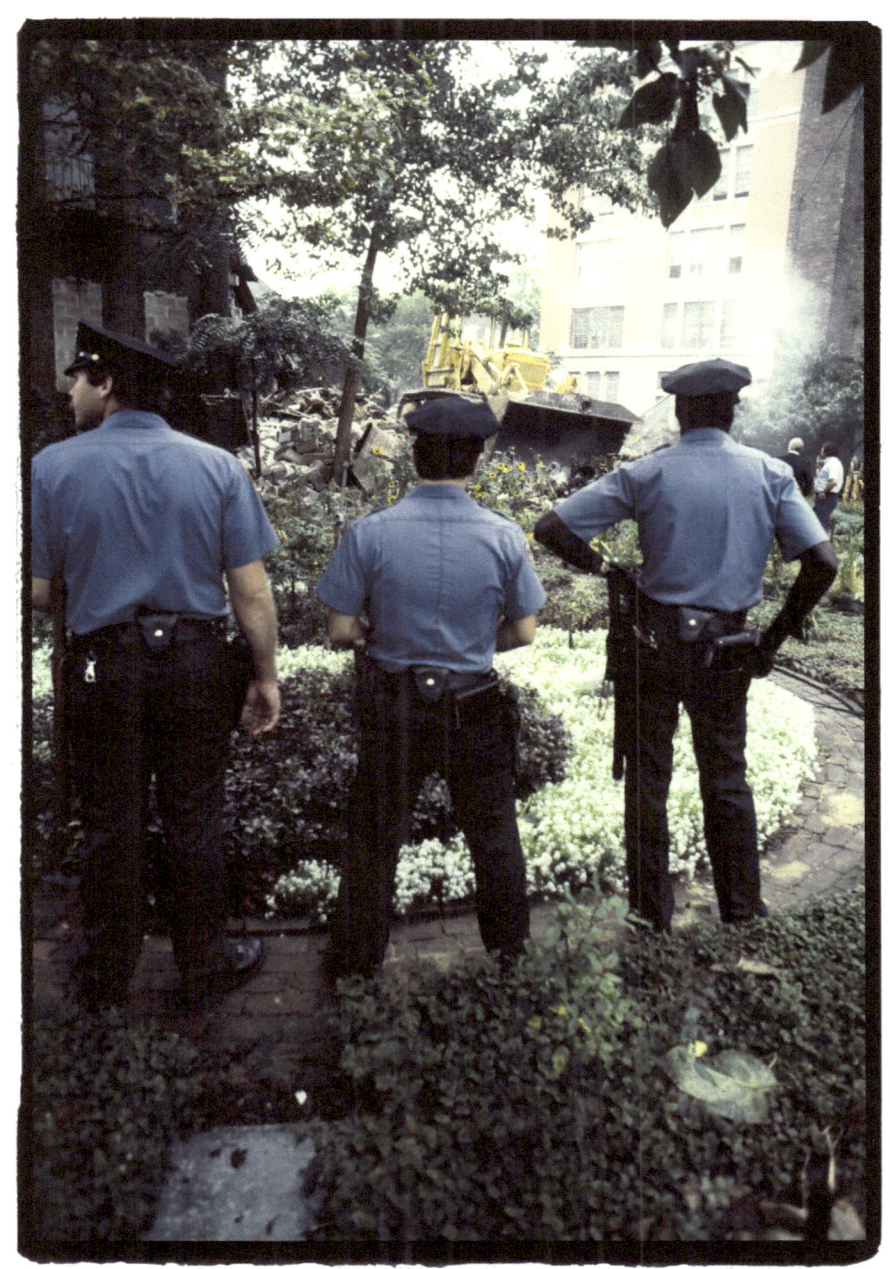

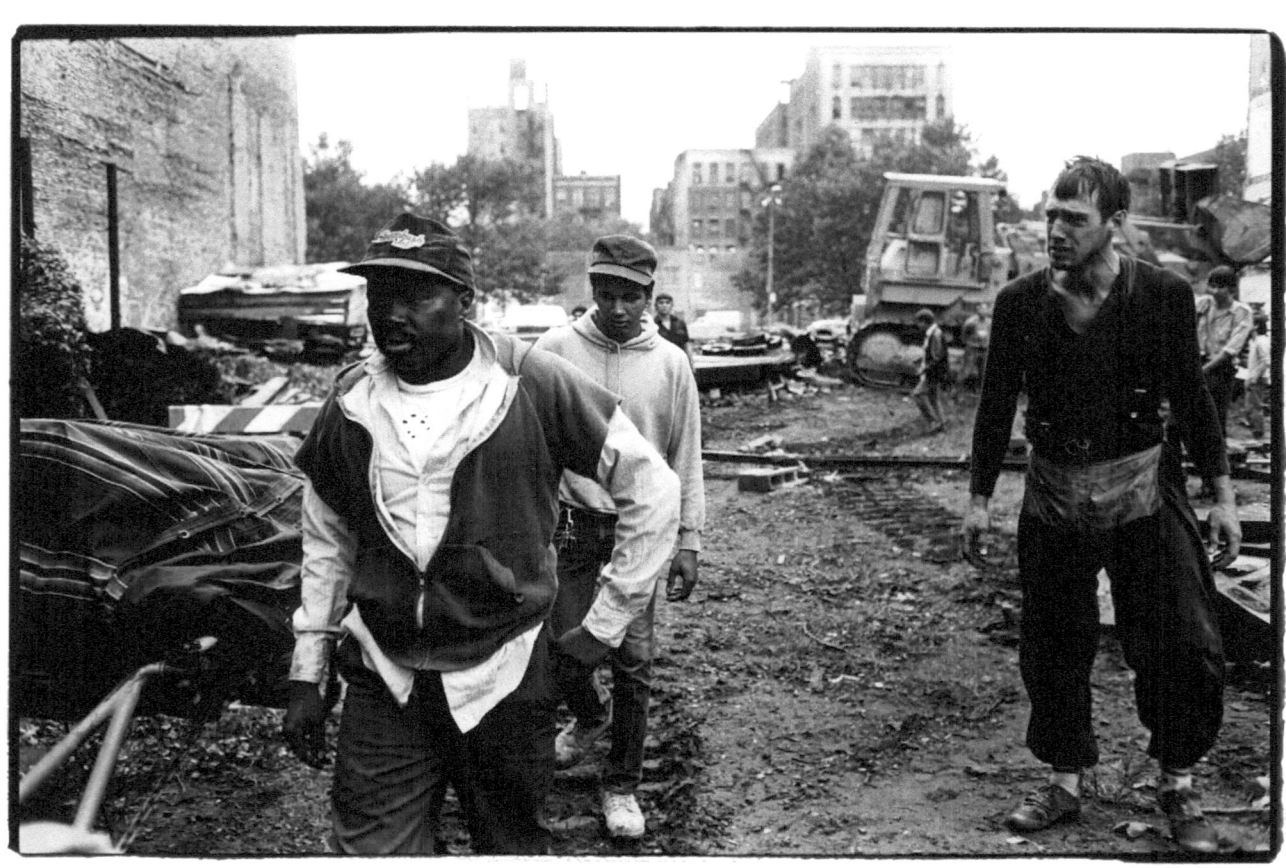

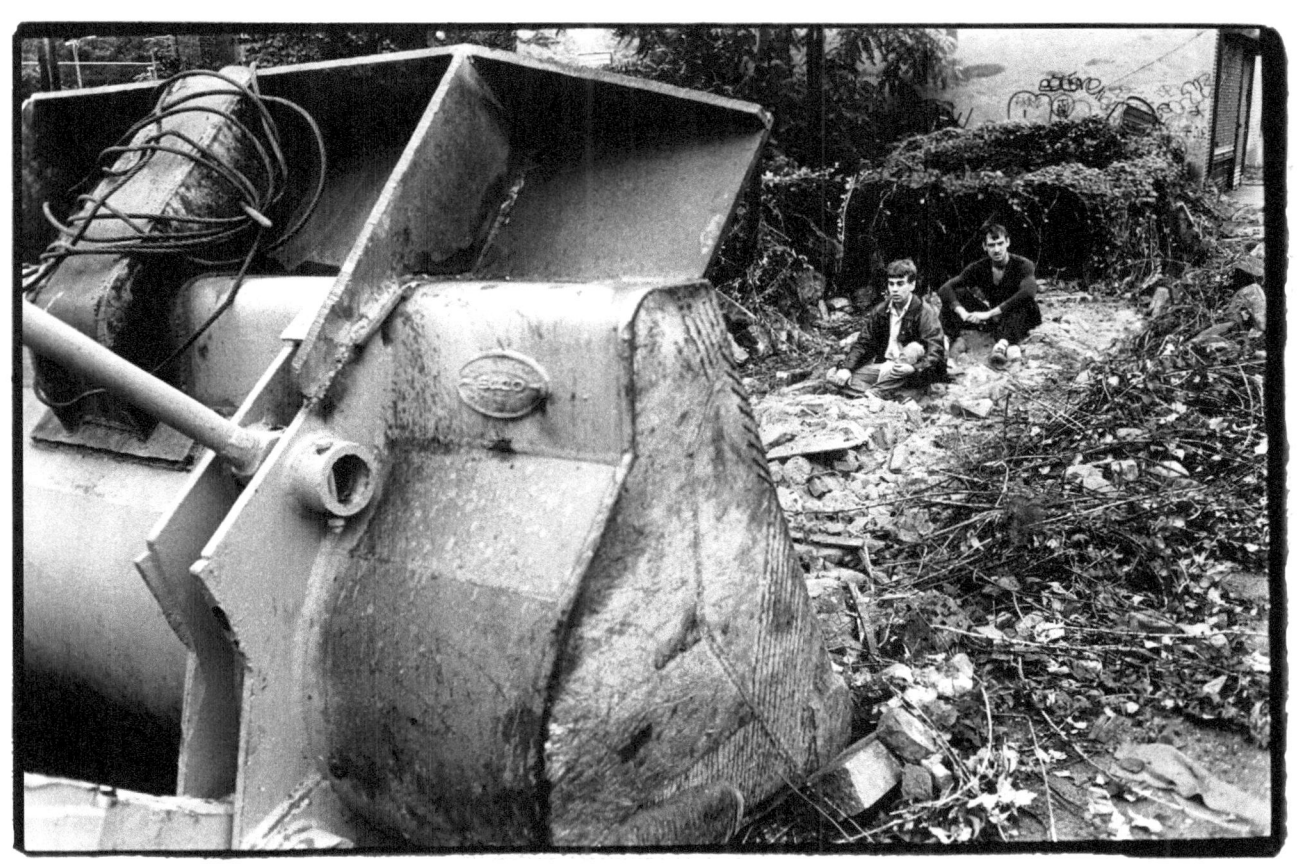

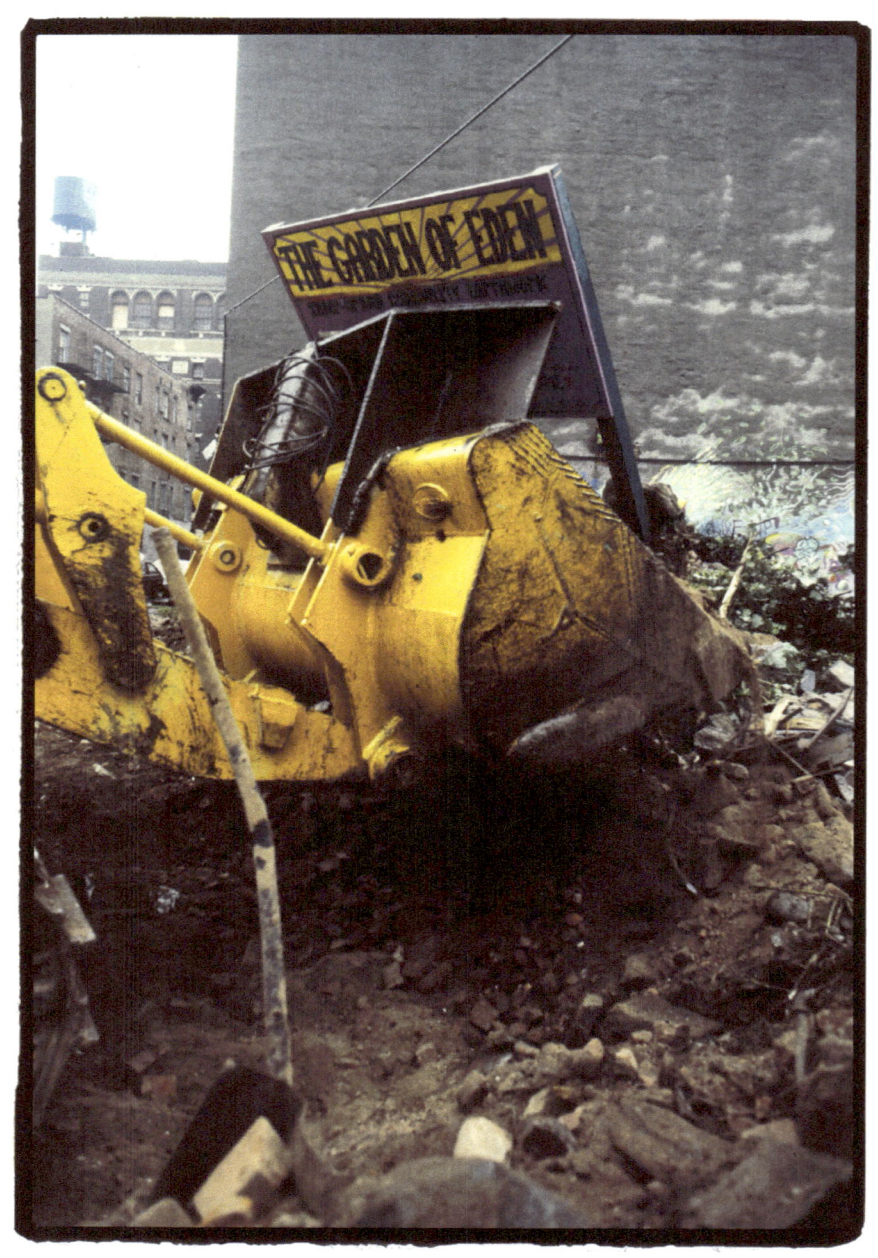

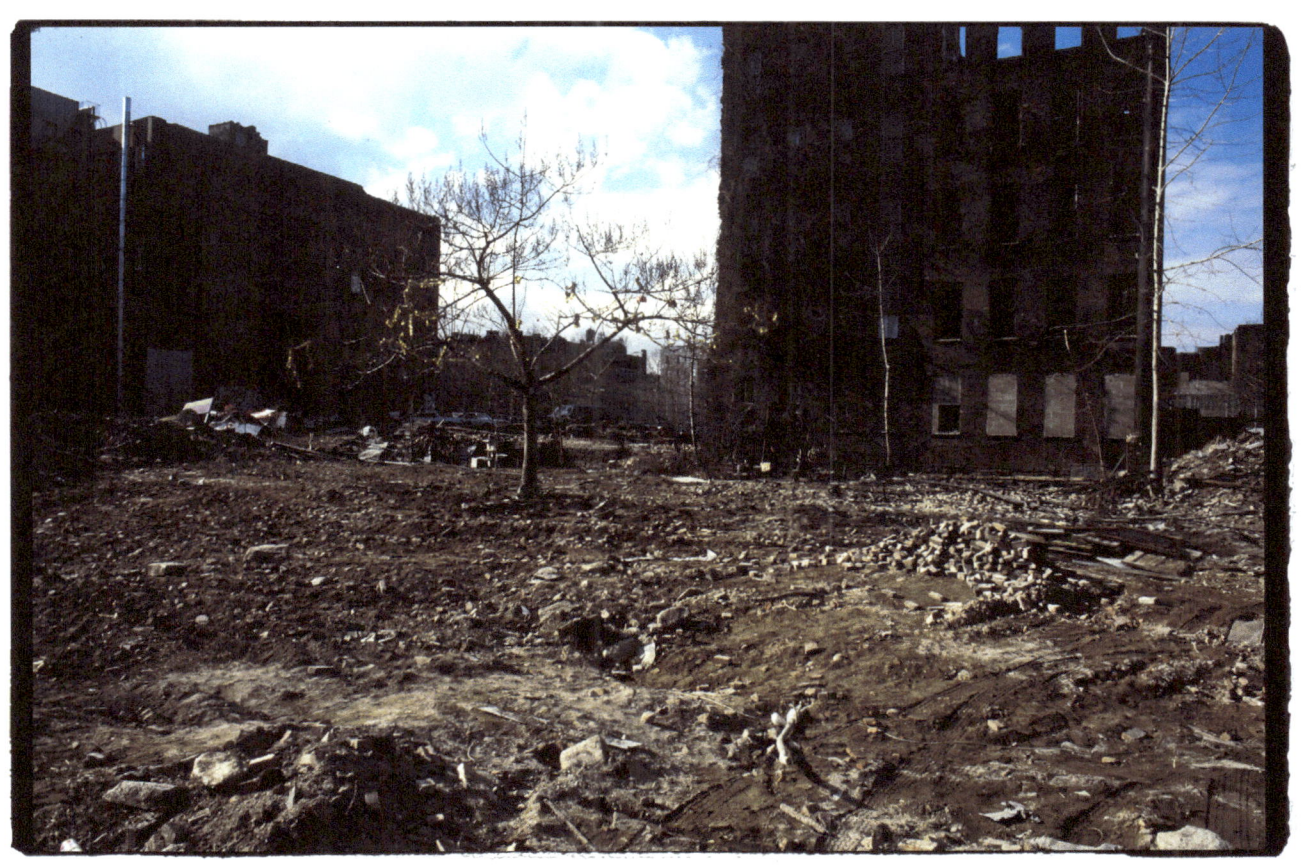

Vandals' Gallery
by Adam Purple

"Destruction of *The Garden of Eden* earthwork didn't "just happen"; it was executed (directly and) by such individuals and organizations as the following (based on journalistic information republished in *LIFE with les(s) ego*):"

Miriam Friedlander, NYC Council
Margarita Lopez, "Community" Board #3
Luis Soler, "Community" Board #3
Frances Goldin, "Community" Board #3
Herman Hewitt, "Community" Board #3
Felix Velaquez, "Community" Board #3
Julita Rossado,"Community" Board #3
Frank Mosco, Chairman "Community" Board #3
Otia Lee, "C"B #3 "wannabe"
Francisco Ferrer, Action for "Progress"
President Jimmy Carter, 1977-1981
President Ronald Reagan, 1981-1989
NYC Police Captain Joseph Wodarski
Edward I. Koch, NYC Mayor
Jed Abrams, HUD
Andrew Stein, Manhattan Boro President
Herbert Sturz, NYC Planning Commission
Carol Bellamy, NYC Council President
NYC Policeman Joe Espocito
NYC Policeman Tony Morales
Benjamin Bell, HPD
Reginald Wing, HPD
Selma Waldman, HPD
Janet Langsam, Ass't Commissioner, Special Housing Unit HPD
William "Bill" Eimicke, HPD
Chemical Bank
NYC Department of City Planning
NYC (Unconstitutional) Board of Estimate
Bess "I wrote a letter" Myerson, Commission*err*,
NYC Dept of Cultural Affairs 1985
U.S. Congressman Bill [anti-]"Green"
Joseph J. Christian, NYCHA
Val Coleman, NYCHA
Francis Juliano, HPD
Tom Hallick, HPD
Anthony Gliedman, HPD
Noah Kinigstein, Esq.,
"my" turn-coat lawyer

1) Rudolph Giuliani, U.S. Attorney and
2) Judge Vincent L. Broderick
=>Both: Southern District of New York

Douglas "blind man" Manley, HUD "Environmental" Clearance Officer, whose sworn testimony was: "between July and August 1985" (at MIDNIGHT!)

The *kNew York Times*, NON-local ("Y") edition, 25 Sept 1985, 3-column photo caption disinformationally "reporting" The Garden's destruction, while never having printed ANY width FULL view of The Garden.

Robert Morgenthau, NYC District Attorney
NY State Judge Bruce McMarion Wright
Wilfred Varga, HPD
Richard Rosenthal, NYCHA
James McCullar, "Project" architect
John Simon, NYCHA
Johnny Wilford, HPD
A(rthur) D. Herman Const. Co., Inc., and
Edward "Eddy" Bottiglieri, ADH employee
Rolald J. DiVito, Esq.
Blanford Construction Co., Inc., Bklyn
Michael Ferone Brick Co., Inc., Bklyn
John Rossi, Moonachie, NJ (8 Jan 1986)
Samuel ("Silent Sam") Riley Pierce, HUD
1) James L. Oakes, Circuit Judge,
2) Amalya L. Kearse, Circuit Judge and
3) John R. Bartels, District Judge
=> All three: U.S. Court of Appeals, Second Circuit

About the Photographs

Page	
27	Adam at work with brick-bat calligraphy, March 21, 1975, photo by Eve Purple
28	*The Garden of Eden*, June 21, 1976, composite, photos by Adam Purple
29	*The Garden of Eden*, September 23, 1977, composite, photos by Adam Purple
30	*The Garden of Eden*, December 30, 1978
31	*The Garden of Eden*, September 23, 1979
32	*The Garden of Eden*, 1980
33	Adam on the fire escape, 1982
34	*The Garden of Eden*, 1985
35	Adam on the roof of a building on Stanton Street
36	*The Garden of Eden* sign, c. 1984
39	Portrait of Adam Purple, 1982
40	Adam's building, 184 Forsyth Street, prior to June 28, 1984
41	Adam sweeping
42	Adam in the doorway of 184 Forsyth Street
43	Adam sawing wood at 184 Forsyth Street
44	Adam on the roof of 184 Forsyth Street
45	Adam walking on Eldridge Street
46	Adam at home at his typewriter
47	Adam at home at the stove
48	Adam at his window, 1983
49	Adam at his window facing Eldridge Street
53	Adam assembling *Zentences* at 184 Forsyth Street
54	Adam holding *Zentences* (ring bound version)
55	Adam holding *Zentences* (bound version)
59	Adam collecting manure in Sara Roosevelt Park, 1984
60	Adam collecting manure in Sara Roosevelt Park, 1984
61	Adam in Central Park, 1979
62	Adam with night soil, 1985
63	Adam and Adam, 1985
64	Adam pushing wheelbarrow, 1979
65	Adam tossing bricks, 1978
66	Brick path in progress, 1985
67	Adam holding a brick, 1985
68	Demolition of 182 Forsyth Street, 1984
69	Demolition of 182 Forsyth Street, 1984
73	Adam raking, 1979
74-75	Adam sowing, 1980
76	Adam on brick path, 1983
77	Adam working in *The Garden of Eden*, July 1985
78	Adam with flowers, July 1985
79	Adam with corn crop
80	Adam holding strawberries, 1983
81	Adam with cherry tomatoes, 1983
82	Adam with cucumber, 1983
83	Boys in *The Garden of Eden*, 1985
84	Adam with neighbors in *The Garden of Eden*, 1985
85	Father and daughter in *The Garden of Eden*, 1985
86	People in *The Garden of Eden*, 1985
87	Adam addressing a group, 1985
88	Man with guitar at the wall of *The Garden of Eden*, 1985
89	Oil paintings by Patricia Melvin in and of *The Garden of Eden*
90	Community gathering in *The Garden of Eden*, 1984
93	Adam on court house steps
94	Adam at hearing
95-98	Bulldozer destroying protective wall at *The Garden of Eden*, September 24, 1985
99	Police at *The Garden of Eden*, September 24, 1985
100	Garden supporter and demolition workers, September 24, 1985
101	Supporters of *The Garden of Eden* blocking bulldozer, September 24, 1985
102	Bulldozer destroying *The Garden of Eden* sign, September 24, 1985
103	The site of *The Garden of Eden* after it was razed on January 8, 1986